AMERICAN ARTISTS
THE & LOUVRE

This publication accompanies the exhibition *American Artists and the Louvre*,
Musée du Louvre, Paris, June 14–September 18, 2006, co-organized with the
Terra Foundation for American Art, with the support of The Florence Gould Foundation.

EXHIBITION CURATORS

Elizabeth Kennedy
Curator of Collection, the Terra Foundation for American Art, Chicago

Olivier Meslay
Curator, Département des Peintures, Musée du Louvre

AMERICAN ARTISTS
THE & LOUVRE

EXHIBITION CATALOGUE EDITED BY
Elizabeth Kennedy and Olivier Meslay

WITH CONTRIBUTIONS BY
Lois Marie Fink, Elizabeth Kennedy, Olivier Meslay, and Paul Staiti

HAZAN

TERRA
FOUNDATION FOR AMERICAN ART

 MUSÉE DU
LOUVRE
ÉDITIONS

Musée du Louvre

HENRI LOYRETTE
Chairman and Director

DIDIER SELLES
Chief Executive Director

ALINE SYLLA-WALBAUM
Deputy Executive Director,
Director of Cultural Development

Terra Foundation for American Art

ELIZABETH GLASSMAN
President & Chief Executive Officer

DONALD H. RATNER
Executive Vice President
& Chief Financial Officer

AMY ZINCK
Vice President

The Terra Foundation for American Art
co-organizes the exhibition *American
Artists and the Louvre*. This exhibition
was made possible thanks to the support
of The Florence Gould Foundation

TERRA
FOUNDATION FOR AMERICAN ART

This exhibition was designed and mounted by
the Direction de l'Architecture, Muséographie
et Technique of the Musée du Louvre,
director Michel Antonpietri, with the Service
Architecture, Muséographie et Signalétique,
director Clio Karageorghis, and the
Service des Travaux Muséographiques,
director Benoît Chalandard. The exhibition
was designed by Patricia Cabotse, with graphic
design by Donato di Nunno. The works were
handled by Eric Persyn and Damien Masselot.

Project coordination was by Nicole Chanchorle
of the Service des Expositions under the
direction of Soraya Karkache, Direction
du Développement Culturel.

This book has been sponsored by
Arjowiggins and the Terra Foundation
for American Art.

Musée du Louvre, direction du Développement culturel

VIOLAINE BOUVET-LANSELLE
Head of Publications

CATHERINE DUPONT
Editorial coordination

CAROLE NICOLAS
Iconography

Terra Foundation for American Art

DIEGO CANDIL
Executive Director,
Musée d'Art Américain Giverny

FRANCESCA ROSE
Chief Editor, Musée d'Art Américain Giverny

Éditions Hazan

ANNE-ISABELLE VANNIER
Editorial coordination

BERNARD WOODING
Editor

SYLVIE MILLIET
Graphic design and layout

JEAN-MARC BARRIER
Cover design

CLAIRE HOSTALIER
Production

Translation

GEOFFREY CAPNER
for Olivier Meslay's essay and for the
catalogue entries nos. 2 to 13.

© Terra Foundation for American Art,
Chicago for illustrations
cats. 1, 17, 22, 25, 26, 27
© ADAGP Paris, 2006
© Musée du Louvre, Paris, 2006
© Éditions Hazan, Paris, 2006

ISBN (Musée du Louvre Editions): 2-35031-071-X
ISBN (éditions Hazan) : 2-7541-0097-0

Registration of copyright: June 2006
Photoengraving: Sele Offset, Turin, Italy
Printed and bound by Pollina, Luçon, France : n°L40047b

This book is printed on Satimat paper 170g and
Satimat paper 400g for the jacket, Arjowiggins Group.

Cover: Samuel F. B. Morse
GALLERY OF THE LOUVRE (detail)
Terra Foundation for American Art, Chicago

Authors

Lois Marie Fink, Research Curator Emerita, Smithsonian American Art Museum

Elizabeth Kennedy, Curator of Collection, Terra Foundation for American Art

Olivier Meslay, Curator, Département des Peintures, Musée du Louvre

Paul Staiti, Professor of Art History, Mount Holyoke College, South Hadley Massachusetts

Lenders

Works have been generously lent by the following:

FRANCE

Blérancourt, Musée National de la Coopération Franco-Américaine

Morosaglia, Musée Départemental de Pascal Paoli

Paris, Musée d'Orsay

Poitiers, Musée Sainte-Croix

Poitiers, town hall

Quimper, Musée Départemental Breton

Quimper, town hall

UNITED STATES

Albany, Albany Institute of History and Art

Brooklyn, Brooklyn Museum

Chicago, Terra Foundation for American Art

Cincinnati, Taft Museum of Art

Detroit, The Detroit Institute of Arts

Forth Worth, Amon Carter Museum

Hartford, Wadsworth Atheneum Museum of Art

New York, National Academy Museum and School of Fine Arts

Norfolk, Chrysler Museum of Art

Philadelphia, Pennsylvania Academy of the Fine Arts

Sarasota, The John and Mable Ringling Museum of Art

Swarthmore, Swarthmore College (on loan to the Philadelphia Museum of Art)

Worcester, Worcester Art Museum

Acknowledgments

An international partnership always presents opportunities and challenges; fortunately, the rewarding outcome is a collegial transatlantic community. The knowledge required to accomplish this significant loan exhibition was expertly provided by numerous individuals. The curators would like to express their gratitude to the following individuals: Ellen Alers, *Smithsonian Institution Archives*, Lynne Ambrosini, *Taft Museum of Art*, Amy Burman, *The Art Institute of Chicago*, Mary Busick, *Wadsworth Atheneum Museum of Art*, Terry Carbone, *Brooklyn Museum*, Laurence des Cars, *Musée d'Orsay*, Aaron DeGroft, *The John and Mable Ringling Museum of Art*, Isabelle Dervaux, *National Academy Museum and School of Fine Arts*, Deborah Diemente, *Worcester Art Museum*, Anne Doppfer, *Musée National de la Coopération Franco-Américaine*, Blérancourt, Barbara File, *The Metropolitan Museum of Art*, Kathleen Foster, *Philadelphia Museum of Art*, Lizanne Garrett, *National Portrait Gallery*, Tammis K. Groft, *Albany Institute of History and Art*, Robert Harman, *Pennsylvania Academy of the Fine Arts*, Jefferson Harrison, *Chrysler Museum of Art*, Joan Henricks, *Taft Museum of Art*, Barbara Katus *Pennsylvania Academy of the Fine Arts*, Elizabeth Mankin Kornhauser, *Wadsworth Atheneum Museum of Art*, Laura J. Latman, *Bowdoin College Museum of Art*, Rebecca E. Lawton, *Amon Carter Museum*, Audrey Lewis, *Philadelphia Museum of Art*, Michele Leopold, *The John and Mable Ringling Museum of Art*, Lynn Marsden-Atlass, *Pennsylvania Academy of the Fine Arts*, Anna Martin, *National Academy Museum and School of Fine Arts*, Jane Myers, *Amon Carter Museum*, Anne Péan, *Musée Sainte-Croix, Poitiers*, Maryse Redien, *Musée Sainte-Croix,*

Poitiers, Joseph J. Rishel, *Philadelphia Museum of Art*, Kim Sajet, *Pennsylvania Academy of the Fine Arts*, Xavier Salmon, *Musée National du Château de Versailles*, Shannon Schuler, *Philadelphia Museum of Art*, Diane Shewchuk, *Albany Institute of History & Art*, Elizabeth Streicher, *Worcester Art Museum*, Melissa Thompson, *Amon Carter Museum*, Jennifer Thompson, *Philadelphia Museum of Art*, Meredith Topper, *Art Commission New York*, James Tottis, *The Detroit Institute of Arts*, Pam Watson, *The Detroit Institute of Arts*, Katie Welty, *Brooklyn Museum*.

In their intellectual journey to explore the rich and early artistic exchange between France and America, the curators offer particular thanks to scholars and friends: Marie Adjej, Brian Allen, Tim Barringer, Leah Boston, François Brunet, Sarah Cash, Annie Cohen-Solal, Barbara Gallati, Thomas Galifot, Amy Galpin, Gabrielle Gopinath, Marie-Alice Seydoux, Wendy Greenhouse, Lauriane Gricourt, Myriam Herlet, Ellen Holtzman, Michael Léja, Eleanor Harvey Jones, Erica Hirshler, Sir John Holmes, Lady Holmes, Frank Kelley, Lucia Martinez, Nancy Mowll Mathews, Agnès Mathieu-Daudé, Kenneth Myers, Alice Odin, Philippe Roger, Maricelle Robles, Philippe Roger, John Schussler, Janine Serafini, Michael Shapiro, Marc Simpson, Lee A. Veddar, Adam Weinberg, H. Barbara Weinberg, Margaret Werth, Jeannette Yvain, Sylvia Yount, and special thanks to Cecil Oulhen.

As always, the staffs of the Musée du Louvre and the Terra Foundation for American Art have provided invaluable support in all aspects of this endeavor. We would like to extend our appreciation to our associates.

MUSÉE DU LOUVRE: Violaine Bouvet-Lanselle, Nathalie Brunel, Nicole Chanchorle, Catherine Dupont, Sophie Kammerer, Sabine de La Rochefoucauld, Aggy Lerolle, Camille Madelin, Christophe Monin, Laurence Roussel, Nicole Salinger, and Aline Sylla Walbaum.

MUSÉE D'ART AMÉRICAIN GIVERNY: Katherine Bourguignon, Diego Candil, Catherine Dufayet, Bronwyn Griffith, Vanessa Lecomte, Sophie Lévy, Clare Munana, Francesca Rose, and Veerle Thielemans.

TERRA FOUNDATION FOR AMERICAN ART (Chicago): Stacy Bolton, Elaine Holzman, Janice McNeill, Kathleen Radcliffe, Donald Ratner, Cathy Ricciardelli, Shelly Roman, Elizabeth Rossi, Jennifer Siegenthaler, Elisabeth Smith, and Amy Zinck.

We appreciate the encouragement of the American Friends of the Louvre, their President Christopher Forbes, their Director Sue Devine, and Brooke Bates.

We express our gratitude to The Florence Gould Foundation.

Finally, the supportive role of Elizabeth Glassman and Henri Loyrette, leaders in furthering international cultural dialogue, was instrumental in realizing this extraordinary exhibition—an important milestone in the reassessment of transatlantic artistic exchange and the Louvre's enduring impact on generations of American artists.

Elizabeth Kennedy and Olivier Meslay

CONTENTS

Throughout its twenty-five-year history, the Chicago-based Terra Foundation for American Art has supported exhibitions, scholarship, and educational programs designed to engage individuals around the globe in an enriched and enriching dialogue on American art. Currently, the foundation operates the Musée d'Art Américain Giverny, initiates and grants to exhibitions and projects in the field of American art, and actively acquires works of art to augment its collection.

The Terra Foundation's collection of American art, which spans the colonial era through 1945, includes more than seven hundred works by such artists as George Bellows, Mary Cassatt, John Singleton Copley, Stuart Davis, Robert Henri, Winslow Homer, Edward Hopper, Maurice Prendergast, and James McNeill Whistler. The foundation provides opportunities for interaction with works in its collection by supporting exhibitions and programming at the Musée d'Art Américain Giverny and through a multi-year loan to The Art Institute of Chicago expanded galleries of American art. In addition, the foundation lends objects from its collection to exhibitions that advance American art scholarship.

The year 2005 marked the official inauguration of the Terra Foundation's expanded grant program, designed to respond to and support worldwide needs in American art. In an effort to make scholarly resources more available around the world,

the Terra Foundation recently gave a substantial, multi-year grant to the Archives of American Art, a division of the Smithsonian Institution, to make their most frequently requested items available online. In addition, the Terra Foundation's own Web site includes comprehensive scholarly information about the foundation's entire collection. The foundation supports scholars through residential fellowships at the Smithsonian American Art Museum and at the Musée d'Art Américain Giverny, in addition to travel grants offered through the Courtauld Institute of Art, the John-F.-Kennedy-Institut für Nordamerikastudien, and l'Institut National d'Histoire de l'Art.

The Terra Foundation for American Art has made it a priority to foster innovative projects that emphasize multinational perspectives and participation. We would like to thank Henri Loyrette, President and Director, and the Musée du Louvre for allowing us to co-organize the first ever exhibition of American art at the Musée du Louvre, and for helping us create a true transatlantic partnership. The Terra Foundation will continue to develop strategic partnerships to foster the interpretation and enjoyment of American art. Currently, the foundation is collaborating with the Solomon R. Guggenheim Museum, New York, to mount an American art exhibition in China in 2007. Implicit in all activities of the Terra Foundation for American Art is the belief that art has the potential both to distinguish cultures and to unite them.

MARSHALL FIELD
Chairman, Board of Trustees, Terra Foundation for American Art

ELIZABETH GLASSMAN
President & Chief Executive Officer, Terra Foundation for American Art

The Musée du Louvre and the Terra Foundation for American Art are proud to present *Les Artistes américains et le Louvre /American Artists and the Louvre*, the first exhibition of American artists ever to be shown at the Louvre. It explores the roots of Franco-American artistic exchange and the history of the Louvre as a site for artistic inspiration for generations of American artists. The exhibition marks the return of Samuel F. B. Morse's tour de force, *Gallery of the Louvre* (1831–33), to the Louvre after 175 years. This signature masterwork in the Terra Foundation for American Art Collection pays homage to the Musée du Louvre and its importance in educating artists. *American Artists and the Louvre* headlines "American Season at the Louvre," a program of complementary symposia, lectures, and concerts, in addition to a school exchange and a survey of American artworks in French collections.

American Artists and the Louvre is curated by Olivier Meslay, Curator, Département des Peintures, Musée du Louvre, and by Dr. Elizabeth Kennedy, Curator of Collection, Terra Foundation for American Art. Olivier Meslay examines the earliest generations of American artists in France (1760–1860), demonstrating that artistic exchange between the United States and France has a long and deep history, while Elizabeth Kennedy investigates the significance of the Louvre as the unofficial American academy (1800–1940), illustrating the importance of visiting the Louvre's galleries both for the sensory experience and for the lessons rooted in its incomparable collection.

The Terra Foundation for American Art has made it a priority to bring American art and interpretation to audiences worldwide in order to encourage a greater understanding and appreciation of America's rich artistic and cultural heritage. This exhibition testifies to the importance of cross-cultural dialogues and underscores the belief that art has the potential both to distinguish cultures and to unite them.

"Open to all since 1793": from the outset, the Louvre has embodied the concept of a truly "universal" institution in the scope of its collections, in its appeal to millions of annual visitors, and in its role as an international center for cultural heritage. From the museum's inception, generations of American artists were allowed unlimited entry to wander its galleries to study, sketch, and paint. *American Artists and the Louvre* venerates Europe's premier art museum and its collection of works by old masters as the cultural talisman for American artists.

ELIZABETH GLASSMAN
President & Chief Executive Officer, Terra Foundation for American Art

HENRI LOYRETTE
Chairman and Director, Musée du Louvre

Americans love Paris. This international affair, begun over two hundred years ago, was often nurtured by American artists, who came to the City of Light to absorb their *métier* and to nourish their souls. While scholars of historic American art have investigated productively and discussed the varied consequences of this intense relationship, there is more to be explored. Amazingly, within this richly textured account of Americans in France, the role of the Louvre—the hub of artistic Paris—has not been considered. In reviewing the abundance of personal documentation, the collective voice of generations of museum visitors tells a tale in which each discovery was more captivating than the last. Adding to these historical discoveries are our own investigations, which will contribute another layer of understanding to Franco-American artistic exchange.

The Louvre was decreed to be a site of artistic connection from its inception as a public museum. As early as 1792, French Interior Minister Jean-Marie Roland declared, "This Museum . . . must nourish a taste for the arts, train art lovers, and serve artists. It must be open to all.

Everyone must be able to set their easel before any painting or statue, draw them, paint them, or model them, as they think fit." The Louvre, exceeding the early fervent expectations of a revolutionary era, was especially beneficial for American artists, who had no national art museum where they could engage in an intense discourse on the history of art. In 1800 John Vanderlyn became the first American artist to see his paintings hung in the Louvre; hundreds of his compatriots were honored to share the same experience over the next hundred years. Several paintings on the checklist of *American Artists and the Louvre* were previously exhibited in the Louvre, and two works of art were actually created in its galleries. Less obvious, but possibly more enlightening, is the inclusion of paintings by artists not normally associated with a notable Parisian art experience. Nonetheless, all the paintings reveal a thoughtful association with the world's most renowned art museum and underscore the complexity of the Franco-American artistic conversation that occurred within the context of the Louvre.

ELIZABETH KENNEDY
Curator of Collection, Terra Foundation for American Art

OLIVIER MESLAY
Curator, Département des Peintures, Musée du Louvre

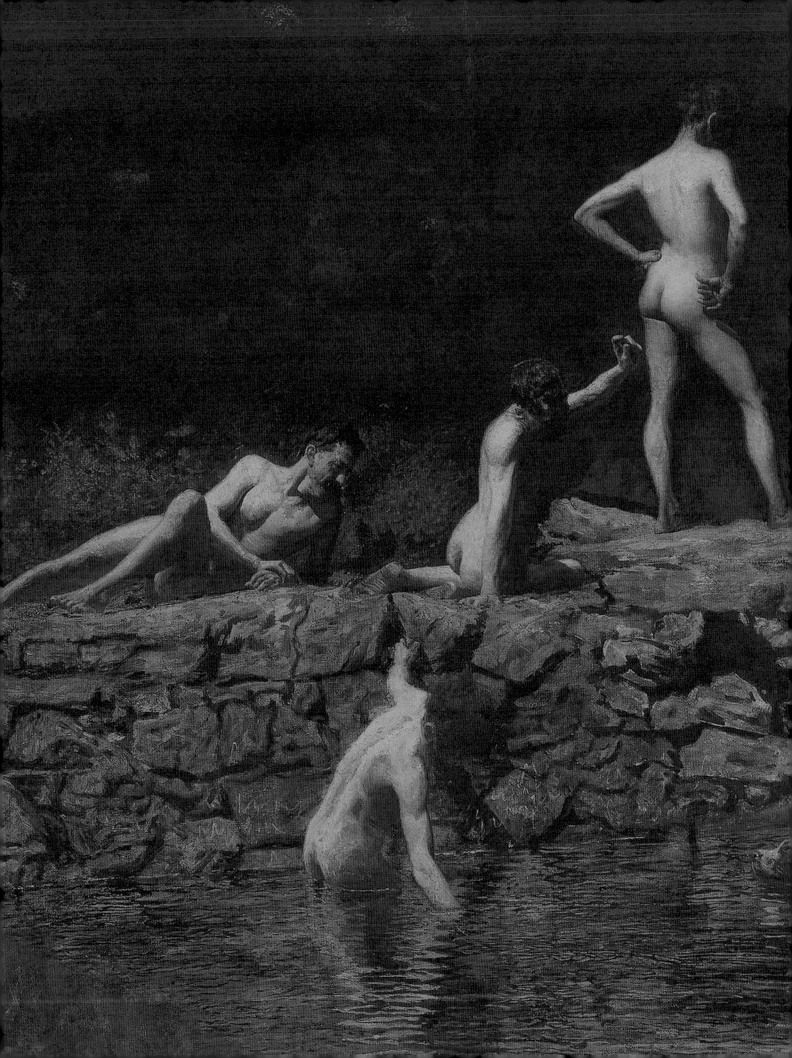

REACTIONS TO A FRENCH ROLE IN NINETEENTH-CENTURY AMERICAN ART

REACTIONS TO A FRENCH ROLE IN NINETEENTH-CENTURY AMERICAN ART

LOIS MARIE FINK

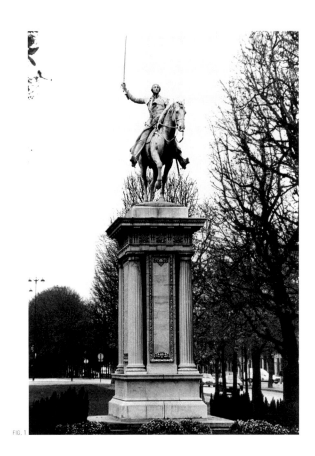

FIG. 1

FIG. 1 PAUL WAYLAND BARTLETT (1865–1925), **MARQUIS DE LAFAYETTE**, 1907, bronze.
Cours-la-Reine, Paris

FIG. 2 CHARLES SPRAGUE PEARCE (1851–1914), **PAUL WAYLAND BARTLETT**, ca. 1890,
oil on canvas, 42 1/2 x 29 3/4 in. National Portrait Gallery, Smithsonian Institution, Washington, D.C.

During the nineteenth century aspiring painters and sculptors from the United States had to go abroad to see original works of art and study with accomplished artists. Each of their destinations—London, Florence, Rome, Munich, or Paris—offered a unique setting with particular advantages. Paris alone incurred the distinction of being denigrated by certain American artists and critics, who became increasingly hostile during the last three decades of the century when the French capital had become the major art center of the Western world. They made threats to the careers of Americans who went there and wrote sarcastic criticism about French art. What was behind this animosity in the face of so many compatriot successes that originated in Paris?

In the light of political disputes between France and the United States in our own day, we may find renewed meaning and a glimmer of understanding in exploring controversies of the past. In a recent study, French historian Philippe Roger delves into two centuries of anti-Americanism in France, relating its origins in colonial America and subsequent development stimulated by responses to historical events.[1] Though at times initiated by legitimate political disagreements, negative perceptions of the United States built on past emotional responses to the point where they lost touch with reality. Ultimately French anti-Americanism tells us much more about the French than about America. That is also the revelation of negative American reactions to a French role in American art; rather than gaining insights into French art, we see more clearly the

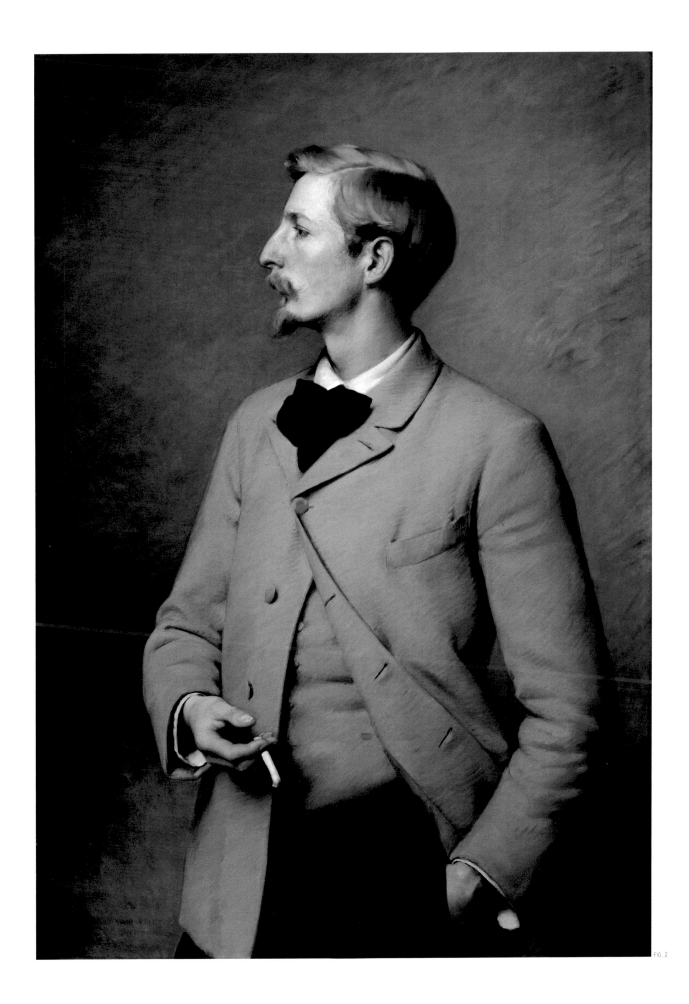

FIG. 2

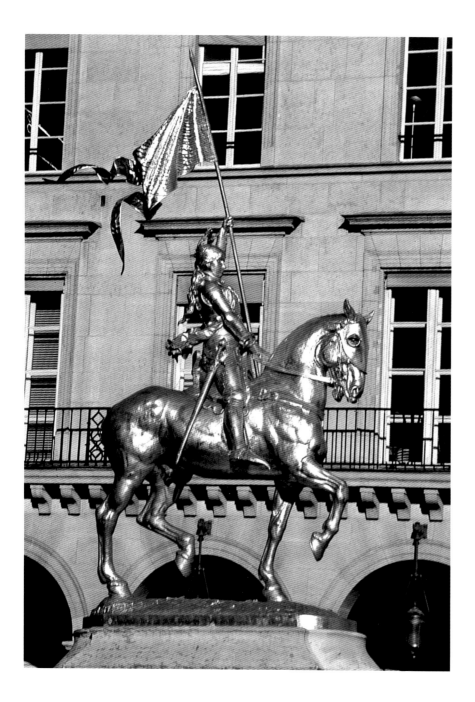

ambitions of Americans for their own art and illusions about their national image.

In my study on American art in Paris in the nineteenth century, I discussed at some length the enormous impact of the Parisian art world on the cultural life of the United States.[2] In this brief essay, I want to begin with the positive career experiences of a sculptor and then touch on several types of denunciatory reactions that have been repeatedly expressed in the United States from the nineteenth century to our own time.

FORMING BONDS BETWEEN NATIONS AND ARTISTS

The equestrian statue of the *Marquis de Lafayette* by Paul Wayland Bartlett stood in the inner garden of the Court of the Louvre from July 1907 until July 1984, when it was relocated to make way for the archaeological excavations that preceded I. M. Pei's glass pyramid. It is now situated on the Cours-la-Reine near the Grand Palais (fig. 1). A plaster model in the collection of the Smithsonian American Art Museum in Washington is life-size (fig. 4); the Paris bronze measures one-and-a-half times life or "heroic" size. Two bronze replicas of the Paris equestrian were cast, the first in 1920, a gift from the Knights of Columbus to the city of Metz in France; it was destroyed during the Second World War. The latter was erected in 1932 in Hartford, Connecticut, Bartlett's home state.

Plans for the monument at the Louvre began a decade before its completion. Intended as a gift to France from the United States, it was to be presented as part of a

celebration at the 1900 Paris Universal
Exposition. A sentimental aura was cast on
the Lafayette project by the memorable gift
from France, *Liberty Enlightening the World*
by Frédéric Auguste Bartholdi (1834–1904),
set in place in 1886 in New York City's har-
bor, and by historic memories of the French
role in the Revolutionary War. On October 19,
1898, the anniversary of the decisive
American victory at Yorktown, President
William McKinley invited schoolchildren
across the country to give pennies and
nickels toward the cost of the Lafayette
statue. On the same day, Congress ordered
50,000 Lafayette dollars to be struck, their
sale to provide additional funding. The
Marquis de Lafayette was an immensely
popular figure among Americans. During a
return visit to the nation in 1824–25, he
made an extensive tour through northeast-
ern and mid-Atlantic states into the south,
leaving in his wake a number of towns
renamed "Lafayette."[3]

Designated as sculptor of the projected
work by a committee of French and
American officials, Bartlett supplied a
painted plaster model for the occasion of the
1900 Exposition to serve as the centerpiece
of a dedicatory program in the courtyard of
the Louvre on the Fourth of July.[4] A great
deal of fanfare accompanied speeches by
representatives of both nations to inaugu-
rate the future monument, including a band
playing a march written especially for the
event by John Phillip Sousa. From that
celebratory moment on, Bartlett's work on
the Lafayette proceeded slowly. When at
last the bronze was put in place in 1907, a
modest ceremony heralded its arrival.
Bartlett included on the pedestal the image

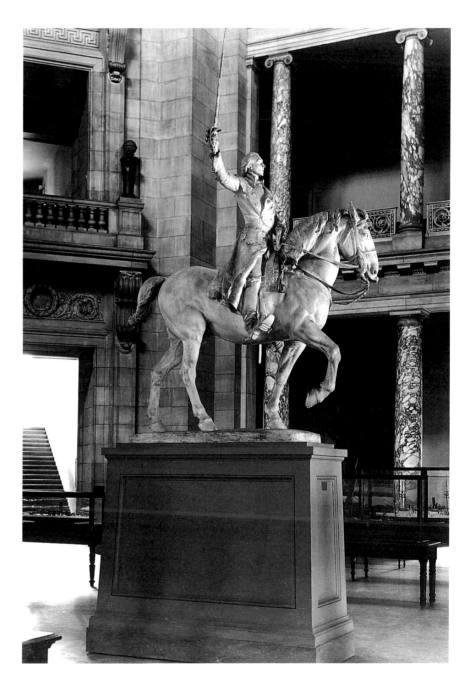

FIG. 4 PAUL WAYLAND BARTLETT (1865–1925), **STATUE OF "MARQUIS DE LAFAYETTE" IN THE ROTUNDA OF THE
NATIONAL MUSEUM OF NATIONAL HISTORY**, 1899, plaster, life-size, Smithsonian Institution Archives,
Washington D.C.

of a turtle to signify the length of time beyond expectations he had required to finish his work. An inscription denotes contributions toward the monument given by American schoolchildren.

A famous equestrian located at the Place des Pyramides—*Joan of Arc* by Bartlett's teacher, Emmanuel Frémiet— had served as inspiration for the American sculptor's *Lafayette* (fig. 3). Both youthful warriors strike dynamic poses: Joan holding forth the staff of her banner, and Lafayette his sword. Sitting bolt upright, they look straight ahead, energized by the confidence in the infallibility of themselves and their mission that belongs only to the very young (Lafayette was nineteen; Joan, fifteen or sixteen).

This representation of Lafayette holding his sword high aloft as he arrives in July 1777 to join General Washington in the struggle for American independence may appropriately symbolize the most significant kind of bond that has been made between the United States and France throughout their history: the giving of aid in times of desperate need. As a work of art, the equestrian embodies another kind of productive relationship that also began in the late eighteenth century, namely exchanges between French and American artists—in this particular case, the creative genius and technical expertise of an American sculptor brought to maturity through his studies in Paris. A fellow American artist in Paris, Charles Sprague Pearce (1851–1914), portrayed the young sculptor in his mid-twenties as a self-assured sophisticate who would expect success at anything he tried (fig. 2).

PARIS AS THE FAVORED ART CENTER FOR AMERICAN ARTISTS

A son of American sculptor Truman Bartlett (1835–1923), Paul had been sent to Paris at the age of nine to complete his education. At fourteen he exhibited at the Salon (a bust of his grandmother); at fifteen he enrolled at the École des Beaux-Arts, where the curriculum emphasized thorough practice in the depiction of the human figure. Subsequently he studied with Frémiet, one of the most famous *animaliers* of the time. The Paris art world provided the educational background and exhibition opportunities that enabled him to embark on a career that fulfilled incipient promise.[5] These were also the main factors that drew other American art students to Paris in the late nineteenth century: study with leaders of contemporary art and participation in the international exhibitions of the Salons. The possibility of sales through the most active art market in Europe offered further benefits.

Study dominated the attractions of Paris, where government art schools—including the École des Beaux-Arts—were free to foreign students as well as to French citizens. Moreover, the most renowned artists of France—indeed, some of the most famous in the Western world—taught in the government institutions and private studios. Arrivals from the United States could only marvel at this, for in their own country many professional artists looked upon teaching with disdain. The National Academy of Design in New York City did not consider its school a priority, and in the mid-1870s when the organization closed the Life Class to save money, infuriated

students with their instructor walked off to form their own school—the Art Students League.[6] In Paris the Salon catalogues proudly stated names of the exhibitors' teachers, who competed with each other to get their pupils accepted in the prestigious exhibitions. Salon participation brought international recognition, the possibility of sales and commissions, and—almost always—an increase in the monetary value of a work.

The Parisian art community represented dynamic leadership in contemporary art. Its closest rival, Munich, fostered a particular method of teaching and a distinctive manner of painting, but even so the Munich style owed something to close admiration of works by Gustave Courbet (1819–1877) and Edouard Manet (1832–1883).[7] At this time the strength of the French school proved almost inescapable. Paris offered a range of stylistic alternatives which enabled the Americans to realize their own propensities and develop in whatever way was most congenial to them. For example, conservative figurative painting and sculpture that employed academic techniques was promoted by Léon Gérôme (1824–1904), the teacher of Thomas Eakins (1844–1916); new approaches to technique and expression, spearheaded by Manet and the Impressionists (their first group exhibition, 1874), became the direction of Mary Cassatt (1845–1926). The majority of French artist-teachers combined various aspects of those two extremes, the traditional and the new, striving to attain a *juste milieu*.[8] Jules Bastien-Lepage (1848–1884), a painter much admired by Charles Sprague Pearce, espoused this approach, as did

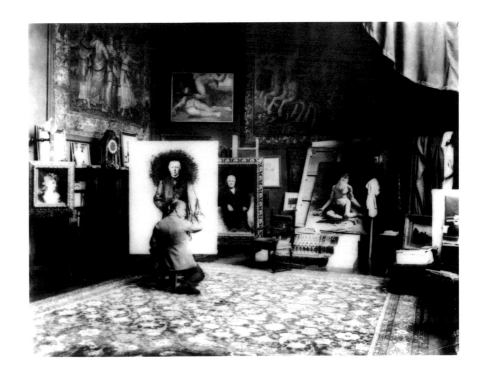

FIG. 5 **Léon Bonnat (1833–1922) in his Paris Studio**, photograph, ca. 1885, National Portrait Gallery, Smithsonian Institution, Washington, D.C.

Léon Bonnat, Pearce's teacher (fig. 5). Most American painters chose to work in this mode, for like their French masters, they wanted to accept modern concepts of composition and color but, at the same time, maintain substantial connections to art of the past. "The business of the good painter," Childe Hassam (1859–1935) believed, "is to carry on tradition as everyone of the good painters have done always and without deviation from the well beaten path. Not to self-consciously attempt to be original and startling."[9] Hassam's own works exemplify this maxim, which directly contradicts American attitudes toward past art held in the first half of the century, when artists felt that their lack of a national tradition in art was advantageous. However, during these decades, even the most original of artists—such as Manet—made obvious connections to works of traditional art. Though the French artists who worked in different styles may have had little else in common, Albert Boime observed that they shared "a deep psychological need to establish rapport with the past."[10] Differences lay in how they used the past.

American artists looked with wistful awe on generous government subsidies for art in France (compared to pennies and nickels from schoolchildren!). French officials considered the arts to be a visible source of the nation's identity and assets in its economy. "Art has not yet in this country become, as in France, a great popular concern, a condition of the national life, a prime cause of the national prosperity," observed an American commentator in 1880.[11] The art market in Paris constituted a significant contribution to the wealth of the nation; in numbers of items bought and sold and in the exchange of money it outclassed other venues in Europe. Lively sales of contemporary art attracted American collectors, who enjoyed the competitive nature of the Parisian art scene—and the possibility of making a profit through timely purchases of an artist's works as they appreciated in value. The possibility of visiting French artists in their studios gave additional pleasure to acquisitions. Another favored meeting place was at the Salon, in front of an artist's exhibit. If a desired work were already sold, a collector sometimes commissioned a replica. American artists resident in Paris often acted as agents, introducing their compatriots to French artists and carrying on correspondence relative to items of potential interest. The Americans themselves benefited from personal contact with American collectors in Paris, selling their works directly out of their studios or at the Salons. These activities did not win friends in art communities across the United States, where preference for art created in Paris, whether by French or American artists, eroded sales for the homebodies and raised complaints as an unpatriotic practice. Adding insult to injury, from the 1860s Paris dealers had been bringing collections of mostly contemporary French art to New York City and other art centers, where they experienced rewarding numbers of sales.[12]

With these advantages, it is no wonder that the Parisian art world in the late nineteenth century became the favored destination for artists from the United States, seeking its unsurpassed environment for the nurturing of their profession. What is a

cause for wonder is the antagonism and rancor against Paris that developed at the same time—though a hint of fermenting anger is implied in the above mentioned practices of marketing art.

FRENCH ART AS AN INFECTIOUS DISEASE

"The influence of France in art is greater than that of any other nation. It inoculates all the world with its disease, but nowhere is its contagion so deeply felt as in the United States."[13]

William Wetmore Story (1819–1895) blasted out this denunciation while in Paris acting as an official of the United States Commission to the Universal Exposition of 1878. As an American sculptor who spent most of his professional life in Rome, he had no objections to his compatriots studying art abroad. To Americans Italy represented the glories of Western art in the incomparable works of great artists. Story's own works interpreted mythical and historical figures familiar in Italian Renaissance art—Cleopatra, the Libyan Sibyl, and Medea, among others. As a sculptor, he found a practical advantage in highly skilled Italian stone cutters who could translate his works modeled in clay or plaster into marble. For painters, the countryside with its colonnaded ruins of the ancient world presented inspiring scenes for subject matter, while Italy's museums, palaces, and churches were a collective treasure-house of artistic sources. In contrast to picturesque views into the past, Paris offered the sight of broad avenues converging in the perspective points of Baron Haussmann's reconstruc-

tion that had created the most modern city in the world—a complementary setting for the creation, exhibition, and marketing of modern art.

Story was right about French art being infectious; a massive infusion of foreign artists from all over the Western world —and Japan—eagerly came to Paris to be "inoculated" by French artists. He was right again about the "contagion" being most evident in American art. Of all the nationals represented in Paris in the last three decades of the century, those from the United States were by far the most numerous—and French and American critics alike commented on the closeness of their works to French masters.

Story's metaphor of French art as a "disease" relates to a growing obsession of this period with health and exercise (not unlike our own era in this respect). As recently as the 1860s Louis Pasteur and Joseph Lister had made their invaluable discoveries of ways to fight infection and prevent diseases that had been fatal for centuries. Dramatic advances in medicine and an awareness of proper health practices were so much a part of the times that art historian Sarah Burns uses the phrase, "Fighting Infection," as part of a chapter title in a book about American art and culture of the late nineteenth century. She points out that words like "clean," "wholesome," and "pure atmosphere" were used to describe the conditions for art production said to prevail in the United States.[14] As an implied contrast with the situation in Europe, this kind of figurative language has a history.

From the early days of the republic when Americans first smarted from European

remarks about their lack of culture, citizens of the new-born nation made an advantage out of deficiencies. With a dearth of original art but no shortage of braggadocio, they claimed an unparalleled advantage in having no cultural tradition and very little history. Poetry, painting, and the other fine arts could start afresh here, without the false and destructive ideas "that have degraded the species in other countries,"[15] as Joel Barlow put it in 1806—with a pointed jab at European assertions that plants and animals of the New World were stunted. A sophisticated business man, poet, and diplomat, Barlow had spent more than twenty years abroad between England and France and was just this side of being a Francophile, but his rhetoric addressed to fellow Americans was intended to encourage the belief that the nation's artistic production could be superior for the very reason of not having a historical background. This perception of the United States as a robust land, free from the effects of a decadent past was alive and well at mid-century. "It is *here*, in our fresh healthy land, that the new and sublime advent of Art may be looked for," Augustine Duganne, author of an 1852 book titled, *Art's True Mission in America*, assured his fellow citizens.[16]

Most of the artists who deplored the influence of Paris had not spent any appreciable length of time abroad; they belonged to an older generation (as did Story) that had been formed by the critical goals of the earlier part of the century. Based on subjective judgments of viewers, these principles evaluated a work of art on how successfully it conveyed moral values and sentimental emotions. An 1855 article in *The Crayon* ranked works of art according to nobility of feeling. American art had "a mission," Duganne's book implied, to inculcate responses of moral virtue, to raise popular taste to a higher level.

As the concept of a pure America that could produce a more wholesome art than was possible in the Old World continued to Story's moment in Paris, the general idea of European decadence became specifically identified with French art. Images of nudes, a genre in which French artists had few peers, were often targeted. "Obscenity is not found in English art, rarely in German, but it is common in Paris," one observer claimed.[17] Every Salon exhibition presented sculptures and large paintings of female nudes, figures that were not generalized in the classical mode. The study of the human figure was basic to the teaching of art in Paris, and once artists had mastered the difficulties of depicting that complex form, they demonstrated their skills by portraying nude subjects—which were highly marketable—not least of all to American collectors! Two Americans, Henry C. Gibson of Philadelphia, in 1870, and John C. Wolfe of New York City, in 1875, commissioned replicas of one of the most sensational nude paintings of the century, *The Birth of Venus* by Alexandre Cabanel (1823–1889). Those paintings are now in the Philadelphia Museum of Art and the Metropolitan Museum of Art, respectively; Cabanel's 1863 original is in the Musée d'Orsay. A number of additional nude subjects by French artists—and by Americans who worked in Paris—today hang on the walls of American art museums as gifts or bequests from late nineteenth-century collectors.

Contemporary French art in all its modes must have seemed to Story a contradiction to those values that stood at the center of his own professional approach, universal and timeless interpretations of tragedy and heroism as represented by historical and literary personages. He and others of his generation found it difficult to accept the present-day direction of art that focused instead on the commonplace and ephemeral in human experiences and scenes of nature.

AMERICAN ARTISTS IN PARIS AS MONGRELS

"The American who lives in Paris till he is a mongrel Frenchman can never paint a great picture."[18]

This claim must have struck a sympathetic chord as an apt figure of speech: first published in a popular periodical in 1880, it was reprinted in a Boston newspaper that same year. It asserts that an American artist who spends a great deal of time in Paris loses the ability to paint a "great picture." On the surface these insulting words may seem to be another manifestation of American pride in independence, but they also reveal a basis in contemporary scientific thought.

By the 1880s many writers on art had accepted the tenets of naturalistic philosophy, promoted by French philosopher Hippolyte Taine, whose writings were well known in the United States. The deterministic principles of this persuasion held that the greatest art was inevitably the product of a people, imbued with its history, climate,

social mores, and economy. "American work must smack of our own soil, mental and moral, no less than physical, or it will have little of permanent value,"[19] insisted Theodore Roosevelt, who fervently believed that the greatest art was linked to nationality. It followed that a superior work of American art could be created only by an artist who was formed by his or her nation's distinctive qualities. Artists who spent any length of time in Paris forfeited their cultural nationality and rendered themselves unable to paint a truly American picture because they had become mixed-breeds or "mongrels." This belief gave urgency to the contention that American artists should work at home, in the United States, and that they depict American life and American surroundings.

Critics who held this opinion often cited American paintings of French peasants as clearly "un-American" subjects. Even so, American collectors of contemporary art were attracted to them, while modest homeowners also enjoyed French rural scenes in the form of inexpensive chromo reproductions. In contrast to American farmers or American city dwellers, European peasants represented a way of life that had endured for ages (and was disappearing). Part of their appeal as images related to contemporary fascination with the history of humankind, which, in an era permeated by evolutionary theory, promised a better understanding of the present through knowledge of the past. By contrast, American life offered little historical depth to connect with earlier human existence, while the life of French peasants seemed to evoke a bygone age.

As they tried to establish themselves in professional circles at home before leaving France, American artists resident in Paris often sent works they had shown at the Salons to art centers in the United States. This practice received wide notice and inspired both acclaim and rejection. Reporting on a Philadelphia exhibition of 1880 that included forty-five American pictures from the Paris Salons, a critic in *The Art Journal* observed, "In no previous year were there in existence forty-five such pictures so notable in quality as these."[20] "French influence seems to be strong," commented another writer of an 1886 event, "and the exhibition might serve to convince the unbelieving that the best side of American art, as far as methods of expression go, comes directly or indirectly from France."[21] The mongrels were pushing aside the pure breeds.

Many of the "unbelieving" were members of the National Academy of Design. For years they rejected most of the Paris works sent to their annuals, and refused to admit members of the American art community in Paris to the honor of Academy membership. While philosophic differences and the perceived need to maintain the "purity" of the American art scene may be cited as factors in those decisions, the real problem, of course, was professional jealousy. The Academicians were to regret these restrictive policies. When Whistler died in 1903, one member reminded his colleagues that the most famous American painter of their time had not been elected to the National Academy of Design. "This is a reproach, and it is a blunder. We should look to it that the like does not occur again."[22]

But why did only the Americans in Paris become mongrels? William Merritt Chase and others who worked in Munich were never so tagged, nor were Story and his fellow expatriates who spent decades in Italy. If it were true that good art could be produced only on home soil, all of those who worked abroad could be denounced as mixed-breeds. The special danger of Paris lay in the unsettling realization of what was happening there, for in Paris artists from the United States became defined as "American"—to themselves and to the world.

When citizens of the United States go to Europe as tourists, they learn what it means to be an American by comparing themselves with what they see of European life styles, mannerisms, expectations of behavior, and so on. Abroad they become conscious of what they share in common; at home they are aware of regional and ethnic differences. And so it was with the more intensive experience of the nineteenth-century artists. Members of the American art community in Paris came from Boston, Baltimore, Saint Louis, Philadelphia, New York, Washington, D.C., Pittsburgh, Richmond, Chicago, Charleston, Cincinnati, New Orleans, Buffalo, and San Francisco —in short from all over the country. They developed a sense of their commonality that was strengthened as foreign artists and the French perceived them together as an identifiable group. In their own country there was no overarching view of artists as representatives of the entire nation— especially not by members of the dominant art organizations of the northeast, which tended to place themselves exclusively in that role. Moreover, in Paris the artists

became known internationally as Americans because of the extensive media coverage of the Parisian art world. The annual Salons allowed the art public to follow individuals and nationalities from one year to the next, for the catalogues identified each artist by place of birth, and the customary hanging of paintings in alphabetical order of artists' names aided Salon critics and visitors in locating particular works. Painters and sculptors from all over the United States were identified and discussed as American artists.

The Paris-defined Americans presented a serious problem to those who wanted to promote the American artist as purely home-grown. They refuted the belief that artists had to be imbued with "the mental and moral soil" of their native land in order to create great art and placed the qualifications elsewhere: with American citizens who produced works of high quality, no matter where they resided.

REACTING WITH HISTORICAL AMNESIA TO A FRENCH ROLE IN AMERICAN ART

The last three decades of the nineteenth century brought life-altering changes to every area of existence in the Western world—not least of all to concepts of art. In the United States some artists and writers on art wanted to forge ahead into a new future of expanded possibilities while hanging onto what they perceived as the particular distinctions of their nation's art—which were rooted in a bygone time. One of their defenses was to belittle the greatest threat to those principles, art in

Paris—while thousands of American artists kept happily trotting off to the French capital to take part in its many advantages for their careers. Their experiences there gained international recognition for art of the United States, and stirred the interest of collectors and the public in contemporary art. Returning to their own country, they became active as teachers and participated in major sculpture and painting projects at the Library of Congress in Washington, D.C. and at state capitals and libraries across the country. As intangibles of their Parisian years, they gained a more confident image of themselves as artists and a new vision of art functioning as national identity.

Throughout the twentieth century and into the twenty-first, historians have looked back on this period with fluctuating reactions, at times with renewed appreciation for the achievements of the Americans in Paris, and at other times negatively, relative to changes in taste, but also—not unlike earlier critics—attempting to promote American art as entirely self-made and independent from outside influences, especially French. Instead of the Paris-bashing comments of the 1870s and 1880s, negative reactions in these later writings tend to be simply dismissive, as if the Parisian experiences had been of little or no significance—or as if they had never happened. At times the role of French art in nineteenth-century American art has been consigned to historical amnesia. Those efforts form a revealing chapter in our cultural history; here, very briefly, are a few indications.

An early sign of historical amnesia appeared in writings about the mural programs of the Federal Art Projects of the

1930s and 1940s. Here scholars made no reference to the important precedents of earlier murals by Paris returnees. A similar response was true in the field of sculpture when renewed interest in monumental public sculpture began in the 1950s, with some critics acclaiming the movement as if it were entirely new. The equestrian and other public monuments by late-century sculptors had become invisible. In the late 1940s and 1950s, the Paris generation was taken to task because their works had not led up to Abstract Expressionism and the New York School of Painting; major museums deaccessioned their paintings, and scholars, considering those works as deviations from the true history of American art, eliminated them from serious consideration. Renewed interest began in the 1970s as part of a reexamination of the nation's history and culture, allowing paintings and sculptures of the maligned era to be seen anew for themselves, not as failed stepping stones to other artistic goals. Museums featured one-person shows and reprised exhibitions of the American works shown at the great International Expositions in Paris, in 1889; at Chicago, in 1893; and again in Paris, in 1900.[23] Even with these opportunities for greater appreciation and knowledge of the late-century artists, scholarly efforts marked by willful amnesia continue to appear.

In an article about scholarship in American art, Wanda M. Corn observed that scholars in the field tend to limit their studies to the geographic boundaries of the nation. She pointed out that "many collectors and scholars formed early on [the habit] of isolating the study of American art from the larger culture of the West."[24] This myopic practice has considerably affected studies of nineteenth-century American art. Issues of national identity or constructions of the persona of the American artist are crafted from factors that exist within the continental borders—or perhaps more accurately, within the bounds of New York City and the northeastern art centers.[25] In an era of global awareness, the history of American art ought to be placed within the international art scene—which was one of the achievements of the American artists in Paris in the late nineteenth century.

1 Philippe Roger, *The American Enemy. A Story of French Anti-Americanism*, trans. Sharon Bowman (Chicago and London: University of Chicago Press, 2005).

2 Lois Marie Fink, *American Art at the Nineteenth-Century Paris Salons* (Washington, D.C.: Smithsonian Institution, and Cambridge: Cambridge University Press, 1990), chapter 6.

3 Mark H. Miller, "Lafayette's Farewell Tour of America, 1824–25: A Study of the Pageantry and Public Portraiture" (Ph. D. diss., New York University, 1979).

4 An illustration and description of this first version, no longer extant, appeared in Edward Insley, "America's Gift to France," *Harper's Weekly* (June 9, 1900). It is also illustrated in Diane P. Fischer, ed., *Paris 1900: The "American School" at the Universal Exposition* (New Brunswick, New Jersey: Rutgers University Press, 1999), 178. For details of plans for the Lafayette monument and Bartlett's commission, see Wayne Craven, *Sculpture in America* (New York: Thomas Y. Crowell, 1968), 428–31, and Thomas P. Somma, "Paul Wayland Bartlett and 'The Apotheosis of Democracy,' 1908–1916: The Pediment for the House Wing of the United States Capitol" (Ph. D. diss., University of Delaware, 1990), II, 135–45.

5 Bartlett received major commissions in the United States for government projects at the Library of Congress and the Capitol Building, and in France was honored with election as an officer of the Legion of Honor and a corresponding member of the Institut de France. Recognition by both nations led to his being selected as a symbol of fruitful cultural relations between France and America in a special issue of *Revue des Arts et des Lettres*, October 1923. Noted by Véronique Wiesinger, "La politique d'acquisition de l'État français sous la Troisième République en matière d'art étranger contemporain: l'exemple américain (1870–1940)," *Bulletin de la Société de l'histoire de l'art français* (1993): 277.

6 Lois Marie Fink and Joshua C. Taylor, *Academy: the Academic Tradition in American Art* (Washington, D.C. Smithsonian Institution Press: 1975): 54–55.

7 Michael Quick, "Munich and American Realism," *Munich and American Realism in the 19th Century* (Sacramento, California: E. B. Crocker Art Gallery, 1978): 21–36.

8 Albert Boime, *The Academy and French Painting in the Nineteenth Century* (London: Phaidon Press, 1971): 16–17 and *passim*.

9 Childe Hassam, handwritten note, Collection of the American Academy of Arts and Letters, microfilm NAA 1, Archives of American Art, Smithsonian Institution.

10 Albert Boime, The Academy and French Painting, *op. cit.*, p. 132.

11 "Sketches and Studies," *The Art Journal*, n.s. 6 (1880): 269.

12 Lois Marie Fink, "The Role of France in American Art, 1850–1870," (Ph. D. diss., University of Chicago, 1970), I, 418–30.

13 William Wetmore Story, *Reports of the U.S. Commissioners to the Paris Universal Exposition* (Washington, D.C, 1878).

14 Sarah Burns, *Inventing the Modern Artist: Art and Culture in Gilded Age America* (New Haven and London: Yale University Press, 1996), chapter 3.

15 From Barlow's preface to *The Columbiad*, quoted in Arthur L. Ford, *Joel Barlow* (New York: Twayne Publishers, 1971): 75.

16 Augustine Duganne, *Art's True Mission in America* (New York: George S. Appleton, 1853): 29.

17 S. G. W. Benjamin, *Contemporary Art in Europe* (New York: Harper and Brothers, 1877): 60.

18 Brooks Adams, *International Review*, reprinted in the *Boston Daily Evening Transcript* (July 26, 1880): 2.

19 Theodore Roosevelt, "Address before the American Academy and National Institute of Arts and Letters" (New York City, November 16, 1916).

20 "The Philadelphia Society of Arts," *The Art Journal* 6 n.s. (1880): 380.

21 "The Fine Arts Notes," *The Critic* 9, n.s. 6 (December 4, 1886): 284.

22 Frederick Dielman, "President's Annual Report," May 13, 1904. Fink and Taylor, *Academy*, 86.

23 Annette Blaugrund, *Paris 1889: American Artists at the Universal Exposition* (Philadelphia: Pennsylvania Academy of the Fine Arts with Harry N. Abrams, 1989); *Revisiting the White City: American Art at the 1893 World's Fair*, organized by Carolyn Kinder Carr and George Gurney (Washington, D.C.: National Museum of American Art and National Portrait Gallery, Smithsonian Institution, 1993); *Paris 1900. The "American School" at the Universal Exposition*. Diane P. Fischer, ed. (New Brunswick, New Jersey: Rutgers University Press, 1999).

24 Wanda M. Corn, "Coming of Age: Historical Scholarship in American Art," *Art Bulletin*, LXX: 2 (June 1899): 188–207.

25 Recent examples include Sarah Burns, *op. cit.*, and Randall C. Griffin, *Homer, Eakins, and Anshutz: The Search for American Identity in the Gilded Age* (University Park, Pennsylvania: Pennsylvania State University Press, 2004).

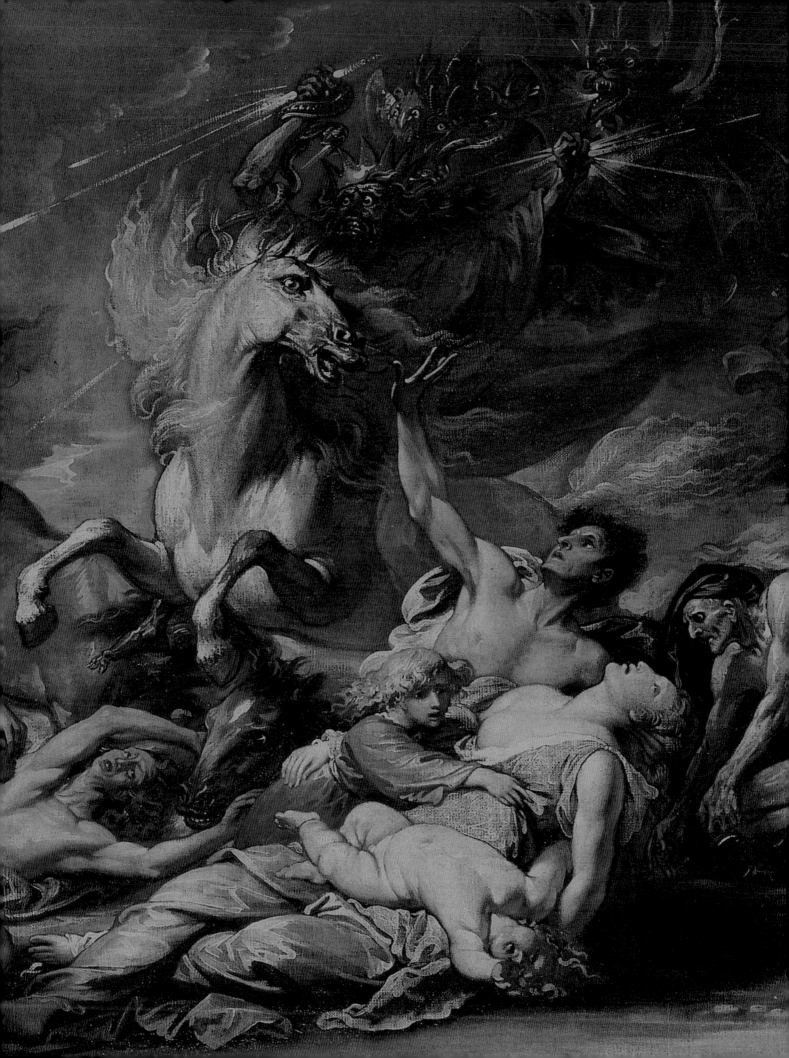

AMERICAN ARTISTS IN FRANCE
BEFORE THE CIVIL WAR

AMERICAN ARTISTS IN FRANCE BEFORE THE CIVIL WAR

OLIVIER MESLAY

Translated from French by Geoffrey Capner

In memory of Alexandre Vattemare, famous ventriloquist
and pioneer of Franco-American artistic relations

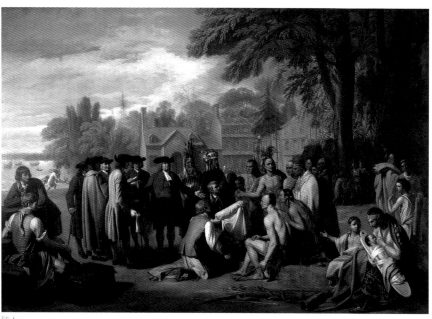

FIG. 6

FIG. 6 BENJAMIN WEST (1738–1820),
WILLIAM PENN'S TREATY WITH THE INDIANS, oil on canvas, 75 1/2 x 107 1/2 in.
Pennsylvania Academy of the Fine Arts, Philadelphia

FIG. 7 GEORGE CATLIN (1796–1872),
LITTLE WOLF, PORTRAIT OF SHON-TA-YE-GA, 1846, oil on canvas, 31 7/8 x 25 1/2 in.
Musée de l'Homme, Paris

At the close of the Ancien Régime at the end of the 1770s, the Marquis de Girardin erected a temple devoted to modern philosophy in his garden at Ermenonville, northeast of Paris in Oise, famous as the original burial site of Jean-Jacques Rousseau. This rustic pantheon was built on modest columns, each one engraved with the Latin name of a philosopher and the field in which he had excelled. As illustrated by this small building, glory was a rare commodity. It honored only eight men—four Frenchmen: René Descartes, Montesquieu (Charles-Louis de Secondat), Voltaire (pen name of François-Marie Arouet), and, of course, Rousseau; two Englishmen: Isaac Newton and Joseph Priestley; and the two American colonists William Penn and Benjamin Franklin. A considerable honor for such a young and modest nation! The passion of the French for Franklin is well known; he was known for his work on electricity and lightning (*Fulmen* is inscribed under his name). But the place occupied by Penn, here associated with philanthropy (*Humanitatem*), is more surprising.

Quakers were not unknown in France. Voltaire, having learned English with one of them, contributed to their fame through his *Lettres philosophiques*, which was published in 1734. Fifty years later, in 1788, the first Quaker community was founded in France, at Congénies, near Nîmes.

Literary antecedents, in particular the fourth *Lettre philosophique*, which mentions him, do not suffice to explain Penn's name on a column in Ermenonville, however. If Quakerism itself had been the reason for Girardin's choice, the name of George Fox, the creator of the movement mentioned by

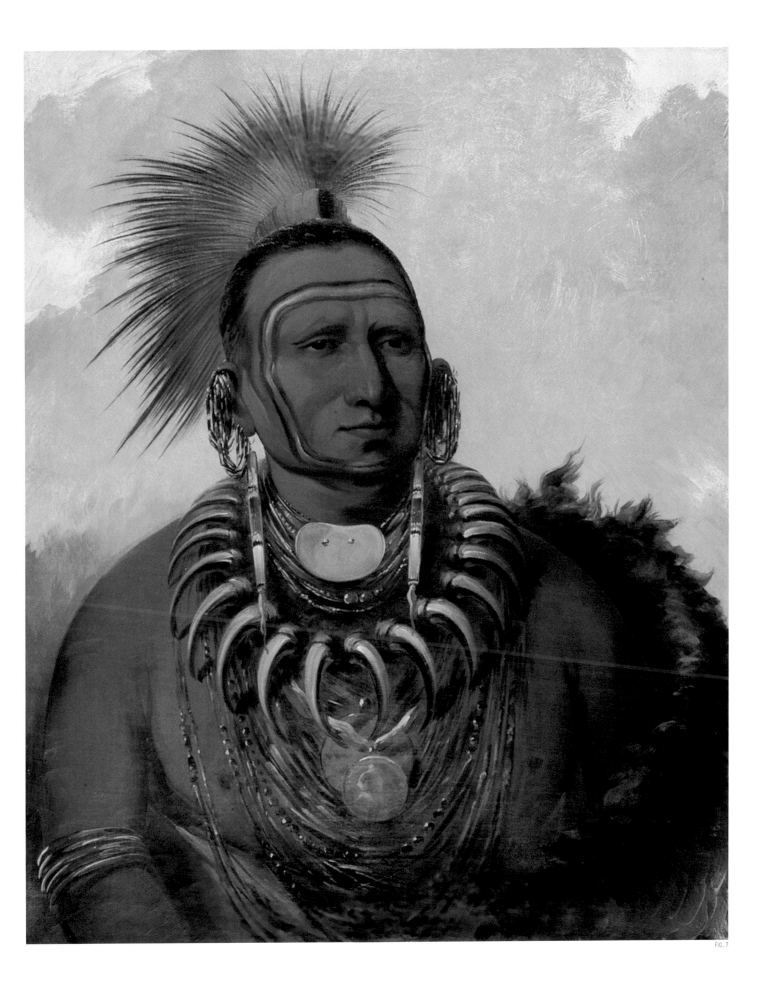

FIG. 7

Voltaire, would have been a more natural choice. The founder of the Pennsylvania colony was doubtless honored because of the success of Benjamin West's painting *William Penn's Treaty with the Indians*, which was phenomenally popular in France (fig. 6). It was first engraved in 1775 by John Hall for the English publishing company Boydell and rapidly published. Through the print, West's image became a model for many artists, including many Frenchmen,[1] and spread Penn's name throughout Europe. Penn's attitude toward North Indian tribes, illustrated by this famous treaty, thus became the symbol of an all–too–rare humanitarianism. West's influence in France at the end of the eighteenth century is only the first example of the important position held by American artists and their works, a role now largely ignored. They were decisive in various fields in which painting, nationalism, independence, and revolution were intermingled.

Before discussing in detail West's influence, it is interesting to note a precedent to these artistic links between what was to be the United States of America and what is now France involving the liberator of Corsica, Pascal Paoli, and Henry Benbridge, the young American painter who went to Corsica in 1768 to paint his portrait (fig. 8).[2] The importance of Paoli for the American rebels has been largely overshadowed by the history of Franco-American relations during the French Revolution and Napoleon's empire. No fewer than seven towns in the United States are named after Paoli, and his Corsican constitution is known to have influenced that of the United States. It is wonderful to think that it was a young painter

who initiated the connection between America and this man who was to serve as a model for so many American politicians less than ten years later. This link between painting and the birth of a nation was to be amplified, of course, during the French Revolution.

Among the artists established in London during the second half of the eighteenth century, the most innovative in the field of history painting (in particular that of contemporary history) were two colonial Americans: the Philadelphian Benjamin West and John Singleton Copley of Boston (1738–1815). This fact did not escape the French, as demonstrated by the question Jacques Louis David (1748–1825) posed to Rembrandt Peale: "Why are all the good painters in London American?"[3] These artists were not the inventors of a contemporary and national history painting, because English artists such as Francis Hayman (1708–1776) had in fact preceded them. No one, however, had so brilliantly interpreted patriotic sentiment, grandeur in sacrifice, and emotion in combat.

During the second half of the eighteenth century, Americans had the privilege, sometimes painful, of experiencing the birth of a nation. Painters took different political positions: Copley, for example, was fiercely loyal toward the British Crown; West was more attracted by independence; and John Trumbull (1756–1843) even saw action on the battlefield as Washington's aide-de-camp. For them, history was a force in action, destroying relationships, killing men, toppling continents, and leading countries toward destinies that became their own. As the century closed, questions of nationalism, independence, and liberty

were in the air, and it was the American painters who expressed them most compellingly, regardless of their political persuasion. Copley, fleeing from the newly independent states of America, excelled as a history painter in glorifying the English victory at Gibraltar and the heroic deaths of English heroes such as Major Pierson. West, long before him, had laid down the new rules of this painting: he had effectively erased the ancient canons governing allegorical glorifications of sovereigns in the manner of Charles Lebrun, Louis XIV's official painter, replacing them with striking and moving images of young heroes, dying nobly but clothed in their actual military uniforms. The spirit of the nation was no longer embodied in its kings but in these more modest fighters, in its political representatives, in its partisans.

While it may seem unnecessarily provocative to view French painting as being under American influence at the end of the eighteenth century, it is certainly valid to note the influence of individual American painters, several of whom were particularly well regarded. The most important American artistic figure for French artists and connoisseurs was undoubtedly West. His success, which should be seen as being part of the general influence of British art, occupies a particular place.[4] His compositions were widely known in France as early as the 1770s, and were copied, plagiarized, and made the subject of pastiches. French engravings of *The Death of Général Wolfe* (fig. 9), for example, are numerous. West's image inspired such French treatments of related themes as *The Death of Montcalm* (1783, Département des Estampes et de la

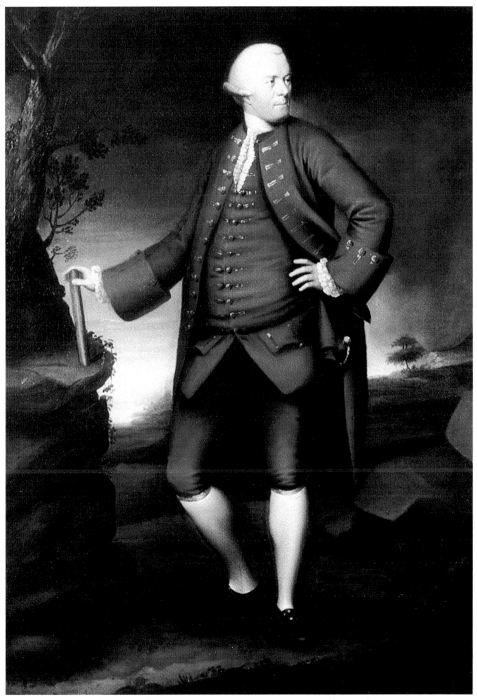

FIG. 8 HENRY BENBRIDGE (1744–1812), PASCAL PAOLI, 1769, oil on canvas, 40 1/8 x 29 1/2 in.
Pascal Paoli's birthplace, Morosaglia

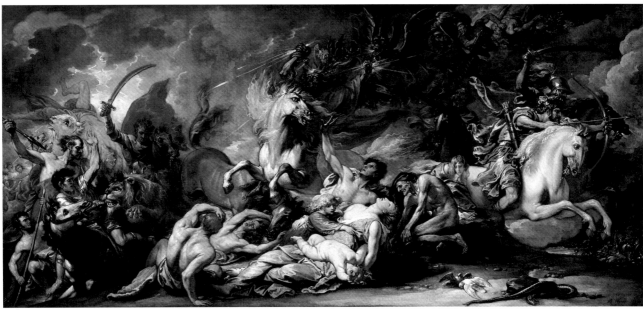

CAT. 4

Photographie, Bibliothèque Nationale de France) by G. Chevillet after François-Louis-Joseph Watteau of Lille (1758–1823). Such was West's fame that, in the Salon at Lyon in 1786, an engraving was displayed showing him with his Quaker family. Lastly, we should not forget that West was elected a member of the Académie des Beaux-Arts in 1803, the year after he exhibited his famous painting *Death on the Pale Horse* in Paris (cat. 4). His influence on French art was to last more than forty years, and the production of prints and lithographs from his work continued until the end of Louis-Philippe's reign in 1848. Copley's influence has received less attention, but the circulation of his compositions is well known, particularly that of *The Death of Major Pierson* (1782–84, National Gallery, London), even though it illustrates a French defeat at Jersey.

A place should be kept also for John Trumbull, soldier, painter, and businessman, patriot and son of a patriot. Even though he painted at very irregular intervals, sometimes leaving his easel for periods ranging from seven to ten years, he gave the American nation an essential part of its founding iconography. Of the American painters of his time he also claimed the strongest attachment to Paris. Arriving for his second long stay there, in 1786, he was welcomed by Thomas Jefferson (ambassador to France from 1784 to 1789) and met David and French Neoclassical sculptor Jean Antoine Houdon (1741–1828). It was in Paris, with the assistance of Jefferson's recollections, that he planned his most famous painting, *The Declaration of Independence*, inscribing the first sketch "Paris, Sept. 1786" (fig. 10). The final composition may have been inspired by the painting *The Generosity of the Roman Women* (1785, Musée National du Château de Fontainebleau) by Nicolas Guy Brenet (1728–1792).

Although Trumbull's works probably did not exert a direct influence on French art, this young painter, who had just participated in the victorious War of Independence, may have represented for French artists, above all David, the idea of the artist personally involved in the history that he painted. For Frenchmen avid for political change, these American actors in their national revolution must have had a considerable aura. If, in addition, these participants were painters, they then became an incarnation of history—modern, positive, alive. Trumbull was known to peddle paintings and negotiate business more or less in secret, and when he was harassed by the Paris police in 1797, some twenty years after American independence and almost ten years after the fall of the Bastille, it was David who came to his aid. Since the latter's involvement in the Terror, the period of brutal repression during the French Revolution, Trumbull had avoided the creator of the *Death of Marat* (1793, Musées Royaux, Brussels). In spite of this, David had followed his career attentively and

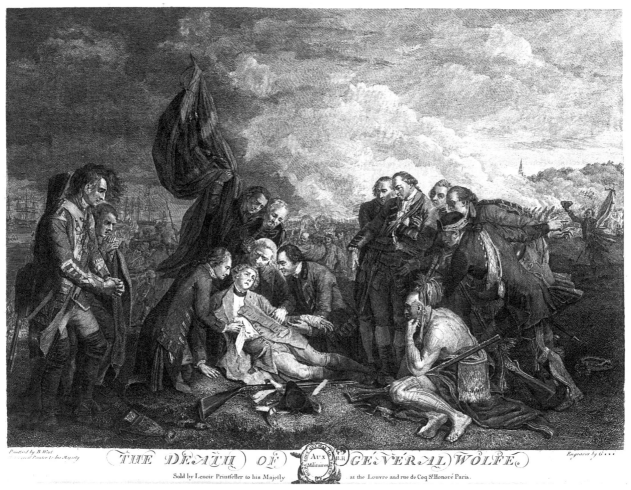

FIG. 9 ANONYMOUS, after William Woollett, THE DEATH OF GÉNÉRAL WOLFE, 1779, engraving.
Bibliothèque Nationale de France, département des Estampes et de la Photographie, Paris

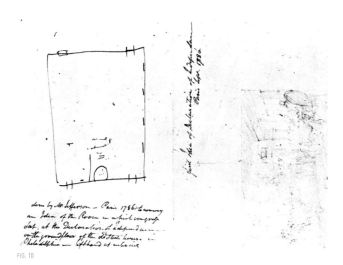

FIG. 10

CAT. 4 BENJAMIN WEST (1730–1820), DEATH ON THE PALE HORSE, 1796,
oil on canvas, 23 3/8 x 50 5/8 in., signed and dated B. West 1796.
The Detroit Institute of Arts

FIG. 10 THOMAS JEFFERSON (1743–1826) AND JOHN TRUMBULL (1756–1843),
PLAN OF ASSEMBLY ROOM AND FIRST IDEA OF THE DECLARATION OF
INDEPENDENCE, 1786, 7 x 9 in., pen, ink, and crayon drawing.
Yale University Gallery

now conversed with him about his painting *The Death of General Warren at the Battle of Bunker's Hill June 17, 1775* (1786, Yale University Art Gallery), which the American was having engraved in Germany. David was perfectly aware of Trumbull's work, and in support of Trumbull leaving France, uttered the famous phrase: "This painting is well worth passports."[5]

However, for the French, this first generation of American artists did not constitute a school as such. They rather regarded the Americans as individuals who stamped their own genius on contemporary European painting, of which the two main centers of production remained London and Paris. The Americans were, moreover, very different in their political affiliations: West, the Quaker, was King George III's favorite but faithful to his own country; Copley was a loyalist who settled permanently in England to avoid the turmoil of war; Trumbull, the artist-soldier, was an intimate of the fathers of the American nation. Clearly they could no more be seen as an artistic school than as political associates. Likewise, their achievement as painters of contemporary history was unprecedented. It was to mark the whole of the French Neoclassical school. This did not happen by chance.

A MODEST GENERATION

This heroic generation was followed by an American presence very different in terms of its reputation, its relationship with France, and its place in the American artistic community. While most American artists directed their steps and their admiration toward England and Italy, a small community settled in Paris. Two artists were fairly stable members: John Vanderlyn, who had studied in the studio of the Neoclassical painter François André Vincent (1746–1816), and New Hampshire painter Benjamin Champney (1817–1907). A painting by Thomas Prichard Rossiter gives a very good idea of the atmosphere that reigned in this circle (cat. 12), which included most of the American artists passing through Paris, from Washington Allston (1779–1843) at the beginning of the century to those, mostly landscape painters, who arrived in the 1840s, notably John W. Casilear (1811–1893), Asher Brown Durand (1796–1886), and John Frederick Kensett (1816–1872). Most only stopped by, a few remained for a longer time. Paris had always been a less natural destination than London for Americans. In 1802, when West came to show his work in the Salon, the American resident community in Paris was small and consisted mainly of radical politicians. Until the 1860s, to choose Paris was a sign of originality that often harmed an artist. There are a few exceptions. Portraitist George P. A. Healy (1808–1894) had in fact a brilliant

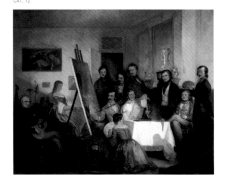

CAT. 12

career there. He was, without doubt, the American artist most involved in French artistic life. Close to Louis-Philippe, he received numerous commissions for the Musée de Versailles, many copies of portraits of great Americans or great Englishmen, but he also painted numerous portraits of Frenchmen.[6] His career was particularly long and enabled him to paint the most important political figures, from military leader Maréchal Soult to republican statesman Léon Gambetta. Notable among these is the portrait of the prime minister, François Guizot (1841, Smithsonian American Art Museum, Washington, D.C.), commissioned by an American as a token of his admiration for the author of a remarkable biography of Washington.

In addition to these academic artists, we should note the case of George Catlin. His success was undeniable, considerable, and almost as great as that of the tours of Buffalo Bill's Wild West shows fifty years later, at the end of the nineteenth century. What did the French think of the paintings in his so-called Indian Gallery when it was first exhibited in Paris in 1846, in the Salle Valentino and then in the Louvre? Probably for the majority of viewers, emotion and curiosity were stirred more by the actual Native Americans who were also part of Catlin's display. A comment by Romantic novelist George Sand illustrates the public's attraction to these real Iowas and Ojibwas: "I thus traversed the Indian tribes without fatigue and without danger; I saw their features, I touched their weapons, their pipes, their scalps; I attended their dreadful initiations, their daring hunts, their frightening dances; I entered their

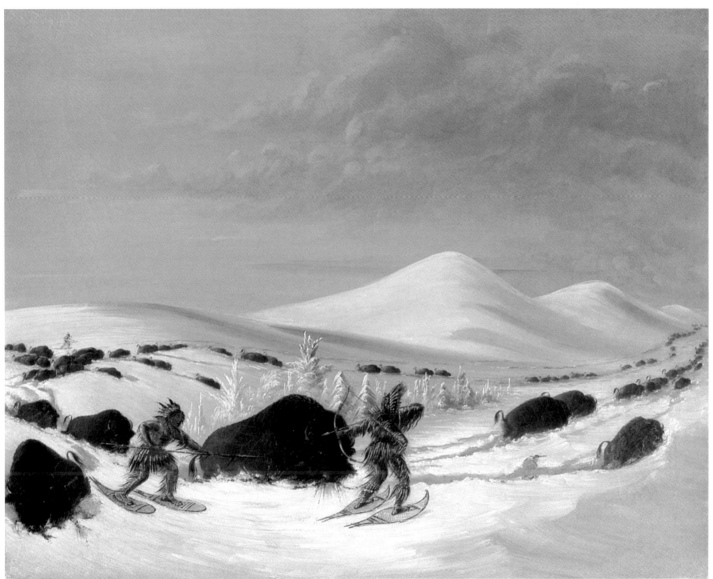

CAT. 12 THOMAS PRITCHARD (or PRICHARD) ROSSITER (1818–1871), **A STUDIO RECEPTION**, 1841, oil on canvas, 32 x 39 5/8 in., Albany Institute of History and Art, New York

FIG. 11 GEORGE CATLIN (1796-1872), **BUFFALO HUNT IN WINTER**, n.d., oil on canvas, 26 x 32 in., Musée de l'Homme, Paris

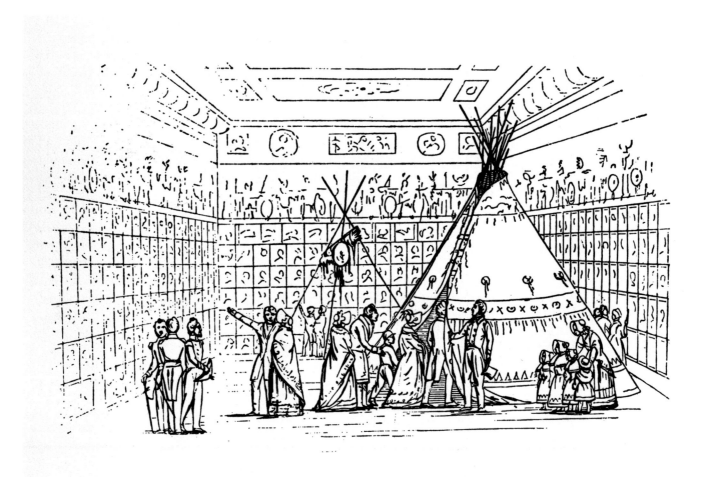

CATLIN'S INDIAN GALLERY IN THE LOUVRE
The Artist's Four Children at Right

FIG. 12 GEORGE CATLIN (1796–1872), CATLIN'S INDIAN GALLERY IN THE LOUVRE, illustration taken from George Catlin, *Catlin's Notes of Eight Years' Travel and Residence in Europe, with his North American Indian Collection*, London, 1848, vol. 2, pl. 22

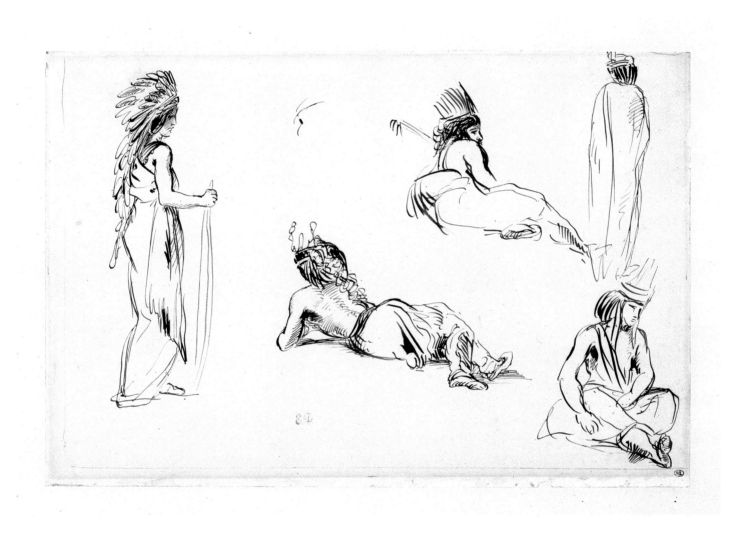

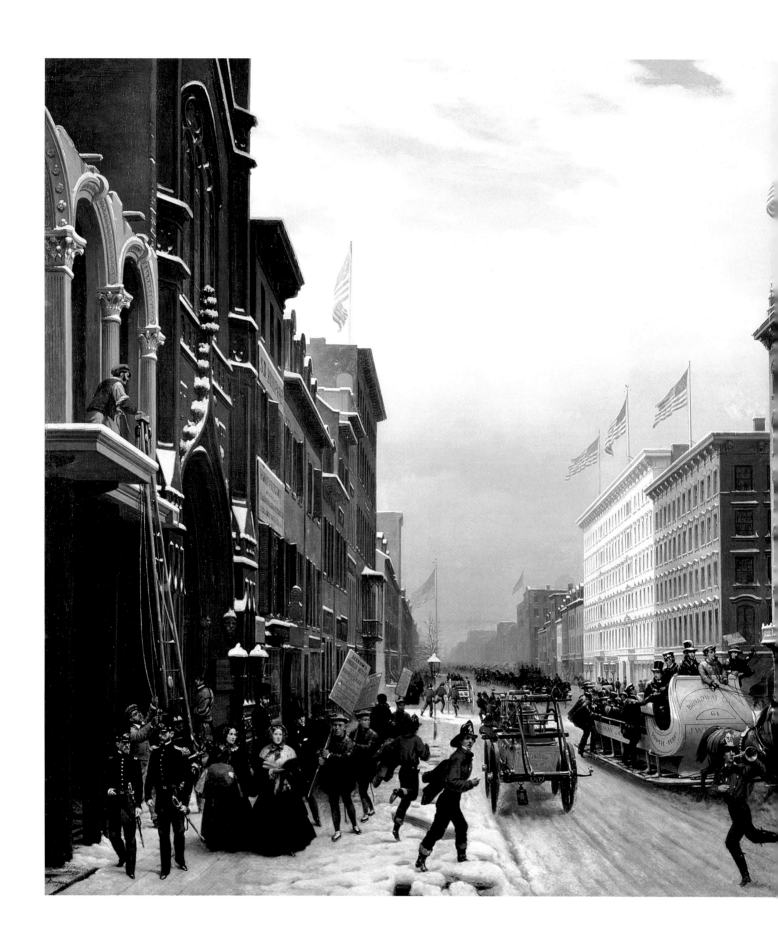

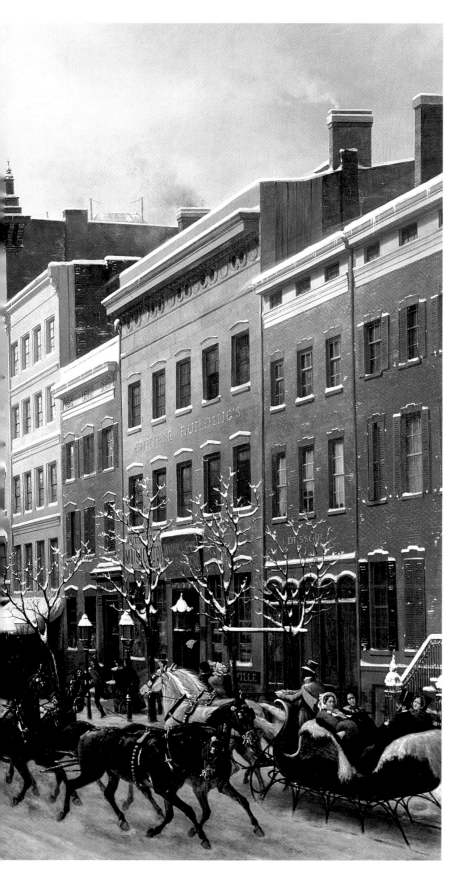

wigwams. All that deserves that the good inhabitants of Paris, who already know these countries poetically, thanks to [author and diplomat François-René] Chateaubriand, to [American novelist James Fenimore] Cooper etc., should leave their firesides and go and see for themselves these fine descriptions and these racy stories."[7] Artists such as Romantic painter Eugène Delacroix (1798–1863), lithographer Achille Devéria (1800–1857), and marine painter Théodore Gudin (1802–1880) came to the exhibition to draw the Indians themselves, not to copy Catlin's paintings (figs. 7, 11, 12).[8] Delacroix's sketches illustrate this predilection well (fig. 13). Another artist, sculptor Auguste Préault (1809–1879), became interested in the dramatic circumstances of O Ki Oui Mi, the wife of Little Wolf (fig. 7), when she died. He fashioned a bust of her, which was destined to decorate his own tomb.

There are two exceptions to this rather moderate interest in Catlin's art. The first was the king, who commissioned no less than fifteen works from the artist. Louis-Philippe had always been fascinated by topographical and ethnological painting. His commissions to two landscape painters, Norwegian Peder Balke (1804–1871) and Australian John Glover (1767–1849), are excellent examples. The large scale of Catlin's commission illustrates the particular link that Louis-Philippe had forged with the United States since his stay there at the beginning of the century.

The second exception was no less than Charles Baudelaire. He was interested in Catlin's painting not only for the subjects, but also for the truth that emanated from them, for his use of bright color, and for the quality of his skies. His comment goes beyond simple anecdote and places Catlin's art on a different plane:

There are, in the Salon, two fairly important curiosities: they are the portraits of *Little Wolf* and *Buffalo Bill's Back Fat*, painted by Catlin, the mahout of the savages. When Catlin came to Paris, with his Ioways and his museum, the rumor spread that he was a decent ordinary man who could neither paint nor draw, and that, even if he had completed some acceptable sketches, it was thanks to his courage and his patience. Was it Catlin's innocent craftiness or the stupidity of the journalists? It is today proved that Catlin knows how to paint and draw very well. These two portraits would suffice to prove it to me, if my memory had not brought back to my mind other pieces just as fine. His skies, above all, had struck me because of their transparency and their lightness. Catlin has rendered in a superior way the proud and free character, the noble expression of these fine people; the structure of their heads is perfectly understood. Through their fine postures and the ease of their movements, these savages help us to understand antique sculpture. As for the color, it has something mysterious about it and pleases me more than I can express. Red, the color of blood, the color of life, was so abundant in this somber museum that it became an intoxication; as for the landscapes—tree-covered mountains, immense savannahs, deserted rivers—they were monotonously, eternally green; red, the color which is so obscure, so thick, more difficult to penetrate than the eyes of a serpent; green, the color calm and gay and

agreeable of nature, I find them singing their melodic antithesis even in the faces of the two heroes. What is certain, is that all their tattoos and colorings were made according to natural and harmonic scales.

I believe that the public and the journalists were led into error by the fact that he does not paint in a gallant way, in a way that our young men have so accustomed them, and that it is now a classical painting.[9]

We should note, however, despite the interest in Fenimore Copper's Western novels and the success of painters Healy and Catlin, American painting was not well known in France during the first half of the nineteenth century. The appeal of the United States was nonetheless on the rise.

HIPPOLYTE SEBRON AND THE FASCINATION OF THE AMERICAN LANDSCAPE

Franco-American artistic relations cannot be discussed without mentioning the existence of French artists who were attracted by the American landscape. Leaving aside John James Audubon (1785–1851), whose work is so closely linked with the United States that France has some difficulty in claiming him as a Frenchman, there were artists such as Hippolyte Sebron (1801–1879), who was from Normandy. A pupil of Louis Daguerre (1787–1851), Sebron arrived in the United States in 1849 and remained there until 1855. He had been trained in the painting of dioramas and was thus used to the representation of grandiose landscapes. We know little about the people he met and the landscapes he came across during his long American stay. He traveled across the American territories from north to south and covered most of the West Coast. His *Giant Steamboats at New Orleans* (1853, Tulane University, New Orleans) and *Broadway in Winter 1855* (1855, Museum of the City of New York) are striking images. Among his paintings kept in France we should mention *View of the Lake Crocodile in Louisiana* (1861, Blérancourt, Musée National de la Coopération Franco Américaine; fig. 15), *View of New York in 1840* (circa 1850, Blérancourt, Musée National de la Coopération Franco-Américaine; fig. 14), and *Great Niagara Falls, Effect of Winter* (1857, Rouen, Musée des Beaux-Arts; fig.16). It is interesting to compare Sebron's works with those of the Hudson River School: he shares their feeling for the grandiose and use of the sublime, while displaying a surprising variety in his subjects and an absence of spirituality that distinguish him from his American contemporaries.

THE EXPOSITION UNIVERSELLE OF 1855

We can close this evocation of this first period of Franco-American artistic relations by observing what happened during the Exposition Universelle of 1855. The context was unusual, as France was attempting to catch up with the other capitals—London, with its Great Exhibition in the Crystal Palace of 1851, and New York, which mounted a similar event in 1853. One man was particularly active in bringing France and America together: Alexandre Vattemare (Paris, 1796–1864), the cornerstone of the artistic links between the two countries. In spite of all his efforts and goodwill, he was

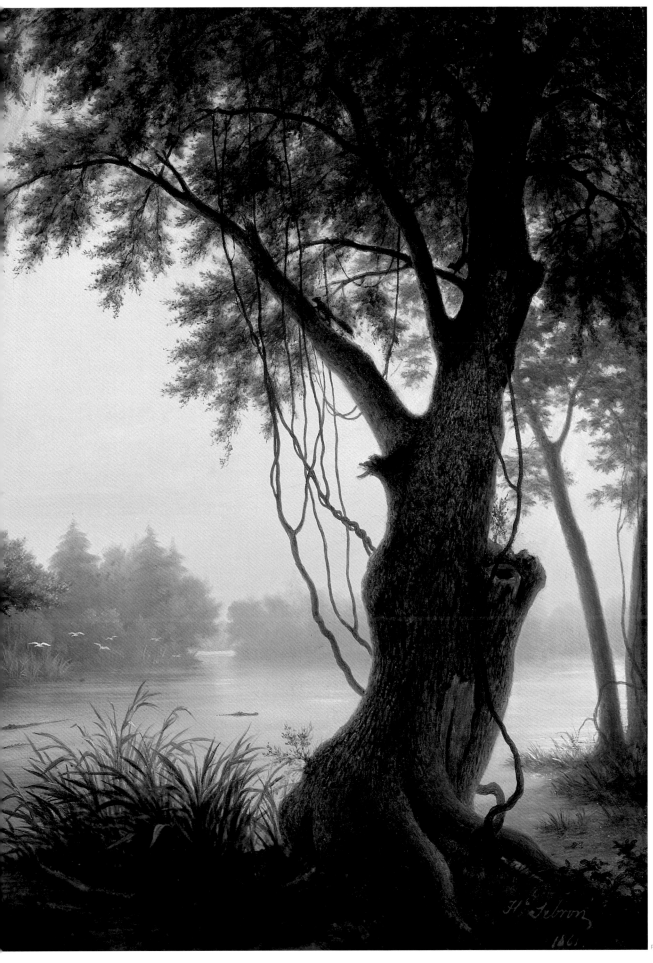

FIG. 15

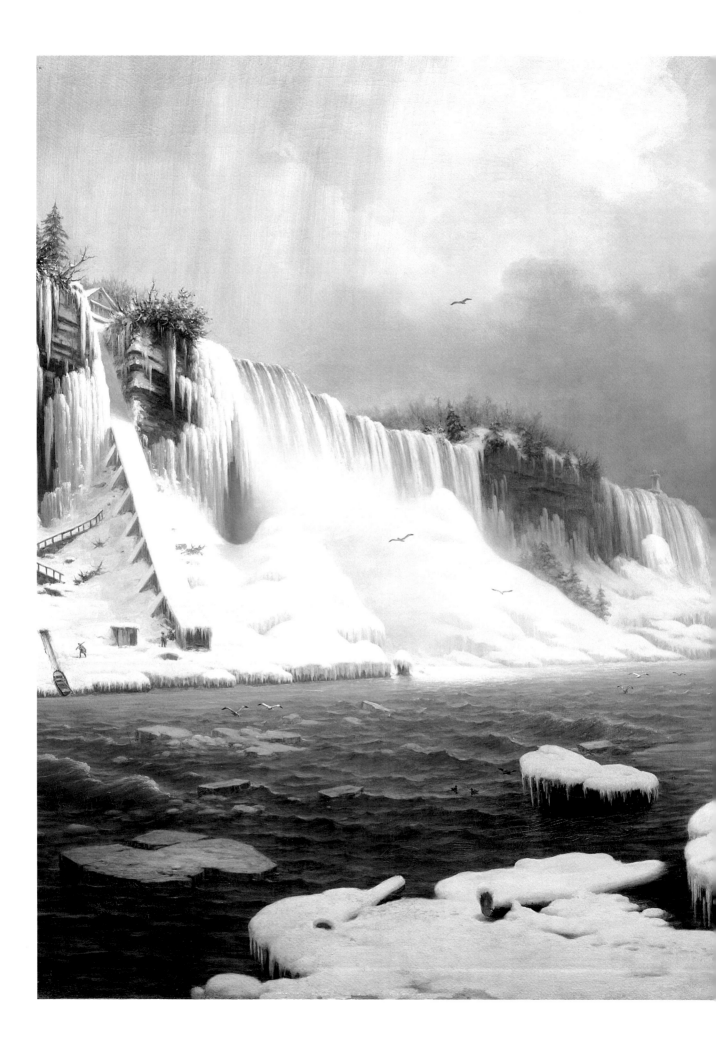

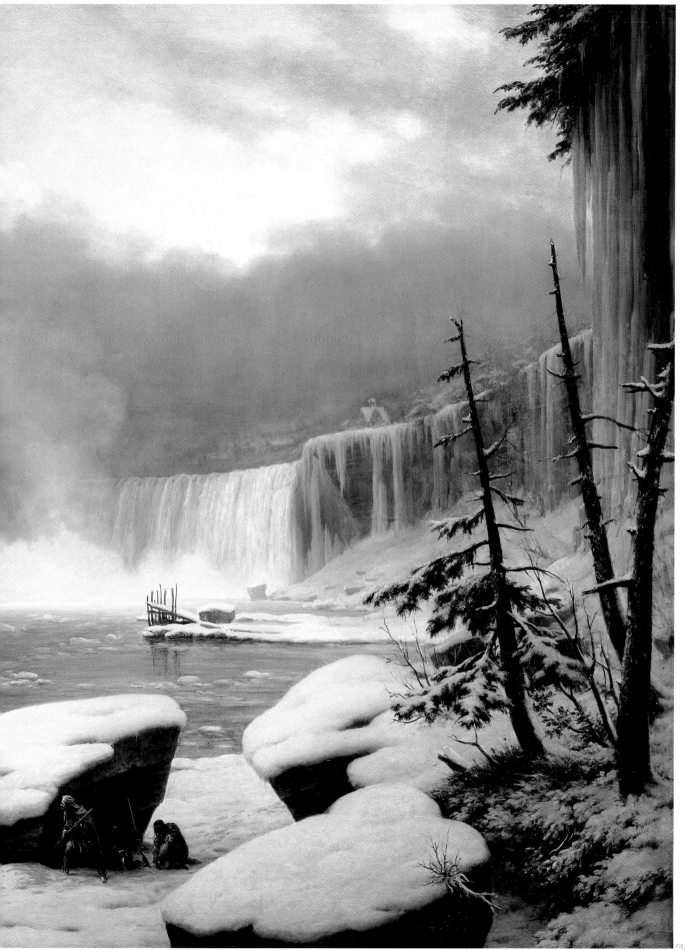

FIG. 16

not able on his own to convince French and American authorities to support the works of art that were sent over from America. While the United States triumphed in industrial products and mechanical engineering, the Exposition Universelle of 1855 shows all the aspects of a missed opportunity concerning the fine arts. Fortunately, it was also a moment of recognition: probably the time when the question of the existence of an "American School" was first posed in France.[10] It was the first time that American artists exhibited as an ensemble, and for the first time their number, even if not very significant, was enough to be noticed. All this should be placed in perspective. They were not numerous—a total of thirteen exhibiting about fifty works. But because of the nature of their selection, in fact through private initiative, they represented only one aspect of the national artistic production. In the main, the American artists had strong links with France. "The American Department of French Painting—Healy and Muller —Babcock and Diaz—Hunt and Millet," is how Edmond About titled his review article concerning the American section: "For a moment I wondered if I should give a separate place to the painters of the United States, or if I should not include them with ours."[11] Another art critic, Louis Enault, wrote: "I should like to point out, by concentrating my judgment on the American School I find myself hampered by the divergence of the paths toward which the artists of the Union launch themselves."[12]

Why such an assessment of the American-French connection? Let us consider this group of artists. Their links with France are undeniable. Healy was one of Louis-Philippe's favorite portraitists, and was an *habitué* of the Paris salons. His principal contributions to the 1855 Exposition were, in the opinion of the many critics who lingered in front of them, the portraits of Mr. and Mrs. Goodyear, both painted on rubber. Edward May (1824–1879) was a pupil, as were many other Americans, of the academic painter Thomas Couture (1815–1879). This was also true of William P. Babcock (1826–1899) and of William Morris Hunt (1824–1879). The latter, a friend of the Realist painter Jean-Francois Millet (1814–1875), became the main artist responsible for the spread of the Barbizon School in Boston. Shown with them, François Gignoux (1816–1882), an émigré painter from Lyon, was one of the rare landscape painters of the group. Lastly, there is Rossiter, mentioned previously. The other painters are of less importance but all very probably were linked with France.

American landscape painters were clearly absent from the 1855 Salon—not only Rossiter's friends Durand or Kensett, for example, but also more famous artists such as Frederick Edwin Church (1826–1900), then at the height of his glory. It is strange that none of these artists should have been present at the 1855 Salon.

Contemporary American landscape painting was not completely unknown in France, however. In 1855, the same year as the Salon mentioned above, writer Jean-Jacques Ampère published a travel book entitled *Promenade en Amérique*. Having spoken disparagingly of American artists in general, with the exception of Emanuel Gottlieb Leutze (1816–1868) among history painters, he remarked that only landscape painting was of interest. After noting the five paintings of Thomas Cole's series *The Course of Empire* (1836, New-York Historical Society; figs. 20, 21), he wrote: "What stimulates my interest most in painting in the United States is landscape; that is where the most original endeavors are made."[13] American artistic isolationism was then dominant, and it corresponded all too well with France's lack of curiosity about American art. One can only dream of what would have been the reaction to a selection of important paintings of the Hudson River School.

American sculpture was represented at the Palais des Beaux Arts by only two artists: Eugène Warburg (1825–1859) and Richard S. Greenough (1819–1904), brother of the better-known sculptor Horatio Greenough (1805–1852) (fig. 18). Their works were appreciated by the French, in particular Ampère, who wrote in 1855: "If there is an art in which the Americans have succeeded, it is sculpture."[14] The most famous work by an American artist in Paris was not a painting, nor even a work figuring in the official exhibition. It was *The Greek Slave* created in 1843 by the Neoclassical sculptor Hiram Powers (fig. 17). Shown outside the Palais des Beaux Arts, in the Hôtel d'Osmond, it was part of a paid exhibition which, as a critic remarked in the American art periodical *The Crayon*, did not permit an artist "to hope to make a fortune with one statue when the whole of the Louvre, filled with famous works, could be seen for nothing."[15] *The Greek Slave* had been known in France from at least 1851, when it was exhibited at the London Exhibition. From this date on, Powers made many replicas in marble, some bought by French residents

as early as 1851.[16] As one can see, the American selection was modest in spite of a few strong points. The prize-giving, however, demonstrated a positive welcome.

The exhibition finished with a series of prizes. Some critics were surprised by these awards: "The United States, the country most backward in all fields of fine arts is, relatively speaking, the best rewarded of all: they have one second class medal and two third class medals, when there are only ten exhibitors."[17] The 1855 exhibition was thus a relative success—ambiguous, perhaps sometimes unjustified, but for the first time the American School acquired a real presence.

This first century of exchange, which stretches from Benbridge to the American War of Independence, is particularly interesting. It shows an unanticipated intimacy, an unexpected reciprocal knowledge.

Traditionally, one imagines the United States as a nation without art, in particular at the beginning of its history. It is strange to note that it was in fact those artists of the early years who, although far from home, taught artistic Europe the new laws of history painting. They were individuals that common experience had brought together or divided, but they did not form a national school in the usually accepted sense. They had not invented an American style, but they had brought to light a new type of subject and a way of treating it. After them, the place of the American artists in France remained obscure until the American Civil War (1861–65). Once that terrible conflict ended, it was toward France that, for more than a century, the artists from the other side of the Atlantic looked. These links then proved decisive for the evolution of American art. With time, the current would be reversed.

[1] Ellen Starr Brinton, "West's painting of Penn's Treaty with the Indians," *Bulletin of Friends' Historical Association* 30 (autumn 1941): 146–66.

[2] Francis Beretti, "Quatre portraits de Pascal Paoli par des artistes britanniques (1768, 1769, 1772)," *Bulletin de la Société des Sciences Historiques et Naturelles de la Corse*, fasc. 686–87 (1er and 2e trimestre 1999): 3–11.

[3] Rembrandt Peale, "Reminiscences," in *The Crayon* 1, no. 2 (January 10, 1855): 23.

[4] Barthélemy Jobert, "Estampe anglaise, estampe française: une histoire commune dans l'Outre-Manche," *L'Art britannique dans les collections publiques françaises* (Louvre, RMN, 1994): 121–22, and Olivier Meslay, "West entre Philadelphie, Londres et Paris," *l'art américain, identités d'une nation* (Paris: École Nationale Supérieure des Beaux-Arts, 2005): 15–41.

[5] Irma B. Jaffé, *John Trumbull: Patriot-Artist of the American Revolution* (Boston: New York Graphic Society, 1975): 180.

[6] George P. A. Healy, *Reminiscences of a Portrait Painter* (Chicago: McClurg, 1894).

[7] George Sand, "Relation d'un voyage chez les Sauvages de Paris" in *Le Diable à Paris, le Tiroir du Diable*, Paris, 1857.

[8] Véronique Wiesinger, "George Catlin et sa galerie indienne" in exh. cat. *Sur le sentier de la découverte. Rencontres franco-indiennes du XVIe au XXe siècle* (Blérancourt: Musée National de la Coopération Franco-Américaine, 1992): 86–95.

[9] Charles Baudelaire, *Salon de 1846*, ed. David Kelley (Oxford: Clarendon Press, 1875): 144.

[10] I should like to thank Cécile Oulhen for the remarkable study that she carried out in 2005 as part of a monograph of museology at the Ecole du Louvre on this subject. Most of the information in this section is taken from her research to be published in a forthcoming article.

[11] Edmond About, *Voyage à travers l'exposition des Beaux-Arts* (Paris: Hachette, 1855): 73.

[12] Louis Enault, *Exposition universelle. Beaux-Arts*, XII, United States, no. 300, October 27, 1855.

[13] Jean-Jacques Ampère, *Promenade en Amérique, États-Unis, Cuba, Mexique, par J.J. Ampère* (Paris, 1855): 296.

[14] Jean-Jacques Ampère, *Promenade en Amérique, États-Unis, Cuba, Mexique, par J.J. Ampère* (Paris, 1855): 302.

[15] Anonymous, in *The Crayon* 1, no. 2: 298.

[16] Richard P. Wunder, *Hiram Powers, Vermont Sculptor, 1805-1873* (Newark: University of Delaware Press, 1991): 157–77.

[17] Georges Guénot, "Clôture de l'Exposition Universelle de 1855," *Revue des Beaux Arts* 6.

Fig. 17 Hiram Powers (1805–1873), The Greek Slave, 1845–47, marble, 65 x 19 1/2 in. Corcoran Gallery of Art, Washington, D.C.

AMERICAN ARTISTS
AND THE JULY REVOLUTION

AMERICAN ARTISTS
AND THE JULY REVOLUTION

PAUL STAITI

"Greenough and Morse and Cole . . . are men to do honour to any nation. The feeling
of interest in one's country's artists and authors becomes very strong in a foreign
land. Every leaf of laurel awarded them seems to touch one's own forehead."

N. P. WILLIS, *New-York Mirror*, May 5, 1832

"You have been very attentive to what has passed
since the Revolution of 1830."

LAFAYETTE to SAMUEL F. B. MORSE, September 27, 1832

"The American leaves his country with a heart swollen with pride. He arrives in Europe
and immediately notices that people there are not as preoccupied as he imagined with
the United States and the great people that inhabits it. He begins to feel annoyed."

ALEXIS DE TOCQUEVILLE, *Democracy in America*, 1835

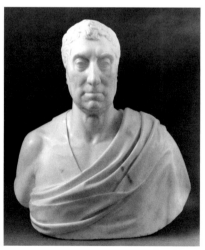

FIG. 18

FIG. 18 HORATIO GREENOUGH (1805–1852), **MARQUIS DE LAFAYETTE**, 1831–32, marble, 25 x 23 x 12 in.
Pennsylvania Academy of the Fine Arts, Philadelphia

FIG. 19 SAMUEL F. B. MORSE (1791–1872), **THE MARQUIS DE LAFAYETTE**, 1825–26,
Collection of the City of New York, Art Commission of the City of New York

However buoyantly American artists initially might have imagined their future residencies in Paris after the July Revolution of 1830, their actual experiences abroad often veered into adventures that were more complex than they could have anticipated. The arts circle—painters Samuel F. B. Morse and Thomas Cole, sculptor Horatio Greenough, and their literary friends, novelist James Fenimore Cooper and journalist N. P. Willis—came to Paris with simple goals: studying old master painting and contemporary architecture, acquiring a commission for a work of art, or just making an extended stop on the Grand Tour. As Willis indicated in his dispatch from Paris to New York, their Americanness was always keenly felt, and expressed. But while Paris was an opportunity for Americans to be American, it also led them to unexpected cultural and political encounters with the unnerving, post-revolutionary, pre-republican ethos of the New Europe. They obsessively compared American and French art, culture, and institutions, and whether that led to feelings of superiority, inferiority, agreement, or indifference, it unavoidably caused them to rethink their own New World identities. Paris had the power to unlock and amplify, rather than inhibit and silence, the tastes and opinions of the Americans. And for Morse, who was among the most engaged and passionate pilgrims, it dislodged his religiosity, republicanism, prudery, xenophobia, and nationalism, to name but a few of the roiling inner forces shaping his encounter with France.

Morse had come to Europe in 1829 and briefly passed through "the great capital of the continent"[1] in January of 1830, while Charles X (1824–August 1830) was still in

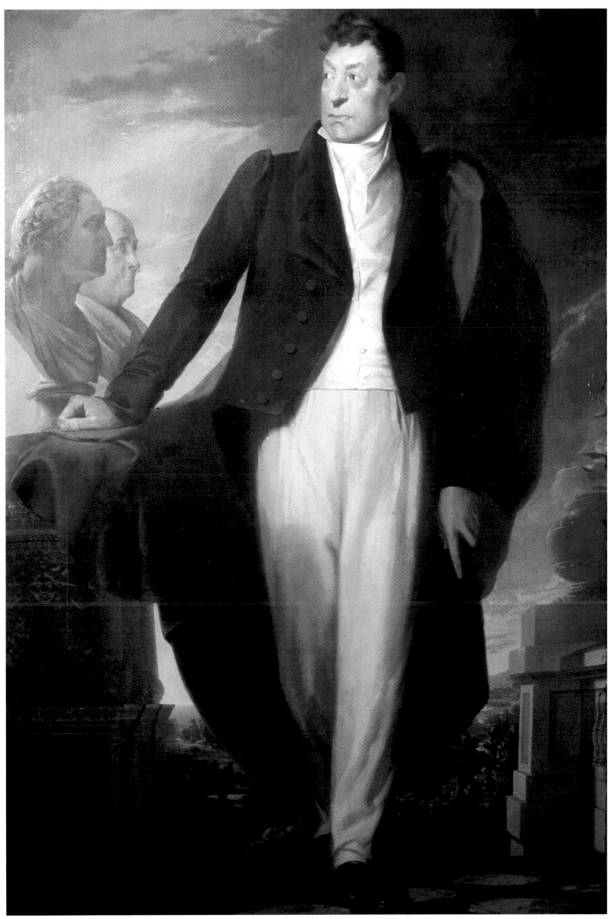

FIG. 19

power. Finding a room at the Hôtel de Lille, he immediately visited the Grand Gallery of the Louvre, where he spent three hours studying "the chefs-d'oeuvre of painting" and marking out "several which I shall copy on my return from Italy." As a traveler from a nation where high culture was thin and underappreciated, Morse predictably toured the continent with open eyes, a critical mind, and a defensive attitude. The one person he knew in Paris was the Marquis de Lafayette. Morse had idolized him from the time he received a commission to paint a portrait for the City of New York on the occasion of the general's "farewell" tour of the United States during the semi-centennial of the American Revolution, in 1826. After Lafayette's first sitting in Washington, Morse confessed to his wife that: "This is the man now before me, the very man, thought I, who suffered in the dungeon of Olmutz, the very man who took the oaths of the new constitution for so many millions, while the eyes of thousands were fixed upon him . . . the friend and companion of Washington, terror of tyrants, the firm and consistent supporter of liberty, the man whose beloved name has rung from one end of the continent to the other, whom all flock to see, whom all delight to honor. This is the man, the very identical man! My feelings were almost too powerful for me."[2]

Morse translated his veneration into the form of an imposing, larger-than-life picture in which Lafayette, dressed as a statesman rather than as a general, pauses on a high terrace to buttress his aging but animated body against pedestals that bear busts of Washington and Benjamin Franklin (fig. 19). In Morse's imagery, Lafayette is not only a nostalgic link to the Founding Fathers, but a living hero from a golden age who is destined to carry the core principles of the American Revolution into the future.

After a year and a half in Italy, Morse reentered "this famous city" of Paris on September 12, 1831, renting rooms on the Rue de Suresnes. Once again, he was drawn to Lafayette, now for his key role in the popular revolt of 1830. "A traitor king has been driven into exile," wrote Morse in his diary, "blood has flowed in its streets, the price of its liberty," and Lafayette, who only recently had been "out of favor with the court," was now "second only to the king in honor and influence as the head of a powerful party."[3] To the Americans, Lafayette had become so venerated that Greenough left his sculptural studies in Florence in order to make a two-month "jaunt," as he put it, to Paris in the autumn of 1831 for the purpose of carving a marble bust that presented the aging statesman as a senator of Republican Rome (fig. 18).

Morse's friend Cooper, who arrived on August 20, 1830, eleven days into the administration of Louis-Philippe (1830–48), wrote that he loved being "on the spot."[4] He openly published his political positions in the *Revue des Deux Mondes* and *Le National*, became an indispensable advisor to Lafayette, and opened his home on the

Rue Saint-Dominique as unofficial head-quarters for several visiting Americans who imagined they were not only firsthand witnesses to the republicanization of Europe but actual agents of political change. These individuals formed the Polish-American committee, spent hours in Lafayette's apartment on the Rue d'Anjou, and monitored and debated the popular uprisings in Poland, Belgium, Parma, Modena, and Bologna. The Americans in Cooper's circle all felt that they represented the possibilities for the future of France and Europe simply by being Americans in Paris.

It was Cooper, a master at deducing "motives from manners," who also could see that Louis-Philippe was a despot at heart.[5] Morse, too, suspected that republican idealism was doomed: "But what a lesson does the state of Paris read to us!" Morse exclaimed in January of 1832: "See the vain struggle for liberty which France makes; vain, I say, because she has not *moral power* to sustain it. She is sinking gradually back to a love of despotic sway."[6] The Americans saw riots in the streets, limits imposed on human rights, and, eventually, the eclipse of Lafayette. At a Fourth of July banquet in 1832, Morse toasted Lafayette as "the staunch, undeviating defender of [republican] principles, of our principles, of American principles,"[7] but by then the reform movement had already begun to collapse. Two weeks later, having given up on political change in Europe, Morse sent an angry letter to the *New York Observer* in which he attacked the undying system of aristocratic privilege: "By what laws are we bound to consider ourselves inferior because we have stamped *folly* upon

the artificial and unjust grades of European systems, upon these antiquated remnants of feudal barbarism? . . . America is the stronghold of the popular principle, Europe of the despotic."[8]

Surely, the American interest and involvement in the affairs of the July Monarchy had everything to do with American nationalism: the sustained belief that America was on to something special, that the United States had gotten it right, and that the American political model was a good one for every nation. "It is only when we contrast our happy [American] lot with that of the enslaved nations of Europe that we feel the infinite and diversified blessings of true liberty," Morse wrote with competitive fervor.[9] The bragging of the Americans led predictably to charges of chauvinism, but Morse countered, "We are accused of National vanity and by whom; we may have our share, but no nation of Europe can charge us with this *mot* whilst each has so large a beam of its own."[10] The relentless American impulse to compare the United States *to* France, and then to differentiate and distance it *from* France was as powerful as the American wish to see the popular movement succeed. The complex dynamic of identification and separation was evident in all the Americans. Whenever Greenough contemplated the precariousness of French republicanism, his thoughts quickly turned to America's own future, which he assured himself would be safe because "our religion," "our church," "our fleet," "our political institutions" were indeed different. Cole would actually visualize the American fascination with and critique of Europe in his epic *The Course of Empire* (figs. 20, 21), which he

FIG. 21 THOMAS COLE (1801–1848), **THE COURSE OF EMPIRE: DESTRUCTION**, 1836, oil on canvas, 39 1/4 x 63 1/2 in., The New-York Historical Society, New York City

began painting shortly after his return to America in 1832. In this series of five pictures, which chart the rise and fall of an imaginary European civilization, Cole proposed that monarchy, aristocracy, and luxury, if unchecked, would lead to endless war, sure decline, and ultimate desolation. Though all the Americans in France harbored doubts about the future direction of their own nation, especially under the presidency of Andrew Jackson (1829–37), they were capable of convincing themselves, in Paris, that exceptional American individuals, national institutions, and natural advantages would protect America from despotism and deliver it to greatness instead. For that process to take hold, however, contemporary France, because of its intellectual turmoil, "dangerous" Catholic beliefs, and monarchical past, could not be America's model, however tempting so many other aspects of its culture might be.

The Americans recognized their vulnerability to Europe's charms and hazards, and thus defended themselves with beliefs and actions that sharpened their sense of American exceptionalism. For example, Cole tried to use American nature to inoculate himself culturally against the seductive charms of modern Europe by making a special trip to Niagara Falls on the eve of his first departure from America. "I wish to take a 'last lingering look' at our wild scenery. I shall endeavor to impress its features so strongly on my mind that in the midst of the fine scenery of other countries their grand and beautiful peculiarities shall not be erased."[11] Cole's prospective nostalgia for the New World was fictionalized in Henry James's lead characters in his 1876 novel *Roderick Hudson*. A young sculptor from Massachusetts, Hudson is a cross between Greenough, a young sculptor from Massachusetts, and Cole, leader of the Hudson River School of landscape painting; he joins his patron and friend, Rowland Mallet, to make a final ascent of Mount Holyoke in western Massachusetts (a site that Cole famously painted). Hudson talks of "National Individuality" in the American arts, and the fictitious Rowland, like Cole earlier, takes in the view so that "later, in a foreign land, he should remember it with longing and regret . . . This is an American day, an American landscape, an American atmosphere."[12] Morse, too, had reinforced his own American values before he arrived in Europe. In 1826 he founded and assumed the presidency of the National Academy of Design in New York City: as the first domestic institution to offer art instruction, the NAD was the first American academy capable of offering young American artists an alternative to expatriation and therefore, Morse believed, the means of developing a national school.

An earlier generation of traveling American artists and architects, however, was not so vexed by their sojourn in Paris: Thomas Jefferson (in Paris 1784–1789); John Vanderlyn (1796–1801; 1803–15); Washington Allston (1803–1804); and Rembrandt Peale (1808; 1809–10). Their easier passage may have had something to do with their pride in the still-fresh American Revolution, in which the French actively participated; to a political/artistic interest in finding alternatives to London as America's cultural authority; or to the francophilia that characterized Jefferson's presidency. It might also have resulted from the newness of the United States itself and its still fluid cultural identity in 1800. Later generations of American artists traveling to France—those who came during the Second Empire (1852–70) and after—were also less perplexed and judgmental, in part because of the acknowledgment of Paris as the undisputed cosmopolis of the Western art world.

What primarily distinguished the generation of Morse and Cooper from the earlier one of Vanderlyn and Jefferson was its cultural nationalism and related quest for American autonomy in the arts. By 1830, the desire for cultural self-sufficiency was great enough to cause critical barbs to be launched across the Atlantic and along the galleries of the Louvre. Yet this cultural self-confidence was not yet strong enough to prevent emergent nationalism from degenerating at times into a mean-spirited cultural partisanship, best expressed in a letter Greenough published in the *New-York Mirror* in 1832 in which he admonished his fellow artist, Rembrandt Peale, to "convince [our countrymen] that one American Work is of more value to the U.S. than 3 foreign ones even of superiour [sic] merit. If [Americans] mean [to have] all their pictures . . . painted by strangers, they are in the wrong, both as regards economy and praiseworthiness." Morse, feeling indignant at the French sense of superiority, crowed that "There can be no *condescension* to an American."[13] For the entire expatriate generation of 1830, being critical was part of becoming American.

The features of Parisian life that Americans living in France after 1830 found

FIG. 22 EUGÈNE DELACROIX (1798–1863), **JULY 28, LIBERTY LEADING THE PEOPLE,** 1831, oil on canvas, 101 1/2 x 126 3/4 in., Musée du Louvre, Paris

most compelling were not Louis-Philippe or contemporary French art but Lafayette and the old master paintings in the Louvre. One represented the political future that Americans imagined for France and all of Europe, based on the republican model of the United States; the other was the emblem of the highest cultural attainment of Europe's mythic past. Recent French painting certainly was in abundance at the Louvre, at the Luxembourg Palace, and in the annual Salons. But the Americans largely felt nothing but contempt for it. Greenough turned sour as he considered modern French painting: indeed, Jacques Louis David's (1748–1825) pictures at the Louvre, presumably *The Oath of the Horatii* (1784, Musée du Louvre) and *The Lictors Bringing Brutus the Bodies of His Sons* (1789, Musée du Louvre), seemed so cold to him that he felt "the want of a great coat and cigar in looking at them."[14] Though he did not specify the other modern French artists caught in his critical lens, he considered them "clever men employed in twiddle-twaddle, caricature, indecent pictures etc."[15] Cole said that "I had been informed that modern painting was very low in point of merit in Paris," but after a trip to the Louvre he wrote that "I had not expected to see so many vile productions with so few good ones—I was disgusted. And was glad to get out although I must go again . . . [All the subjects are] bloody or voluptuous, death, murder, battle."[16] Morse enjoyed his entire visit to the church of Sainte Geneviève but recoiled from court painter Baron Gros's huge *Apotheosis of Sainte Geneviève* (1824) as representative of "a class of painting I detest."[17] Cooper recounted his days spent

at the street stalls looking for old master pictures, but he did not have a thing to say about living French artists.

It is not known whether any of the American artists attended the Salons of 1831 or 1832, but certainly the 3,000 or so works of art on display at each exhibition could hardly escape notice. The galleries were full of portraits that legitimized the rule of Louis-Philippe and pictures that dramatized the intense street fighting during the July Revolution.[18] To the Americans, some of the contemporary imagery might have recalled Gilbert Stuart's (1755–1828) portraits of Washington or John Trumbull's (1756–1843) Revolutionary War series. But tellingly, the most famous and enthralling of the pictures in the 1831 Salon, Eugène Delacroix's *July 28, Liberty Guiding the People* (fig. 22), was never mentioned in any of the Americans' letters or diaries, and in fact almost none of the most prominent French artists of the day—Eugène Delacroix, Paul Delaroche, Eugène Isabey, Horace Vernet, François Gérard—were ever cited.

Why such a wholesale rejection? To be sure, it had something to do with the Americans' residual British taste. But more specifically, the dismissal was an expression of American cultural politics in Paris. There, Greenough, Morse, and Cooper believed adamantly in a prospective vision of the rising glory and future triumph of American arts, even though they would discover upon their return to America that there was little evidence for it. They thought they already had the perfect political system. And in that delirious state of Manifest Destiny that Paris awakened in them, they came to believe that American arts too

would eclipse those of Europe. Standing in the Louvre, or anywhere else in Paris, the Americans thought long and hard about the United States. "For as we are, [we] have no reason to decline a comparison with the present nations of Europe as far as *taste* in Architecture is concerned," wrote Greenough. "As for what painting and Sculpture are to do among us, it seems to me that they will depend entirely on our love for our institutions—If we continue to stand tip-toe along the Atlantic shore endeavouring [sic] to catch the last word from Europe, nothing great will surely be done—But if we will turn our eyes inward a little, calculate results and embody principles, then art becomes important and we shall have it, for we seldom long feel the want of anything in America."[19] Philosopher Ralph Waldo Emerson, who was in Paris in 1833, had a deep appreciation of and respect for European culture. But he too appreciated the pressing need for America to detach itself from its European paternity if the nation's thinking and values were to assume an independent authority and vigor. Writing on this theme in his speech of 1837, "The American Scholar," Emerson feared that America already was becoming "timid, imitative, tame," and if it was ever to be its own country it could not continue to "be fed on the sere remains of foreign harvests." Echoing Greenough, Cooper, and Morse, Emerson concisely warned Americans that "we have listened too long to the courtly muses of Europe."[20]

Yet as much as the Americans disparaged contemporary French art, they revered the old masters in the Louvre. That was what Cole was expecting to see when he

FIG. 23 PAOLO CALIARI, known as VERONESE (1528–1588), **THE WEDDING FEAST AT CANA**, 1563, oil on canvas, 266 1/2 x 391 1/4 in., Musée du Louvre, Paris

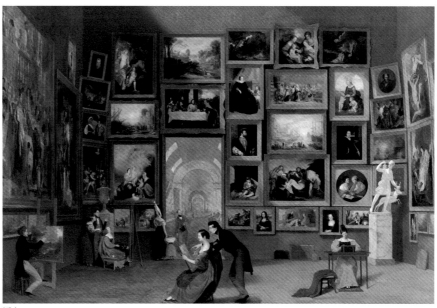

CAT. 1

walked toward the museum in May of 1831, but upon arrival he said he "was painfully disappointed in finding that the works of the Old Masters were covered by the productions of Modern painting."[21] Greenough swooned over the *The Wedding Feast at Cana* (fig. 23) by Veronese (whom he warmly called "Paolo"): "He held his broad mirror up and a world is there with gleams of exquisite feeling and truth that would seem out of the reach of art."[22] But it was Morse who was most fully engaged with the Louvre. As early as 1830, when he stopped briefly in Paris, he formulated a plan to paint a picture containing reduced versions of the best of the collection and take the canvas back to New York as a potent instrument for American cultural education. As president of the National Academy, Morse

had taken personal responsibility for shaping America's cultural future. But if he wanted to accomplish his goal of encouraging American artists and an American audience for American art, he had to show what it was that constituted excellence in the visual arts. How could that be done, however, when there were so few models of artistic excellence in the United States? There were very few old master paintings in America, and most Americans were very unlikely to travel abroad to see originals. And while European novels and poetry lost nothing in reproduction, copies of European artworks available in America fell far short of their originals. Morse, like Emerson, did not want to see America merely imitating Europe. But as an American making an American picture about great European

pictures, Morse would be able to personally select and import accurate, even erudite reproductions. And in doing so he thought he could bridge the sizeable cultural gap between Europe and America without turning the United States into a provincial outpost of Europe. If he were successful, he believed, he could push his young nation toward eventual parity with the Old World— on its own terms. For his fellow American students and citizens, Morse envisioned his *Gallery of the Louvre* (cat. 1) as a portal to personal enlightenment and national improvement.

If Nicolas-Sébastien Maillot's *Salon Carré du Louvre in 1831* (fig. 24)[23] can be accepted as documentation, Morse must have been crestfallen to discover the changes made at the Louvre when he

FIG. 24

CAT. 1 SAMUEL F. B. MORSE (1791–1872), **GALLERY OF THE LOUVRE,** 1831–33, oil on canvas, 73 3/4 x 108 in.,
Terra Foundation for American Art, Daniel J. Terra Collection, Chicago

FIG. 24 NICOLAS-SÉBASTIEN MAILLOT (1781–1856), **SALON CARRÉ DU LOUVRE IN 1831,** 1831, oil on canvas,
49 1/2 x 55 7/8 in., Musée du Louvre, Paris

returned to Paris to paint the *Gallery of the Louvre* in September of 1831: the walls of the Salon Carré, historically the gallery devoted to the best of the collection, were covered with contemporary French artworks, Théodore Géricault's *Raft of the Medusa* (1819, Musée du Louvre) prominent among them. The reorganization would have forced Morse to seek out the pictures he wished to represent from sites scattered throughout the Grand Gallery and other rooms in the museum.[24] In true academic fashion, he set himself the difficult task of trying to approximate the style of twenty-eight different painters as represented in thirty-eight pictures, five national schools, and three centuries. He worked on his picture of pictures for about a year, from the autumn of 1831, through the cholera epidemic of 1832, and into September of the same year, and maintained a punishing schedule, "all day from 8 til dark" with time off only to eat and sleep.[25] German naturalist and explorer Alexander von Humboldt came to watch Morse work, as did Cooper, who walked to the museum each day to see Morse "stuck up on a high working stand" copying; "crowds get round the picture," he wrote to William Dunlap (1766–1839), "for Samuel has made quite a hit in the Louvre."[26] Even the self-effacing Morse had to admit that it is a "splendid and valuable work. It excites a great deal of attention from strangers and the French artists. I have many compliments on it, and I am sure it is the most *correct* one *of its kind* ever painted, for everyone says I have caught the style of each of the masters."[27] Back in New York City late in 1832, he continued work on the walls of the salon and

added the figures: in the center foreground he painted himself appropriately instructing a young student, while in the far left corner he showed Cooper discussing a picture with his wife and daughter (cat. 1, detail). Morse finished the picture in August of 1833.[28]

Gallery of the Louvre was the culmination of the voyage of the Americans to Paris in the wake of the July Revolution. Morse intended the unveiling of the picture in New York to set in motion a chain of cultural epiphanies that would shepherd America toward its destiny as the next great civilization. Greenough had once imagined the intoxication of that moment: "In the year 1833 S. F. B. Morse and H. Greenough will be in the city of N. Y. decidedly the merriest and best fellows in the place."[29] The disastrous public showing of *Gallery of the Louvre* during October and November of 1833 thus came as a shock to Morse and the artists in his circle. "Every artist and connoisseur was charmed with it," William Dunlap observed, "but it was caviar to the multitude."[30] Admission receipts did not even pay the rent on the gallery space. Morse terminated the exhibition prematurely, sold the picture cheap, brooded about a "paralysis of spirit," and began "to stifle all aspiring thoughts."[31] What had gone wrong? It had something do with the very idea of a large picture of miniaturized old master pictures, a type of painting that had no precedent in America and one that had so little narrative interest it could not hold or even draw in casual viewers. But most fatally, Morse had grossly miscalculated the interest of the American public in becoming art-historically literate by means of an Americanized abridgement of their European paternity.

Morse came to realize that *his* vision of America's cultural triumph was a dream: "There is a great deal to dishearten in the state of feeling, or rather the state of *no* feeling on the arts in that city [New York]."[32] He complained to various correspondents that in New York, "everyone is driving after money, as usual," that "commerce, commerce, commerce is the only thought and occupation of this great enterprising, thriving people," and that "boorishness and ill manners [are] preferred to polish and refinement."[33] He was crushed by the rejection of his picture and of the entire agenda he had formulated in Paris, and confessed that "my life of poetry and romance is gone."[34] Within four years he would stop painting forever, ending his career as an artist, and move on to his more successful experiments with the electromagnetic telegraph.

All along, of course, underneath the Americans' posturing in France, there was a deep-seated fear that the arts in America were going nowhere, and that failure was as imminent as triumph. In a letter printed in the *New-York Mirror* in 1832, Greenough anxiously reminded his colleague Rembrandt Peale that "the scholars of America have looked so much abroad for salvation in letters, arts, and manners that they have not only overlooked home but have unfitted all under their influence for judging impartially of anything American. They have carted sand in upon a fine soil and nothing but a flood of satire can remove it and bring to light the fertile bottom which they encumbered."[35] Greenough's anxiety was confirmed when his classical statue of a half-nude Washington, which Congress

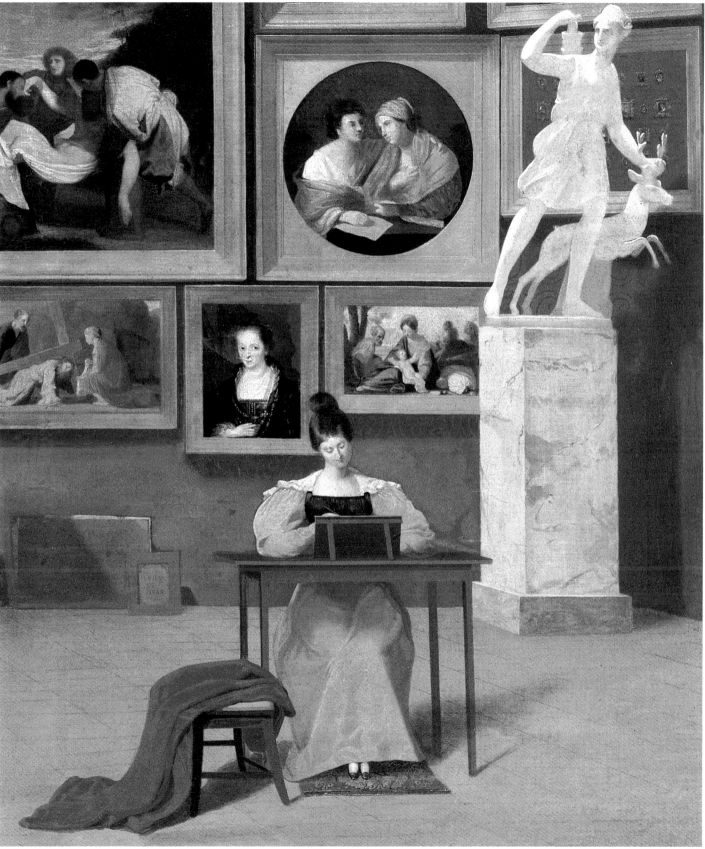

commissioned in 1832 and which he sculpted in Florence, was ridiculed on its American unveiling because it seemed entirely —absurdly—European in both concept and form. Even the ever-buoyant Cooper became a cynic when he returned to the United States in 1833. In France he had written *The Bravo*, a novel that attacked aristocratic tyranny and lauded the common people. But when he returned to the United States in 1833 his popularity dropped; "King" Andrew Jackson seemed as offensive to him as King Louis-Philippe; and he became convinced that America was moving inexorably toward vulgarity, ignorance, and demagoguery, not enlightenment.

The returning Americans might have averted their collision with American realities, or at least avoided their colossal disappointment, had they been able to speak with Alexis de Tocqueville and his fellow traveler Gustave de Beaumont. The Frenchmen toured America between May 1831 and February 1832 with the stated goal of studying, and filing a report on, the American penal system, but unofficially they were more motivated to travel by their distaste for the political dishonesty of the July Monarchy. As critical witnesses of America, they saw both political and economic examples for France (democracy, public spirit, manufactures, institutional efficiency) and all the social disadvantages that Morse and Cooper would soon lament (materialism, mediocrity, philistinism,

tyranny of the majority, and "individualisme"). Had Tocqueville and Beaumont met Cooper and Morse, both parties might have detected similarities between their projects abroad. All four were sifting through their host nations' cultures in an effort to bring back those aspects that would advance their home civilization, at least as they imagined it should be. Tocqueville and Beaumont may have published more of their observations than their American counterparts, but Cooper's and Morse's experiences were just as rich and complex. In fact, Cooper and Morse produced parallels to Tocqueville's *Democracy in America* (1835) and *The Penitentiary System in the United States and its Application in France* (1833), for Morse's *Gallery of the Louvre* was in effect a visual essay on "The Artistic Patrimony of France and its Application to the United States" and Cooper's political and fiction writings together amounted to a brutal account of "Despotism in France."[36] All four men were elitist, recondite, dogged, opinionated, and astute. And as they traveled in different directions during the same years, all four carried intellectual baggage of national interests, proclivities, and aspirations. They never crossed paths, of course, but they were nonetheless linked by obsessively comparative critiques of their respective host countries that, in the end, had the function of sharpening their definitions of themselves as Americans and Frenchmen respectively.

Relative to the disappointment of their return to the United States, the time the Americans spent in Paris after the July Revolution was a golden moment in which doubt was suspended and dreams of the future were freely formed. Instead of despairing, they asked themselves what needed to be done to eventually realize a great American art. Morse temporarily put aside any latent anxiety over that question, and adopted instead a boastful nationalistic language of American success and quick censure of foreign art and cultures. He boldly took responsibility for being America's cultural redeemer, euphorically sang the praises of a rising golden age, and even produced an audacious instrument for cultural transformation in the shape of *Gallery of the Louvre*. But in the end, betrayed by his own dreamy Parisian visions, Morse failed in his desperate struggle to design a cultured America where the fine arts might reign. In retrospect, his *Gallery of the Louvre* takes on the aspect of a quixotic venture, and the vaunted expectations he formulated in France for America's cultural ascendancy now seem both lush and arrogant, heroic and impossible, a brief journey into hubris.

The author thanks Robert L. Herbert, Donald Weber, Angela Miller, Roger Stein, and Susan Orlando for their advice, encouragement, and ideas.

[1] Morse to Mrs. Margaret Roby, January 7, 1830, in *Samuel F. B. Morse: His Letters and Journals*, ed. Edward Lind Morse (Boston and New York: Houghton Mifflin Company, 1914), I:315.

[2] Morse to Lucretia Morse, February 8, 1825, in *Samuel F. B. Morse: His Letters and Journals*, I:262.

[3] Morse, diary entry for September 12, 1831, Samuel F. B. Morse Papers, Library of Congress, Washington, D.C.

[4] James Fenimore Cooper to Elizabeth Caroline De Lancey, December 3, 1831, *The Letters and Journals of James Fenimore Cooper*, ed. James Franklin Beard (Cambridge: Harvard University Press, 1959), II:158.

[5] *Letters and Journals of Cooper*, II:4.

[6] Morse to Sidney Edwards Morse and Richard Cary Morse, January 8, 1832, Morse Papers, Library of Congress, Washington, D.C.

[7] Morse, Toast to Lafayette, July 4, 1832, *Morse: Letters and Journals*, I:425.

[8] Morse to Sidney Edwards Morse and Richard Cary Morse, July 18, 1832, Morse Papers, Library of Congress, Washington, D.C.

[9] Morse to Sidney Edwards Morse and Richard Cary Morse, January 8, 1832, Morse Papers, Library of Congress, Washington, D.C.

[10] Morse to Sidney Edwards Morse and Richard Cary Morse, July 18, 1832, Morse Papers, Library of Congress, Washington, D.C.

[11] Quoted in Ellwood C. Parry III, *The Art of Thomas Cole* (Newark: University of Delaware Press, 1988): 93.

[12] Henry James, *Roderick Hudson* (London: Rupert Hart-Davis, 1961): 41–42.

[13] Morse to Sidney Edwards Morse and Richard Cary Morse, July 18, 1832, Morse Papers, Library of Congress, Washington, D.C.

[14] *Ibid.*

[15] *Ibid.* Parry (*Art of Thomas Cole*, 115) notes that American painter George Cooke was in Paris at this time copying Géricault's *Raft of the Medusa*.

[16] Thomas Cole, Writing Book, quoted in part in Louis Legrand Noble, *The Life and Works of Thomas Cole*, ed. Elliot S. Vesell (Cambridge: Harvard University Press, 1964): 89. Parry found the full text in Cole's Writing Book no. 1, Archives of the Detroit Institute of Arts, Detroit (DIA 39.558A).

[17] Morse, diary entry for January 9, 1830, Morse Papers, Library of Congress, Washington, D.C.

[18] See Michael Marrinan, *Painting Politics for Louis-Philippe: Art and Ideology in Orleanist France, 1830-1848* (New Haven: Yale University Press, 1988).

[19] Horatio Greenough to Washington Allston, October 1831, Dana Papers, Massachusetts Historical Society, Boston.

[20] Ralph Waldo Emerson, *The American Scholar; an Address Delivered before The Phi Beta Kappa Society, at Cambridge, August, 1837* (New York: Laurentian Pres, 1901): 54.

[21] Cole, Writing Book, quoted in Noble, *Life and Works of Thomas Cole*, 89.

[22] Greenough to Washington Allston, October 1831, Dana Papers, Massachusetts Historical Society, Boston.

[23] It is difficult to determine the exact hanging of the Salon Carré in late 1831. At the time Morse was in the Louvre, John Scarlett Davis, an English artist, copied numerous pictures in the Louvre. His large *Main Gallery of the Louvre, Paris* (United Kingdom Government Art Collection) resembles Morse's picture in that it shows old master paintings, not contemporary French art. In fact, the two pictures share seven of the same pictures, five of which are hung in nearly identical locations. There are a number of possible explanations for this coincidence: that the Maillot picture is not an accurate record of the hanging of the Salon, which was actually hung with old master pictures; that Davis "copied" Morse; that Morse "copied" Davis; or that the two worked in some relation to each other. For Davis, see G. Watkins Williams, "The Life and Works of John Scarlett Davis," *Old Watercolor Society Club* XLV (1970): 8–28.

[24] Morse recorded that he "copied" pictures "into" the gallery, as indicated in the title of the pamphlet he published to accompany the exhibition: *Descriptive Catalogue of the Picture, Thirty-Seven in Number from the Most Celebrated Masters Copied into the Gallery of the Louvre* (New York: James Van Norden, 1834).

[25] Morse to Sidney Edwards Morse and Richard Cary Morse, March 13, 1832, Morse Papers, Library of Congress, Washington, D.C. Morse also made copies of individual pictures, which he sold to American collectors. The only one extant is his copy of Titian's *Francis I* (Terra Foundation for American Art), in which he reduced the 43-by-35-inch original to an 8-by-10-inch panel.

[26] Cooper to William Dunlap, March 16, 1832, in Dorothy C. Barck, *Diary of William Dunlap (1766-1839); The Memoirs of a Dramatist, Theatrical Manager, Painter, Critic, Novelist, and Historian* (New York: The New-York Historical Society, 1930), III:608.

[27] Morse to Sidney Edwards Morse and Richard Cary Morse, July 18, 1832, Morse Papers, Library of Congress, Washington, D.C.

[28] The key essays on the picture are Paul Staiti, *Samuel F. B. Morse* (Cambridge and New York: Cambridge University Press, 1990): 175–206, and David Tatham, "Samuel F. B. Morse's *Gallery of the Louvre*: The Figures in the Foreground," *American Art Journal* 13 (autumn 1981): 38–48.

[29] Horatio Greenough, *Letters of Horatio Greenough, American Sculptor*, ed. Nathalia Wright (Madison: University of Wisconsin Press, 1972): 90–91.

[30] William Dunlap, *A History of the Rise and Progress of the Arts of Design in the United States*, fac. ed. (1834; New York: Dover Publications, 1969), II:317.

[31] Morse to DeWitt Bloodgood, December 29, 1833, Historical Society of Pennsylvania, Philadelphia.

[32] Morse to James Fenimore Cooper, February 21, 1833, James Fenimore Cooper Papers, Beinecke Library, Yale University, New Haven.

[33] Morse to James Fenimore Cooper, February 28, 1833, James Fenimore Cooper Papers, Beinecke Library, Yale University, New Haven; Samuel F. B. Morse to Madame Frainays, April 10, 1833, Morse Papers, Library of Congress, Washington, D.C.; Samuel F. B. Morse, "Thoughts on Art," Morse Papers, Library of Congress, Washington, D.C.

[34] Morse to George Hyde Clarke, June 30, 1834, Morse Papers, Library of Congress, Washington, D.C.

[35] Greenough to Rembrandt Peale, November 8, 1831, New-York Historical Society, reprinted in Greenough, *Letters*, 94. Reprinted in the *New-York Mirror*, March 3, 1832, 278–79.

[36] Willis's *Pencillings by the Way*, first published in three volumes in London in 1835, is also a non-political equivalent of Tocqueville's *Democracy in America*. In it, Willis includes hundreds of sketches capturing continental life and manners.

American Friends of the

LOUVRE

March 11, 2008

Mr. Tom Barwick
c/o Cigna Financial
701 N. 36th St #310
Seattle, WA 98103

Dear Tom:

It was a pleasure to meet you at the v.i.p. opening of *Roman Art from the Louvre* at the Seattle Art Museum. I greatly enjoyed being one of your dinner partners and having the opportunity to speak to you about your involvement with SAM. The museum is indeed fortunate to have your involvement.

As I mentioned, the Musée du Louvre is hoping to expand its collection of American art by artists working up to the mid-19th century. American Friends of the Louvre funded a study on the subject that analyzed the challenges and opportunities to collecting in this area. Overall, the study was positive, and the Louvre is now focusing on educating curators in the departments of painting, sculpture and decorative arts so that a real plan can be put in place. I will keep you up to date on progress as this project advances.

In the meantime, thank you for giving a tour of your collection to Greg Hedberg, one of our Chairman's Circle members, and Nicole Salinger from the Louvre. They thoroughly enjoyed it.

Again, it was a pleasure meeting you. I hope you will enjoy the enclosed catalogue from an exhibition two years ago co-organized by the Musée du Louvre and the Terra Foundation for American Art.

Sincerely,

Sue Devine
Executive Director

encl.

AMERICAN ARTISTS AND THE LOUVRE:
AN ENDURING LEGACY

AMERICAN ARTISTS AND THE LOUVRE: AN ENDURING LEGACY

ELIZABETH KENNEDY

"This Museum . . . must nourish a taste for the arts, train art lovers, and serve artists. It must be open to all. Everyone must be able to set their easel before any painting or statue, draw them, paint them, or model them, as they think fit."

French Interior Minister JEAN-MARIE ROLAND to painter JACQUES-LOUIS DAVID, 1792[1]

FIG. 25

FIG. 25 VIRGIN AND CHILD WITH ST. ELIZABETH AND ST. JOHN, attributed to John Smibert (1688–1751) after an engraved copy of Raphael's THE LITTLE HOLY FAMILY, oil on canvas, 43 1/8 x 39 3/4 in. Bowdoin College Museum of Art, Brunswick, Maine, bequest of the Honorable James Bowdoin III

FIG. 26 AUGUSTE BOUCHER-DESNOYERS (1779–1857), LA VIERGE AU BERCEAU, after Raphael's THE LITTLE HOLY FAMILY, 1857, engraving. Musée du Louvre, Paris

The Louvre. Notoriously difficult for most Americans to pronounce, the Louvre, nonetheless, needs no translation. American meditation on this monument to the history of art—equal parts anticipation, experience, and memory—has forged a bond between the Old World and the New. The largest number of foreign visitors to the museum, Americans today tour the Musée du Louvre as if its collections were their own national treasure. True to its mission, the museum has welcomed generations of artists, who wander in its galleries to study, sketch, and paint in what amounts to a free art school for kindred spirits. Until now, the Louvre's legacy as an unofficial academy for American artists has been little appreciated. This essay serves as an introduction into what I characterize as the "Louvre effect": the aura of the Louvre for American artists.

Transatlantic visitors were euphoric and exhausted by their first overwhelming encounter with the Louvre, especially by the visual cacophony of dazzling colors from the seemingly endless rows of paintings, the ceiling decorations, and other gallery ornamentation. For American artists, years of anticipation mediated their first visual experience in the galleries. There, they spent innumerable hours scrutinizing one artwork after another as they lingered in Paris for weeks, months, or years, creating an inventory of memories. Long after the artists returned to America, they would reminiscence about their artistic discoveries at the museum, and teachers, in particular, attempted to reconstitute for their students their own understanding of the magic of the Louvre effect. Influential artist, teacher, and writer Kenyon Cox (1856–1919) expressed

FIG. 26

American artists' commitment to the study of the Western art heritage in his 1911 speech for the Art Institute of Chicago's Scammon lecture series. In one's encounter with the great masterpieces of the Louvre, Cox urged, one should "try to find in them, not hard and fast rules of what to do and what to avoid, but the guiding principles on which they are built . . . then to set one's self to invent new forms."[2] The Louvre effect served as a potent agent for American artists' definition of their own aesthetic identities and, for the most ambitious, it nurtured a desire to have their own art acquired by the most impressive museum in the world. In 1891, the French state purchased controversial painter James McNeill Whistler's *Arrangement in Gray and Black no 1: Portrait of the Painter's Mother* (fig. 28), today the most famous American painting in a European collection. The thought of the notorious modern master joining the ranks of the treasured old masters in the Louvre[3] encouraged other American artists to dream of their own artistic apotheoses.

THE LOUVRE IN AMERICANS' IMAGINATION

Prosperous New York merchant Luman Reed never traveled to Europe, yet his library in the late 1830s contained collection catalogues from the Louvre. Furthermore, he commissioned copies of specific artworks from the Louvre to add to his art collection of sixteenth- and seventeenth-century paintings, reproductive engravings of celebrated masterpieces, and extraordinary contemporary American paintings by, among

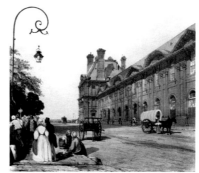

FIG. 27

others, Thomas Cole, founder of the Hudson River school of landscape painting (see the essay "American Artists, the July Revolution, and the Making of National Identity"). As a collector, Reed exemplifies those Americans who felt a need to engage with the European artistic heritage while encouraging the development of a national art by patronizing American artists. His artistic self-education illustrates the Louvre effect that existed for American art aficionados long before the French museum became a prime cultural destination for tourists, following the American Civil War (1861–65).[4]

Americans' initial engagement with the Louvre and its collections began with reproductions—textual descriptions and painted copies. Possibly the earliest reproductions of a work of art associated with the Louvre were on view in the Boston studio-shop of John Smibert (1688–1751), a Scottish painter who emigrated to America in the late 1720s, including his own painted version of the Louvre's *Small Holy Family*

by Raphael presumably copied from an engraving since it is reversed (figs. 25, 26).[5] Reproductive engravings, which sought to faithfully represent paintings, drawings, and sculpture, introduced Americans to old master paintings and antique masterworks. As an American critic ruefully acknowledged, many Americans' yearning to view "the immortal works of Europe" would have to be satisfied by engravings, and "if they convey no adequate idea of the originals, they do afford us a knowledge of their composition and drawing which is better had so than not at all."[6]

In 1797, four years after the Louvre was established as a museum, it inaugurated a chalcography—a commercial shop, still in operation today, to sell reproductive engravings of artworks in the museum's collection.[7] A half-century earlier, private connoisseurs had commissioned French reproductive engravers, previously allied with such business entities as tapestry producers, to copy masterworks in the royal collection. Within a few years of the museum's founding, the Louvre's chalcography contained thousands of plates for reproductive engravings. Prints were sold directly to visitors at the museum or through an agent, who shipped them to collectors in America. Boston connoisseur Francis Calley Gray's collection of several thousand prints was regularly exhibited with original paintings and copies in annual exhibitions at the Boston Athenaeum between 1827 and 1873.[8]

In the mid-nineteenth century, photography revolutionized the art reproduction industry at a time of growing demand for tourist souvenirs. Affordable reproductions of the Louvre's celebrated artworks,

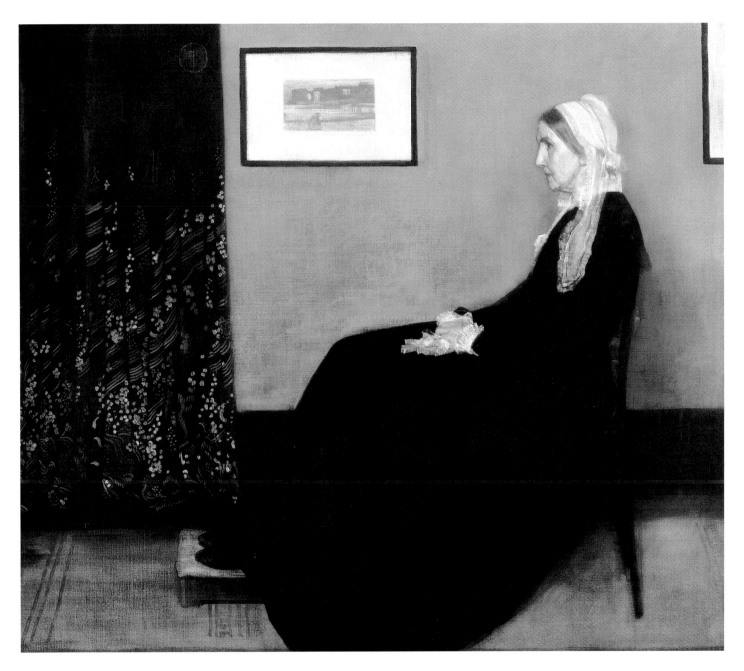

Fig. 27 THOMAS SHOTTER BOYS (1803–1874), VIEW OF THE LOUVRE: FLORE PAVILION, photograph

Fig. 28 JAMES MCNEILL WHISTLER (1834–1903), ARRANGEMENT IN GRAY AND BLACK NO 1: PORTRAIT OF THE PAINTER'S MOTHER, oil on canvas, 1871, 64 1/4 x 59 3/4 in., Musée d'Orsay, Paris

along with images of its lavish interior and imposing exterior, were accessible as never before (fig. 27). Interestingly, the development of copy photographs for paintings depended on reproductive engravings. As Louvre curator Frédéric Villot noted in 1866, photographing actual paintings was impractical due to varnish reflections and the difficulties of accurately expressing tonal values: yellows, reds, and greens appeared in early monochrome photographs as black spots, while blues were rendered almost as white.[9] Photographing engravings and drawings, however, yielded legible images in which subtle gradations of tone were clearly conveyed by varied density of black lines in relation to white paper.

Improvements in technology soon overcame the early challenges of photographing actual paintings. In 1883, Braun and Company, France's leading photographic firm, which had accumulated a huge collection of carbon photographic prints of artworks from the great museum collections of Western Europe, negotiated an exclusive contract (which it held until 1920) to photograph the Louvre's collections; from a room in the museum adjacent to the Salon Carré, considered the palace's premier gallery space, the firm sold copies for an affordable 8 francs each. The earlier ornamental photographic art reproduction, mounted on board and embellished with engraved gold trim and lettering, gave way to the fashionable *carte de visite* and stereoscopic card (fig. 29). By the mid-1860s, official catalogues of copy photographs listed over one thousand titles, enabling ordinary individuals to obtain reproductions of their favorite works of art from the Louvre.

Catalogues of copy photographs facilitated an international trade that targeted art-related shops, libraries with photography collections, and private individuals. An 1869 Braun inventory shows that two of their largest orders were from Americans, Charles Pollock of Boston and Charles Haseltine of Philadelphia. By the end of the century, the French firm of Goupil, Vibert and Company, which had opened a New York branch in 1849 to sell European prints, capitalized on the popularity of photography, offering over 802 items in one catalogue.[10] While satisfying the needs of both American armchair travelers and actual tourists, these early copy photographs often disappointed artists and art students because of their technical limitations. The professional usefulness of photographic reproductions of art was transformed by the introduction of the so-called lantern slide by Philadelphia daguerreotypists William and Frederick Langenheim in 1850. By printing the negative onto another sheet of glass rather than paper, they created a transparent positive image suitable for projection. The copy photograph thus was no longer limited to a small scale that could be viewed only by a single individual. Projected lantern slides modernized the dynamics of lectures, benefiting especially such visual disciplines as the history of art and architectural studies.

These black-and-white engravings and photographs remained deficient in two important aspects: color and scale. Boston colonial artist Smibert included hand-painted engravings in his repertoire of study materials, and New York collector Reed in the 1830s owned painted copies after the old masters to aid his imagination in translating

reproductive engravings into colorful pictures. Exhibitions continuing into the 1870s at the Boston Athenaeum's art gallery displayed the Gray collection of reproductive engravings as well as Thomas Dowse's collection of watercolor copies of old master paintings. Painted copies provided the necessary corrective of color, and sometimes scale, to reproductive prints. However, more sophisticated art-loving Americans knew that copyists often altered the scale of original paintings in their copies and took liberties with composition as well. By the 1870s, the appeal of painted copies and engraved reproductive prints after renowned old masters diminished for American collectors as transatlantic crossings multiplied and acquiring modern French art became fashionable (see the essay "Reactions to a French Role in Nineteenth-Century American Art").

But for artists, sketching and painting copies of masterworks in the Louvre remained an essential component of their education. In a humorous drawing, realist artist Winslow Homer captured one of the most distinguishing aspects of the Louvre experience: copyists painting in the galleries (fig. 30). Published in a January 1868 issue of the widely circulated magazine *Harper's Weekly*, the engraving accompanied a brief article that announced, "The gallery of the Louvre is a splendid studio."[11] Homer's amusing focus on the Grand Gallery's female copyists and his caricature of the "bohemian" male artists behind them was a familiar trope for the magazine's urbane audience. Nevertheless he hints at a more serious topic—the camaraderie of students and professional

artists, many of whom savored their personal relationships and their bond with the Louvre's cadre of old masters.

Guidebooks that aided the English-speaking traveler in France proliferated after 1865, when the trickle of Americans arriving in Paris became a deluge. From its inception as a museum, the Louvre published and sold guides to its collections. Organized by national schools, these catalogues supplied brief biographical information on artists and descriptions of the paintings' subjects. The earliest tourist guidebooks advised purchasing these Louvre catalogues and limited themselves to descriptions of the museum's architectural decorations. Baedeker's popular *Handbook for Paris*, first published in English in 1865, broke with tradition and listed the museum's most celebrated works of art, marking them by relative importance to save the time and energy of the typically overwhelmed visitor. Noteworthy among the many published explications of the Louvre's masterworks was the erudite guide by Charles Eastlake, director of London's National Gallery, published in 1883; it was one of the first to be copiously illustrated so as to "aid the visitor in his observations on the spot and afterwards assist his memory in recalling the chief characteristics of style and treatment."[12] Anticipating the first visit to the Louvre could be as simple as referring to a basic travel handbook or as demanding as years of artistic study, but once in Paris, the visitor taking in his first view of the Louvre's facade quickly moved from speculation to experience.

Fig. 29 Hippolyte Jouvin (1852–1887), **Venus de Milo**, stereoscopic view, 6 3/4 x 3 1/2 in., Département des Estampes et de la Photographie, Bibliothèque Nationale de France, Paris

LOUVRE AS EXPERIENCE

Many Americans expected to feel on familiar terms with the Louvre thanks to prints, photographs, or descriptive texts, but their first visit was always an awakening. Boston Brahmin Charles Sumner's emotional reaction to the Louvre keenly portrays the limitations of American cultural life in the 1830s: "You can imagine my feelings in such a scene as I passed through [the Louvre] to-day, when you think that Mr. Sears's house was my type of a palace, the Athenaeum Gallery, of a collection of paintings, and the plaster casts in the Athenaeum reading-room and Felton's study, of a collection of antiques."[13] Among the revelations of the Louvre's collections, the effects of color and scale are noted repeatedly in Americans' records of their first impressions of the museum. As an example of the conse-quences of the unaccustomed riot of color, an 1825 guidebook warned the prospective visitor that "he will feel overpowered by a confused sensation of dizziness, produced by the rapid transition before the aching vision of so many different sorts of bright colors and shades."[14] A generation later, Reverend Henry Ward Beecher, accustomed to the scale of cathedrals during his European travels, noted his astonishment at the effect of the Louvre's huge pictures: "Large canvas conveys something which is more than mere figures—there is a sense of reality of things of life-size, or even greater than nature, which does not belong to and can not be conveyed by under-sizes."[15]

Critically, it was not just the works of art that inspired this ecstasy over color and scale: the complex of buildings that com-prised the Louvre was incomparable to any structure in America. Writing to her stu-dents, New England schoolmistress Emma Willard cautioned that familiar reproduc-tions of the Louvre did not convey its actual scale.[16] Travel writer N. P. Willis echoed the centrality of the Louvre in any Parisian excursion and expanded on the physical dimensions and splendor of the museum: "Truly, for one who has been accustomed to convenient dimensions only, its breath, its lofty ceilings, its pillars and statuary, its mosaic pavements and splendid windows, are enough to unsettle for the standards of size and grandeur."[17] Harriet Beecher Stowe, Reverend Beecher's sister and author of the phenomenal bestseller *Uncle Tom's Cabin* (1852), deftly articulated the Louvre effect when she recorded her own reaction on her first visit to the vast museum. Despite her preparation, Stowe was sensually overwhelmed as anticipation met experience: "To one who has starved all a life, in vain imaginings of what art might be, to know that you are within a stone's throw of a museum full of miracles . . . it was, then, with a thrill almost of awe that I approached the Louvre . . . The ascent to the picture gallery tends to produce a flutter of excitement and expectations . . . and prepare the mind for some grand enchantment."[18] Stowe's overripe account stands in stark contrast to the feeble guide-book clichés that appear in the diaries of

Fig. 30 Winslow Homer (1836–1910), **Art Students and Copyists in the Louvre Gallery**, 1868, wood engraving on paper, 9 x 13 3/4 in., Bowdoin College Museum of Art, Brunswick, Maine, museum purchase, Hamlind Fund

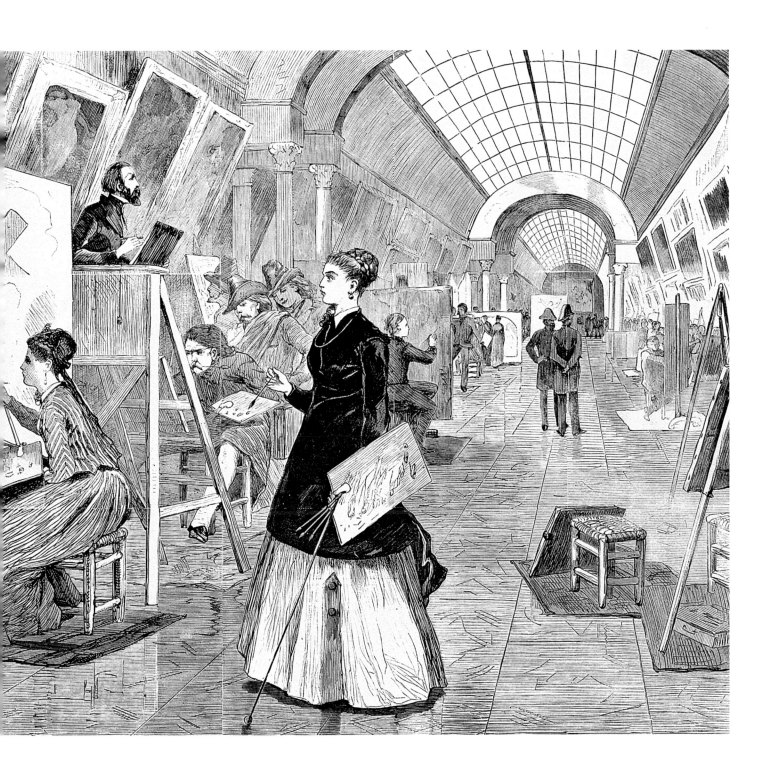

CAT. 7

CAT. 9

CAT. 7 REMBRANDT PEALE (1778–1860), JACQUES LOUIS DAVID, 1810,
oil on canvas, 28 3/4 x 23 1/4 in., Pennsylvania Academy of the Fine Arts, Philadelphia

CAT. 9 REMBRANDT PEALE (1778–1860), DOMINIQUE VIVANT DENON, 1808, oil on canvas, 28 3/4 x 23 1/4 in.,
Pennsylvania Academy of the Fine Arts, Philadelphia

fatigued tourists. Not surprisingly, artists, in their shared experience of artistic instruction, describe a similar version of the Louvre effect that was in accord with their professional training.

AMERICAN ART ACADEMIES

Before the middle of the nineteenth century, Paris was rarely an art destination for Americans. Many, however, were sympathetic to the ideals of the French Revolution and fascinated by Napoleon Bonaparte's subsequent military and political triumphs. In particular, the Napoleonic era's transformation of the Louvre from a royal residence to a public museum enthralled many Americans. The emergence of the Louvre as an art museum with a democratic identity is associated with the political upheaval of both the French Revolution (1789–99) and the Napoleonic Wars (1800–15). Not only was France affected as paintings, sculpture, and decorative arts were appropriated from royal residences and churches to form a new national collection, but also the European art world was turned upside down by the French army's systematic plunder of other nations' artistic patrimonies. Dominique Vivant Denon (cat. 9), director of the Louvre under Napoleon, justified the international looting of masterworks as a mission to save them from neglect by applying French expertise in art restoration. Undeniably, the Louvre established a new paradigm for viewing centuries-old art by its aggressive restoration policy of removing accumulated surface grime (and sometimes, unfortunately, original surfaces as well). Much to the delight of visitors, especially artists and connoisseurs, the newly cleaned and conserved paintings, their brightness and clarity restored, were astonishingly colorful.

As Europe's first public art museum, the Louvre modernized the display of its collection by implementing the now-standard arrangement of works in chronological order within national schools. The Louvre's "scientific" approach won over the usual "aesthetic comparison" mode of placement

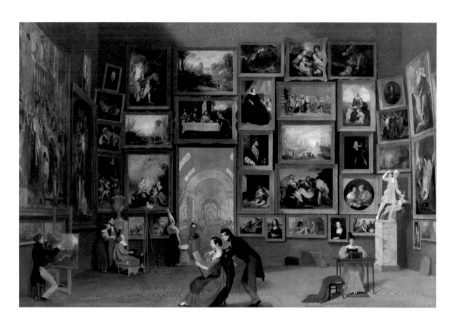

CAT. 1 SAMUEL F. B. MORSE (1791–1872), **GALLERY OF THE LOUVRE**, 1831–33, oil on canvas,
73 3/4 x 108 in.,Terra Foundation for American Art, Daniel J. Terra Collection, Chicago

because it was considered more effective in conveying the history of art and the evolution of stylistic advancements.[19] While other nations could jealously compare their art museum, usually a transformed royal collection, to the French museum, American visitors, with no such institution of their own, proclaimed the Louvre the quintessential art museum because of the authenticity and restored condition of its collections, the enchantingly palatial setting its vast buildings provided, and its modern display practice.

The Louvre's debut as an art museum on August 10, 1793, coincided with the opening within its walls of an annual display of contemporary art, formerly the official exhi-

bition of the Académie Royale de Peinture et de Sculpture. Between 1725 and 1848, the Salon Carré became the site of this popular event, its prestige reflected in the simple designation "the Salon." Previously only academy members were allowed to exhibit, but after 1791 a new jury system permitted outsiders, including foreign artists, to submit their works. Neoclassical painter and political revolutionary Jacques Louis David (1748–1825; cat. 7) was adamant about maintaining the critical link between the Louvre's collection and contemporary artists. "The museum is not supposed to be a vain assemblage of frivolous luxury objects that serve only to satisfy idle curiosity," he declared. "What it must be is an imposing

school."[20] David's demand became policy, and only artists or foreigners were allowed unlimited entry during official hours. For zealous republicans, the extraordinary relationship between artists and the Louvre exemplified democratic principles, specifically the notion of a classless citizenry learning taste and practicing deportment from their gallery experience of viewing the icons of Western civilization.

While in Paris negotiating the Louisiana Purchase, Robert R. Livingston, President Thomas Jefferson's Minister to France, experienced the Louvre's refurbished galleries and wrote to his brother Edward, the mayor of New York, proposing the acquisition of plaster casts of works in the Louvre's

famous collection of antiquities as the core of an art academy. In 1802, the founders of the newly organized American Academy of Fine Arts in New York demonstrated remarkable diplomatic savvy by inviting the First Consul of the French Republic to become the institution's first honorary member. Graciously accepting the honor, Napoleon gave the school twenty-four bound volumes of engravings by Italian etcher and architect Giovanni Battista Piranesi (1720–1778) and a number of books on drawing. Three years later, the Pennsylvania Academy of the Fine Arts in Philadelphia, the former capital of the new republic, also ordered casts from the Louvre's collection of antique statuary and petitioned France for official recognition, yielding a similar gift of Piranesi engravings from Napoleon, now Emperor of France.[21] Clearly, fledgling American art academies were concerned to acquire the imprimatur of the Louvre.

The nascent American art schools willingly adapted the educational program of the École des Beaux-Arts in Paris, but yearned for the autonomy of the English artists, who managed the Royal Academy of Arts in London. For American artists struggling to define their role in a democratic culture,[22] the plaster casts of antique statuary embodied the prestige of the Louvre and the beneficial relationship of its collection to artists. Yet dissatisfaction with the lackluster operation of the New York academy and its dismissive attitude toward artists provoked the 1825 founding of a rival institution, the still-operational National Academy of Design. Under the guidance of its first president, painter Samuel F. B. Morse, the artist-managed academy reaffirmed the relationship between the development of a national art and the great heritage of the past embodied in the Louvre's collections. There is no more telling demonstration of the Louvre's enormous impact on American academies' pedagogical agenda than Morse's masterwork, *Gallery of the Louvre* (cat. 1; see the essay "American Artists, the July Revolution, and the Making of National Identity"), which elucidates the ideal of the academy-museum tie.

AMERICAN MUSEUMS

Authentic old master paintings seemed unobtainable in 1870 when Boston Brahmin Charles C. Perkins lamented that a "Louvre is out of our reach."[23] Yet only a decade before there was insufficient interest in two important collections of genuine old master paintings, both formulated on the example of the Louvre's installation. Thomas Jefferson Bryan arduously amassed his "Gallery of Christian Art," designed to illustrate the various schools of art from the thirteenth to the eighteenth centuries, after

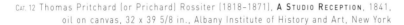

CAT. 12 Thomas Pritchard (or Prichard) Rossiter (1818–1871), **A STUDIO RECEPTION**, 1841, oil on canvas, 32 x 39 5/8 in., Albany Institute of History and Art, New York

FIG. 31 **MAIN STAIRWAY OF THE METROPOLITAN MUSEUM OF ART**, photographed in 1944, The Metropolitan Museumof Art, New York. Photograph, all rights reserved, The Metropolitan Museum of Art

years spent in Paris under the influence of the Louvre. Following what he described as a life-transforming first visit to the Louvre in 1851, Boston native James Jackson Jarves collected Italian primitive paintings from the twelfth through fifteenth centuries. Rejected by the cities of New York and Philadelphia, Bryan's collection was dismissed as merely educational and ultimately was bequeathed to the New-York Historical Society. Cosmopolitan writer Henry James voiced fellow Bostonians' contempt of Jarves's paintings as portraying "ugly Madonnas and uglier babies, strange prayers and prostrations." After numerous failures to place his collection, Jarves eventually sold it to Yale University.[24] There were many reasons why cities declined to acquire these European old masters—among them, lingering suspicions about the authenticity of old master works, anti-Catholic sentiment prevalent in America, and preferences for "secularized" Christian imagery. The immediate rationale for rejecting these valuable collections inspired by the Louvre, however, was the lack of an actual museum building and an influential board of trustees.

Civic inertia finally ended with a call to action from Paris in 1865: at the American expatriates' customary Fourth of July dinner, John Jay, grandson and namesake of America's celebrated chief justice, proposed that it was "time for the American people to lay the foundations of a National Institution and Gallery of Art."[25] Five years later, the Metropolitan Museum of Art, the American Louvre, was born in New York. By the turn of the century, America's latter-day Medici princes had adopted the mantle of cultural stewardship as art collectors. They memorialized themselves in highly visible bequests to local museums, and the New York museum benefited more than most. As late as 1944, the Metropolitan Museum paid homage to the Louvre by "quoting" its dramatic grand staircase (fig. 31). The New York museum's preference for old master paintings and antiquities directly affected artists. The Metropolitan was indifferent not only to acquiring contemporary art but also to a direct relationship with contemporary artists. The disassociation between the city's art academy and its major art museum was a substantial departure from the Louvre's example of museum-as-academy, one not followed in other American cities, such as Boston and Chicago, where art schools were one with art museums. It is no wonder that American artists venerated the Louvre: the French museum actively encouraged contemporary painters to see themselves as a part of the Western art tradition on view in its galleries, while New York's influential art museum ignored them.

AMERICAN ARTISTS

New York painter John Vanderlyn was the first American to enroll at the Ecole des Beaux-Arts and the first to see his paintings hung in the Louvre, where they were included in the Salon of 1800 (see the essay "American Artists in France Before the Civil War"). By mid-century, artists began to gather in Paris as part of their studies abroad, and a significant number became a part of an American expatriate community (cat. 12). American artists' preparation in anticipation of their first transatlantic voyage included reading treatises on art theory and records of their compatriots' Louvre experiences, notably those in William Dunlap's (1766–1839) pioneering 1834 compilation of biographies of American artists. Boston painter Washington Allston (1779–1843) recalled for Dunlap his impressions of the dazzling colors of paintings in the Louvre, many of them recently cleaned and restored during the Napoleonic era's conservation agenda; as Allston recalled, "[they] absolutely enchanted me, for they took away all sense of subject . . . It was the poetry of color which I felt."[26] Other eyewitnesses also reminisced about the Louvre by describing the ambiance of the galleries. Writing after the 1830 renovation of the Louvre's interior, Rembrandt Peale marveled at its splendor: "This whole series of halls is indeed in a style of magnificence surpassing any conception . . . architectural skill, by means of columns, pilasters, arches, walls of marble and porphery [sic], carved, and painted ceilings, panels of basso relievo, pedestals, statues, vases, candelabra, sphinxes, busts and mosaics."[27] Whether immortalized in biographies of the notable, letters home, or even artist gossip, the anticipatory aspect of the Louvre effect gained momentum among the growing brotherhood of American artists as such accounts proliferated. The resulting sense of expectation could only be satisfied by an art pilgrimage to Paris.[28]

Improved opportunities for art education in America meant that students enjoyed excellent instruction at home, but no

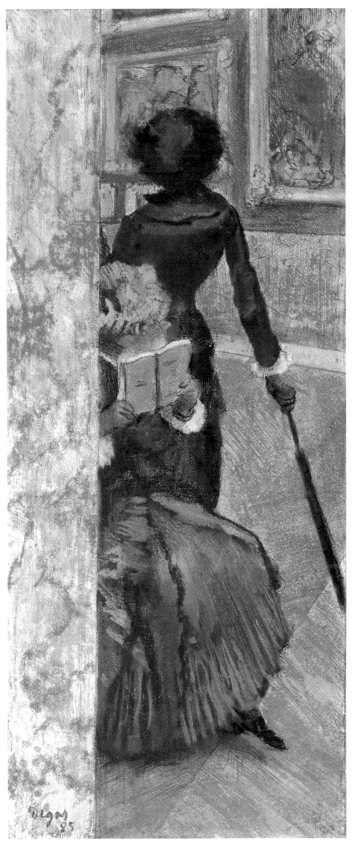

FIG. 32 EDGAR DEGAS (1834–1917), MARY CASSATT AT THE LOUVRE: THE PAINTING
GALLERY, 1879–80, etching, aquatint, drypoint, and electric crayon, heightened
with pastel, on tan wove paper, 12 x 5 in., The Art Institute of Chicago,
Chicago, bequest of Kate L. Brewster

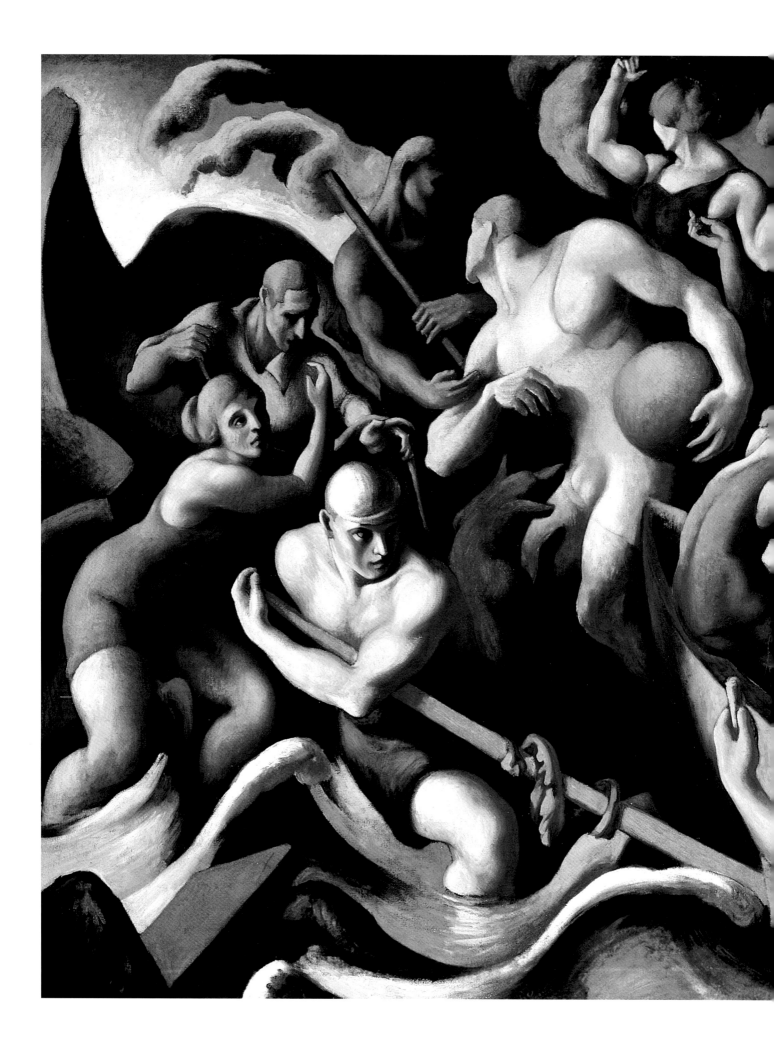

domestic city had the richness of Paris's artistic life. According to Boston landscape painter Christopher Cranch (1813–1892), "The general effect of Paris, taken through an artist's eye, and into an artist's brain, is to educate that eye and brain, as our American life cannot . . . Then he has the Louvre, which he can enter at any time, and if he chooses, study and copy in."[29] The Louvre was not the only attraction for artists in Paris, observed critic Henry T. Tuckerman: "Galleries, studios, lectures, models, criticism, illustrious men, noble examples, friendly words, and true companionship, made his daily life, independent of its achievements, one of self-respect, of growing knowledge, and assured satisfaction."[30]

Even for avant-garde artists, who challenged the rigidity of academic standards in the third quarter of the nineteenth century, the aura of the Louvre and its collections remained. This is clear in *Mary Cassatt at the Louvre: The Painting Gallery* (fig. 32), in which French Impressionist Edgar Degas (1834–1917) portrayed his friend, American expatriate artist Mary Cassatt, studying paintings in the Louvre, a site that both artists returned to repeatedly for stimulation. In Paris in the first decade of the twentieth century, painter Thomas Hart Benton suggestively incorporated a sculptural icon of the Louvre, Michelangelo's *Dying Slave* (1513–15), into his modernist exploration of color theory in *People of Chilmark* (fig. 33). As art historian Lois Fink has argued, many American artists found the antique sculptural heritage and the European art canon both an inspiration and a burden as they sought to create their own works worthy of the grand tradition.[31] Contemporary with Benton's

painting, artist Will Hickok Low (1853–1932) recounted in detail the continuing relevance of the Louvre for American artists:

"Each time that I entered the Louvre, I hastened down the long corridor drawn as though by a magnet to the supreme beauty of this noble work [the Venus de Milo]; of which no plaster replica gives more than a superficial aspect of the original marble . . . [seeing the great Venetian canvases] is an experience for which no previous study of photographs from the original fully prepares you, and is one that the more often you repeat it grows the more in value. These were indeed brave days of youth when the Louvre was new, but I have the testimony of others to add to my own conviction that with each successive visit these works became more precious, more influential, more absolutely necessary to the well-being of the artist, young or old, no matter what may be the aim or the scope of his efforts."[32]

Anticipation and memory are essential elements in the formation of the Louvre effect, but the sensual encounter with the genuine work of art was the transformative moment for artists, not just once but every time they entered the galleries of the Louvre.

CONCLUSION

Distance was never an obstacle in American artists' determination to forge a bond with the legacy of the Louvre. Each generation brewed a heady elixir of anticipation, experience, and memory, distilling for itself a particular Louvre effect. Operating as an unofficial academy,

the Louvre had an immeasurable impact on American artistic training on a practical level through its generous copying policies and, equally significant, as an ideal that affirmed artists' consciousness of their role in art history. Lecturing before art students at the Metropolitan Museum in 1893, revered cosmopolitan artist John La Farge (1835–1910) sagely described art as "composed of memories and effected by them."[33] Intentionally or not, American artists formed a reservoir of images during those cherished hours spent in the company of old and modern masters—reminiscences, infused with a Louvre effect, that were essential to the creation of their art.

By the late nineteenth century the infrastructure of American art education had changed significantly: art schools offered an excellent education grounded in academic fundamentals; museums were rapidly acquiring troves of old and modern masterworks; and modernist attitudes were winning converts, albeit slowly, among an increasingly urbane American art audience. None of these changes, not even the rise of New York as the center of modern art after 1945, affected Americans' addiction to Paris. As a monument of stability within the artistic turmoil of the past two hundred years, the Louvre was and is American artists' first stop on their art pilgrimages abroad. For some, perhaps, it is an obligatory destination; for most, a visit to the Louvre is made in homage to the canonical heroes of art history and to the museum's legendary support of artistic education. Even today, artists and art students are affected by the awesome association of anticipation and imminent

experience expressed by one first-time witness to the Louvre, who wrote almost two centuries ago of his "delight not unmixed with anxiety, lest overwrought expectation should lead to disappointment. I ought perhaps to be ashamed of the trem- bling veneration with which I entered, but it was not a moment for a zealous lover of the arts to be exactly in his senses; nor will I believe that any person who approaches the Louvre without emotion can fully enjoy the treasures it contains."[34]

[1] Letter dated October 17, 1792, quoted in Donald Sassoon, *Mona Lisa: The History of the World's Most Famous Painting* (New York: Harper Collins, 2001): 47. The definitive source on the history of the Louvre as a museum is David Andrew McClellan, *Inventing the Louvre: Art, Politics, and the Origins of the Modern Museum in Eighteenth-Century Paris* (Berkeley: University of California Press, 1994).

[2] Kenyon Cox, *The Classic Point of View* (New York, 1911), quoted in Lois Marie Fink, "The Innovation of Tradition in Late Nineteenth-Century American Art," *The American Art Journal* 10:2 (November 1978): 65.

[3] Whistler's painting was shown at the Luxembourg Gallery where works by living artists were exhibited. A work of art was allowed to be transferred to the Louvre ten years after an artist's death.

[4] One of the best introductions to the nuances of the American art world before 1850 is Ella M. Foshay, *Mr. Lumen Reed's Picture Gallery: A Pioneer Collection of American Art* (New York: Abrams, 1990). For an overview of Americans' preparation for travel abroad see Harvey Levenstein, *Seductive Journey: American Tourists in France from Jefferson to the Jazz Age* (Chicago: University of Chicago Press, 1998).

[5] David Alan Brown, *Raphael and America* (Washington, D.C.: National Gallery of Art, 1983).

[6] Critic quoted in Foshay, *Mr. Lumen Reed's Picture Gallery*, 41.

[7] For an overview of the Louvre's print sales shop see Françoise Viatte, "La chalcographie du Louvre d'hier à aujourd'hui," *Nouvelles de l'estampe* 148 (October 1996): 43–46.

[8] The context of collecting reproductive engravings in America is provided by Marjorie B. Cohn, *Francis Calley Gray and Art Collecting for America* (Cambridge: Harvard University Press, 1986). Gray's collection was donated to Harvard University in 1857.

[9] See Elizabeth Anne McCauley, *Industrial Madness: Commercial Photography in Paris, 1848-1871* (New Haven: Yale University, 1994): 285. The copy photographs of contemporary art, shot before varnishing, were technically successful and very popular.

[10] Hélène Lafont-Couturier, "Mr. Gérôme Works for Goupil," *Gérôme & Goupil: Art & Enterprise* (Paris: Editions de la Réunion des Musées Nationaux, 2000): 13–29.

[11] "The Gallery of the Louvre," *Harper's Weekly* 12:576 (January 11, 1868): 25.

[12] Charles L. Eastlake, *Notes on the Principal Pictures in The Louvre Gallery at Paris* (London: Longmans, 1883): v.

[13] Edward L. Pierce, *Memoir and Letters of Charles Sumner, 1811-1838* (Boston: Roberts Bros., 1881): 236.

[14] Zacharias Allen, *The Practical Tourist or Sketches of the State of the Useful Arts, and of Society, Scenery, etc. in Great Britain, France, and Holland* (Boston: Richardson, Lord, and Holbrook, 1832): 51.

[15] Henry Ward Beecher, *Star Papers: Experiences of Art and Nature* (New York: J. C. Derby, 1855): 68.

[16] Emma Willard, *Journals and Letters from France and Great Britain* (Troy, New York: N. Tuttle, 1833).

[17] N. P. Willis, *Pencillings By the Way: Written During Some Years of Residence and Travel in Europe* (New York: Charles Scribner, 1852): 40.

[18] Harriet Beecher Stowe, *Sunny Memories of Foreign Lands* (Boston: Phillips, Sampson, 1856): 159–60.

[19] See McClellan for an in-depth explanation of the merits of the aesthetic versus the scientific methodology in displaying paintings.

[20] David in 1794, quoted in McClellan, *Inventing the Louvre*, 91.

[21] For the establishment of American art academies see Eliot Clark, *History of the National Academy of Design, 1825-1953* (New York: Columbia University Press, 1954); Theodore Sizer, Introduction to Mary Bartlett Cowdrey, *American Academy of Fine Arts and American Art-Union, 1816-1852* (New York: The New-York Historical Society, 1953); Lois Marie Fink and Joshua C. Taylor, *Academy: The Academic Tradition in American Art* (Washington D.C.: Smithsonian Institution Press, 1975); and Frank H. Goodyear, Jr., *In This Academy: The Pennsylvania Academy of the Fine Arts, 1805-1976* (Philadelphia: Pennsylvania Academy of the Fine Arts, 1976).

[22] For an analysis of the role of artists in early American society see Neil Harris, *The Artist in American Society: The Formative Years, 1790-1860* (1966; Chicago: University of Chicago Press, 1982).

[23] Quoted in Lillian B. Miller, *Patrons and Patriotism: The Encouragement of the Fine Arts in the United States, 1790–1860* (Chicago: University of Chicago Press, 1966): 220.

[24] For the history of the Bryan and Jarves collections see Lillian B. Miller, "'An Influence in the Air': Italian Art and American Taste in the Mid-Nineteenth Century," in *The Italian Presence in American Art, 1760-1860* (New York: Fordham University Press, 1989): 26–52.

[25] Calvin Tomkins, *Merchants and Masterpieces: The Story of the Metropolitan Museum of Art* (New York: E. P. Dutton, 1970): 28.

[26] Quoted in James Thomas Flexner, Introduction to William Dunlap, *A History of the Rise and Progress of the Arts of Design in the United States*, fac. ed. (1834; New York: Dover Publications, 1969) I:XIV.

[27] Rembrandt Peale, *Notes on Italy: Written During a Tour in the Years 1829 and 1830* (Philadelphia: Carey & Lea, 1831): 16.

[28] For the significance of Paris as part of an American artist's portfolio see Lois Marie Fink, "American Artists in France, 1850–1870," *American Art Journal* 5:2 (November 1973): 32–49; Lois Marie Fink, *American Art at the Nineteenth-Century Paris Salons* (Washington, D.C.: National Museum of American Art, 1990), and H. Barbara Weinberg, *The Lure of Paris, Nineteenth-Century Painters and Their French Teachers* (New York: Abbeville Press, 1991).

[29] Quoted in Lois Marie Fink, *The Role of France in American Art, 1850–1870* (Ph.D. diss, University of Chicago, 1970): 13–14.

[30] Henry T. Tuckerman, *Maga: Papers About Paris* (New York: Putnam, 1867): 70.

[31] Lois Marie Fink, "The Innovation of Tradition in Late Nineteenth-Century American Art," *The American Art Journal*, X, no. 2 (November 1978): 63.

[32] Will H. Low, *A Painter's Progress* (New York: Charles Scribner's Sons, 1910): 173–74 and 176.

[33] John La Farge, *Considerations on Painting: Lectures Given in the Year 1893 at the Metropolitan Museum of New York* (New York: Macmillan, 1901), quoted in Fink, "Innovation of Tradition," 64. For an in-depth analysis of the significance of studying the old masters, see Wayne Craven, "The Grand Manner in Early Nineteenth-Century American Painting: Borrowing from Antiquity, the Renaissance, and the Baroque," *The American Art Journal* (April 1979): 5–43.

[34] Henry Milton, *Letters on The Fine Arts Written from Paris in the Year 1815* (London: Longman, Hurst, Reed, Orme, and Brown, 1816): 3.

CATALOGUE

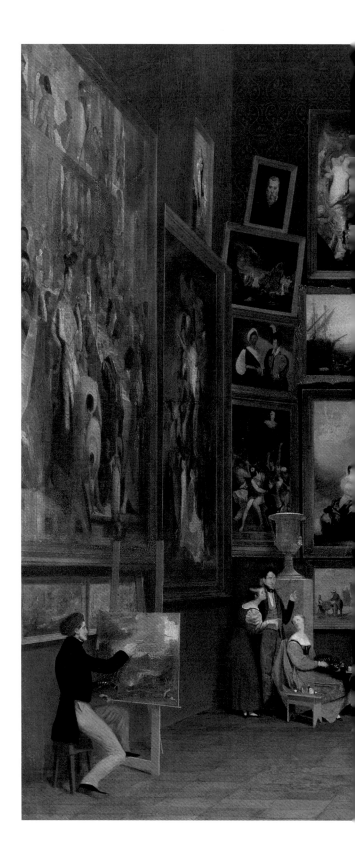

1 SAMUEL F. B. MORSE [CHARLESTOWN, MASS, 1791–NEW YORK, NY, 1872]

GALLERY OF THE LOUVRE, 1831–33
Oil on canvas
73 3/4 x 108 in. (187.3 x 274.3 cm)
Terra Foundation for American Art, Daniel J. Terra Collection, Chicago

Honored for his scientific inventions, most notably the "dots and dashes" telegraphic code that bears his name, Samuel Finley Breese Morse played a crucial part in defining the artist as a professional in early nineteenth-century America. Morse was instrumental in founding New York's National Academy of Design, serving as its first president between 1826 and 1845, and he was America's first professor of art history. Morse's cultural ambition inspired his *Gallery of the Louvre*, which expresses his belief in the importance of learning from "masterpieces." Going beyond mere documentation of the Louvre's collection, Morse's tour de force advocates the art museum as a force for cultural education.[1]

Appalled by the paintings by modern French masters he saw displayed in the Salon Carré, the Louvre's most prestigious gallery, Morse imagined an installation of thirty-eight actual masterworks of the Renaissance and Baroque eras. The main figure in the foreground is assuredly Morse, framed in the entrance to the Grande Galerie, instructing a young female copyist. James Fenimore Cooper, the artist's mentor in Paris and the author of the popular *Leatherstocking Tales*, stands beside his wife and daughter in the left corner of the gallery. Less certain are the identities of the male artist at his easel and the awestruck visitor with his hat in hand: they are thought to represent American artists Horatio Greenough (1805–1852) and Richard W. Habersham (1812–1889).[2] Through this remarkable tribute to the Louvre and its generous support of artistic education, Morse hoped to instruct his countrymen in the importance of the fine arts and to inspire future cultural achievements in the young democracy. While critically admired, the painting's complexities baffled its American audience.

[1] Paul J. Staiti, *Samuel F. B. Morse* (Cambridge and New York: Cambridge University Press, 1989): 175–206.
[2] David Tatham, "Samuel F. B. Morse's *Gallery of the Louvre*: The Figures in the Foreground." *The American Art Journal* 8:4 (Autumn 1981): 38–48.

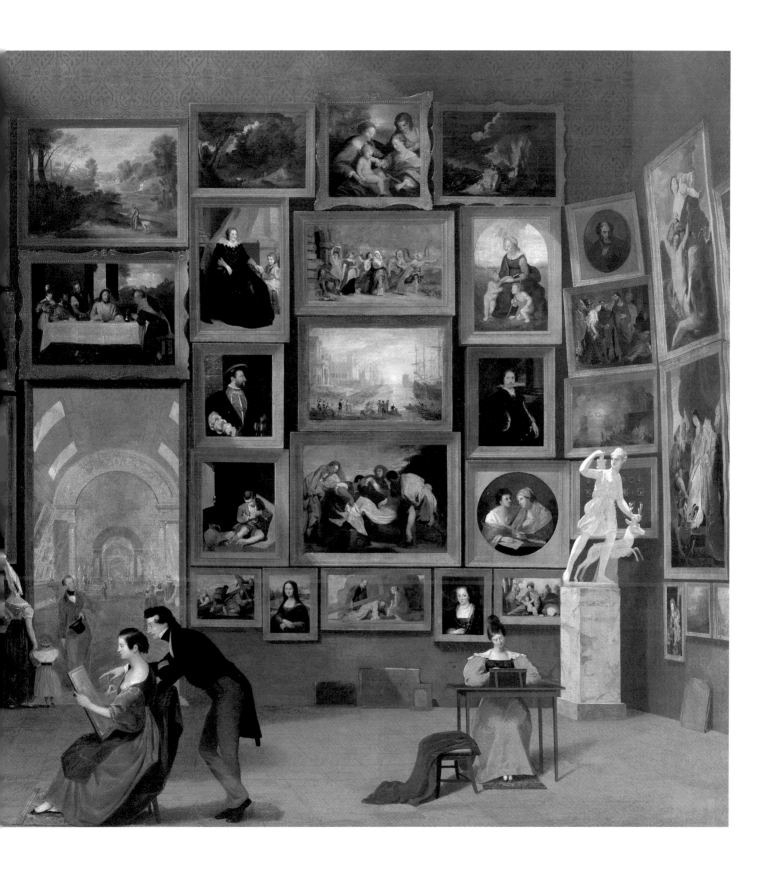

GALLERY OF THE LOUVRE, Samuel F. B. Morse

1. PAOLO CALIARI, known as VERONESE (1528-1588, Italian)
 THE WEDDING FEAST AT CANA
 INV. 142

2. BARTOLOMÉ ESTEBAN MURILLO (1618-1682, Spanish)
 THE IMMACULATE CONCEPTION
 M.I. 144

3. JEAN JOUVENET (1644-1717, French)
 DESCENT FROM THE CROSS
 INV. 5493

4. JACOPO ROBUSTI,
 known as TINTORETTO (1518-1594, Italian)
 SELF-PORTRAIT
 INV. 572

5. NICOLAS POUSSIN (1594-1665, French)
 WINTER, or THE DELUGE
 INV. 7306

6. MICHELANGELO MERISI known as CARAVAGGIO
 (ca. 1571-1610, Italian)
 THE FORTUNE-TELLER
 INV. 55

7. TIZIANO VECELLIO, known as TITIAN (1488/9-1576, Italian)
 THE CROWNING WITH THORNS
 INV. 748

8. ANTHONY VAN DYCK (1599-1641, Flemish)
 VENUS REQUESTING ARMS FOR AENEAS FROM VULCAN
 INV. 1234

9. CLAUDE GELLÉE, known as LE LORRAIN (ca. 1602-1682, French)
 THE LANDING OF CLEOPATRA AT TARSUS
 INV. 4716

10. BARTOLOMÉ ESTEBAN MURILLO (1618-1682, Spanish)
 THE HOLY FAMILY, known as THE VIRGIN OF SEVILLE
 INV. 930

11. DAVID II TENIERS, THE YOUNGER (1610-1690, Flemish)
 THE KNIFE-GRINDER
 INV. 1889

12. REMBRANDT HARMENSZ VAN RIJN,
 known as REMBRANDT (1606-1669, Dutch)
 THE ARCHANGEL RAPHAEL LEAVING THE FAMILY OF
 TOBIAS
 INV. 1736

13. NICOLAS POUSSIN (1594-1665, French)
 DIOGENES THROWING AWAY HIS BOWL
 INV. 7308

14. TIZIANO VECELLIO, known as TITIAN
 (1488/9-1576, Italian)
 THE SUPPER AT EMMAUS
 INV. 746

15. CORNELIS HUYSMANS (1648-1727, Flemish)
 BORDER OF A FOREST WITH WOODSMEN
 INV. 1379

16. ANTHONY VAN DYCK (1599-1641, Flemish)
 PORTRAIT OF A LADY OF QUALITY AND HER DAUGHTER
 INV. 1243

17. TIZIANO VECELLIO, known as TITIAN
 (1488/9-1576, Italian)
 FRANCIS I
 INV. 753

18. BARTOLOMÉ ESTEBAN MURILLO (1618-1682, Spanish)
 THE YOUNG BEGGAR
 INV. 933

19. PAOLO CALIARI, known as VERONESE
 (1528-1588, Italian) and workshop
 JESUS FALLING UNDER THE WEIGHT OF THE CROSS
 INV. 144

20. LEONARDO DA VINCI (1452-1519, Italian)
 MONA LISA
 INV. 779

21. ANTONIO ALLEGRI, known as CORREGGIO
 (1489 ?-1534, Italian)
 THE MYSTICAL MARRIAGE OF ST CATHERINE OF
 ALEXANDRIA, WITH ST. SEBASTIAN
 INV. 41

22. PETER PAUL RUBENS (1577-1640, Flemish)
 LOT AND HIS FAMILY LEAVING SODOM
 INV. 1760

23. CLAUDE GELLÉE, known as LE LORRAIN
 (ca. 1602-1682, French)
 SEA PORT WITH SETTING SUN
 INV. 4715

24. TIZIANO VECELLIO, known as TITIAN (1488/9-1576, Italian)
 THE ENTOMBMENT
 INV. 749

25. EUSTACHE LE SUEUR (1616-1655, French)
 JESUS CARRYING HIS CROSS
 INV. 8016

26. SALVATORE ROSA (1615-1673, Italian)
 ROCKY LANDSCAPE WITH A HUNTER AND WARRIORS
 INV. 586

27. RAFFAELLO SANTI OR SANZIO, known as RAPHAEL (1483-1520, Italian)
 VIRGIN AND CHILD WITH ST. JOHN THE BAPTIST
 AS A CHILD, known as LA BELLE JARDINIÈRE
 INV. 602

28. ANTHONY VAN DYCK (1599-1641, Flemish)
 GENTLEMAN WITH A SWORD (the painter
 Paul de Vos (1595-1678)?)
 INV. 1248

29. GUIDO RENI (1573-1642, Italian)
 THE UNION OF DRAWING AND COLOR
 INV. 534

30. PETER PAUL RUBENS (1577-1640, Flemish)
 SUZANNE FOURMENT (1599-1643)
 INV. 1796

31. SIMONE CANTARINI, known as IL PESARESE (1612-1648, Italian)
 THE REST OF THE HOLY FAMILY
 INV. 175

32. REMBRANDT HARMENSZ VAN RIJN,
 known as REMBRANDT (1606-1669, Dutch)
 STUDY OF AN OLD MAN
 INV. 1748

33. ANTHONY VAN DYCK (1599-1641, Flemish)
 JESUS AND THE WOMAN TAKEN IN ADULTERY

34. JOSEPH VERNET (1714-1789, French)
 NIGHT, A SEA PORT IN THE MOONLIGHT
 INV. 8334

35. GUIDO RENI (1573-1642, Italian)
 DEJANIRA ABDUCTED BY THE CENTAUR NESSUS
 INV. 537

36. PETER PAUL RUBENS (1577-1640, Flemish)
 THOMYRIS WITH THE HEAD OF CYRUS
 INV. 1768

37. PIERRE MIGNARD (1612-1695, French)
 THE VIRGIN WITH THE BUNCH OF GRAPES
 INV. 6634

38. ANTOINE WATTEAU (1684-1721, French)
 PILGRIMAGE TO THE ISLE OF CYTHERA, traditionally
 known as L'EMBARQUEMENT POUR CYTHÈRE
 INV. 8525

39. Unidentified Greco-Roman vase

40. ARTEMIS WITH A HIND, known as "DIANE DE VERSAILLES"
 Roman, of the Imperial Period (1st-2nd century A.D.)
 M.R.152

41. Unidentified miniatures, perhaps of paintings
 or engraved gems

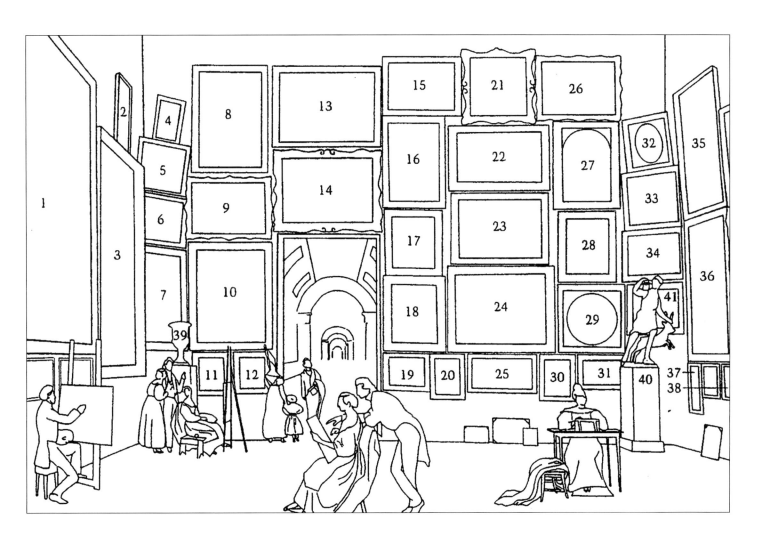

2 HENRY BENBRIDGE (PHILADELPHIA, PA, 1744-LONDON, 1812)

PASCAL PAOLI AND HIS STAFF AT THE BATTLE OF PONTE NOVU, 1769
Oil on canvas
41 1/3 x 33 1/2 in. (105 x 85 cm)
Musée Pascal Paoli, Morosaglia

Pascal Paoli and his Staff at the Battle of Ponte Novu claims an early place in the history of Franco-American artistic exchange. When Henry Benbridge painted it in 1769, the United States of America had not yet been proclaimed and Corsica had only been French territory for a few months. The work is especially important as a prophecy of the close association between American painters and the ideas of liberty and national independence: it commemorates the role of the ephemeral Corsican Republic as an inspiration for the War of American Independence. Until his death in 1807, Pascal Paoli was in fact one of the most famous incarnations of the political ideals of the Enlightenment, as demonstrated by the number of American towns and streets that bear his name. Liberator of Corsica from Genoese domination, he governed the island until 1769, installing a particularly democratic political regime. For the writing of its constitution he solicited the help of the most noteworthy jurists, and of Jean-Jacques Rousseau. Paoli's fame was largely eclipsed in France by the French Revolution, and then by Bonaparte and the succeeding regimes.

Benbridge's depiction of Paoli at the battle of Ponte Novu, which ended Corsican independence in 1769, anticipates the series of paintings by eighteenth-century American artists portraying defeated or dying military heroes: the large compositions by Benjamin West, John Singelton Copley, and John Trumbull of the deaths of Generals Wolfe and Chatham, Major Pierson, and the Chevalier Bayard.

Benbridge, a Philadelphian, went to Rome in 1765 and shared a studio there with the Irish sculptor Christopher Hewetson (1739–1799). In 1768, at the request of the Scotsman James Boswell, admirer and biographer of Paoli, he went to Corsica and painted several portraits of Paoli, in particular a full-length portrait that was exhibited with success in London, from which he painted some other versions (fig. 8).

Acquired in 1998 by the Musée Pascal Paoli, *Pascal Paoli and his Staff at the Battle of Ponte Novu* is part of the noteworthy collection housed at the hero's birthplace. It takes its place alongside portraits by Sir Thomas Lawrence (1769–1830) and Richard Cosway (1742–1821), and another recently acquired Benbridge portrait, a version of the large portrait shown in London in 1768.

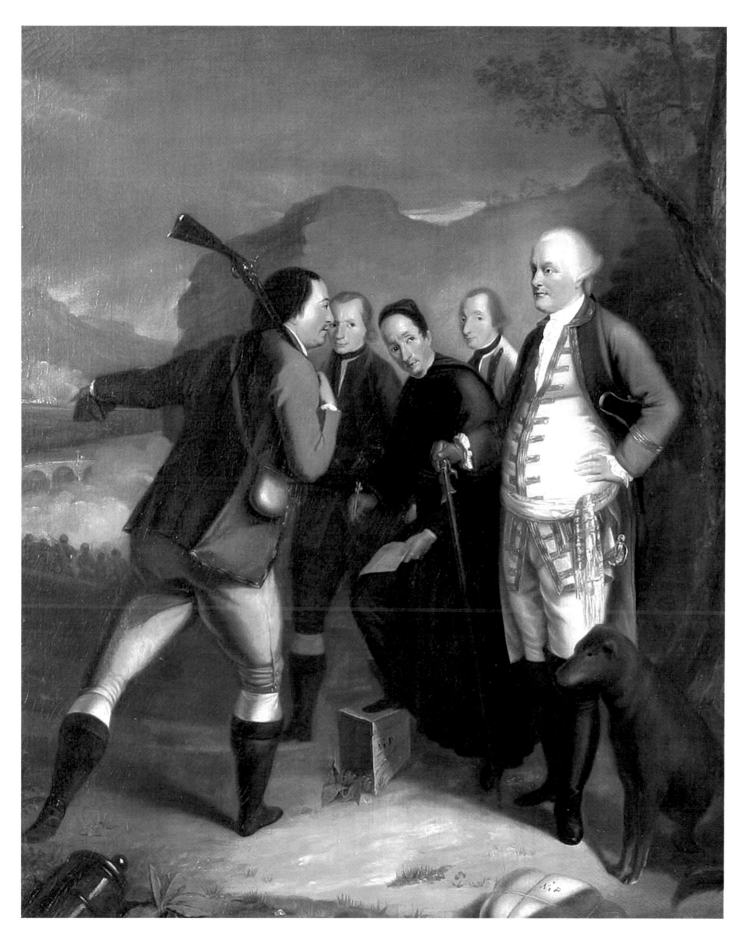

3 BENJAMIN WEST (SPRINGFIELD, PA, 1738–LONDON, 1820)

THE DEATH OF GENERAL WOLFE, 1770
Oil on canvas
59 1/2 x 84 in. (151 x 213.5 cm)
National Gallery of Canada, Ottawa
(Not part of the exhibition)

Although it celebrated a French defeat, American painter Benjamin West's composition paying homage to the victor of the Battle of Quebec was resoundingly successful in France.[1] James Wolfe, a young English general, died during the battle. His opponent, the French general the Marquis de Montcalm, suffered the same fate. To celebrate the British victory at Quebec, West created a painting whose daring composition was to influence history painting for some time to come. Treating a contemporary event with a grandeur usually reserved for themes from ancient history, the young artist of American origin successfully overthrew tradition: he depicted the protagonists in contemporary costume while celebrating the death of a hero by placing the young general in the position of Christ taken down from the cross. This innovative way of treating history, which exalted the idea of a nation not only to glorify kings but also to pay deference to those who die on battlefields, was immediately influential. With his images of contemporary heroes, West, a Quaker from Pennsylvania who later trained in Italy, overthrew convention less through a desire to break with tradition than through his own freedom from prejudices. French artists, under his influence and under the direction of Charles-Claude de La Billarderie, Comte d'Angiviller (1730–1809), rapidly took up the exaltation of their own national history. For example, West's *Death of the Chevalier Bayard* (1772, Royal Collection, Great Britain) may have influenced such artists as Nicolas-Guy Brenet (1728–1792) and Louis-Jacques Durameau (1733–1796), who respectively showed a *Death of Duguesclin* (Musée du Louvre) and a *Continence of Bayard* (Musée de Peinture et de Sculpture, Grenoble) in the 1777 Paris Salon.

Artistic influences may be difficult to prove concretely, and there is no doubt that the painting *The Death of General Wolfe* (1770, National Gallery of Canada, Ottawa) never came to France. The engraving by English printmaker William Woollett (1735–1785), however, was extremely popular from its first appearance in 1779. To illustrate this one need only cite an anonymous French print, an illicit reversed copy of Woollett's engraving, whose very title mixes French accents and English spelling: *The Death of Général Wolfe* (fig. 9). The engraving by Justus Chevillets (1729–1802) after the painting by François-Louis-Joseph Watteau of Lille (1758–1823) is even more remarkable. To glorify the death of Wolfe's adversary, the Marquis de Montcalm, at the same battle of Quebec, the French painter did not hesitate to create a true counterpart to West's painting by simply inverting his composition. As in West's painting, the hero is shown dying, surrounded by his officers, while an Indian kneels in an attitude of affection and respect.

Together with Gavin Hamilton (1723–1798), the Scottish Neoclassical painter active in Rome, West was incontestably one of Europe's most innovative artists during the period between 1760 and 1770. West's influence was widely felt, and his American origin was always present in the minds of the French. Several of his works, notably this painting and *William Penn's Treaty with the Indians* (1772, Pennsylvania Academy of the Fine Arts; fig. 6), contain clear references to America.

The very subject of the death of Wolfe, the arrangement of the composition, and even the Indian kneeling in the foreground are all marks of American identity, which reinforced the novelty of West's painting in the eyes of the French.

[1] See Helmut von Erffa and Allen Staley, *The Paintings of Benjamin West* (New Haven: Yale University Press, 1986), no. 93 to 100 for detailed information on the painting.

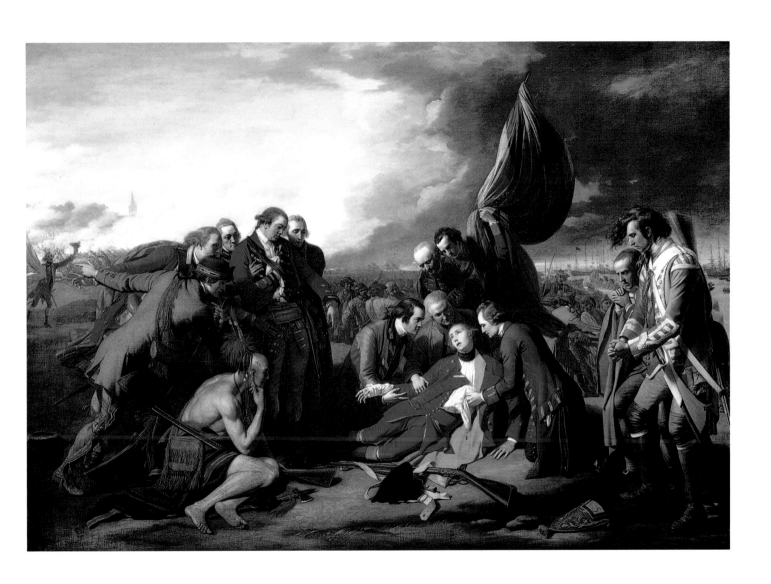

4 BENJAMIN WEST (SPRINGFIELD, PA, 1738-LONDON, 1820)

DEATH ON THE PALE HORSE, 1796
Oil on canvas
23 3/8 x 50 5/8 in. (59.5 x 128.5 cm)
Signed and dated *B. West 1796*
The Detroit Institute of Arts

When Benjamin West's painting *Death on the Pale Horse* was shown in the Paris Salon of 1802, it testified to the effect on the arts of the Peace of Amiens, recently signed between England and France.[1] At that time, politics and arts were closely intertwined. The presence of this work in the 1802 Salon aroused much controversy, not among the French—Napoleon Bonaparte came in person to congratulate West at length, speaking to him in Italian—but rather among the artist's English colleagues. Many of them thought that West never should have taken part in the exhibition. In addition, the president of the British Royal Academy, with all his authority and prestige, had agreed to write for the Muséum Central des Arts a report certifying that the works of art seized by Napoleon's army in Italy and displayed in the Louvre had not suffered from their transportation. Following the example of the First Consul, the French amply demonstrated their great respect for the "famous West," as he was named by the poet Joseph Lavallée during a banquet given in his honor. This admiration reached its height the following year, when an absolute majority of the Institut elected West a member on May 14, 1803.

In itself, *Death on the Pale Horse* surprised both West's fellow artists and his French admirers. Expecting something in the vein of the *Death of Hyacinth* or the *Death of General Wolfe*, they discovered a work that showed all the characteristics of the Romantic movement already triumphant in England and reflecting the Baroque influence of Peter Paul Rubens (1577–1640), contradicting the French canons of the time. Furthermore, its subject was a religious theme rarely evoked in French painting: the Apocalypse of John, commonly known as the Book of Revelation, which describes the end of the world in a battle between God and Satan before the eventual restoration of eternal peace. Followers of Jacques Louis David probably were disconcerted, but the Romantics, soon to be curbed by imperial taste, must have reveled in it. A few years later, on a preparatory sketch for the *Death of Sardanapalus* (1827, Musée du Louvre), Eugène Delacroix wrote: "One must study West's sketches."[2]

[1] See Helmut von Erffa and Allen Staley, *The Paintings of Benjamin West* (New Haven: Yale University Press, 1986): no. 403 for detailed information on the painting.
[2] E. Delacroix, *Étude pour* La Mort de Sardanapale, RF 5278.R.

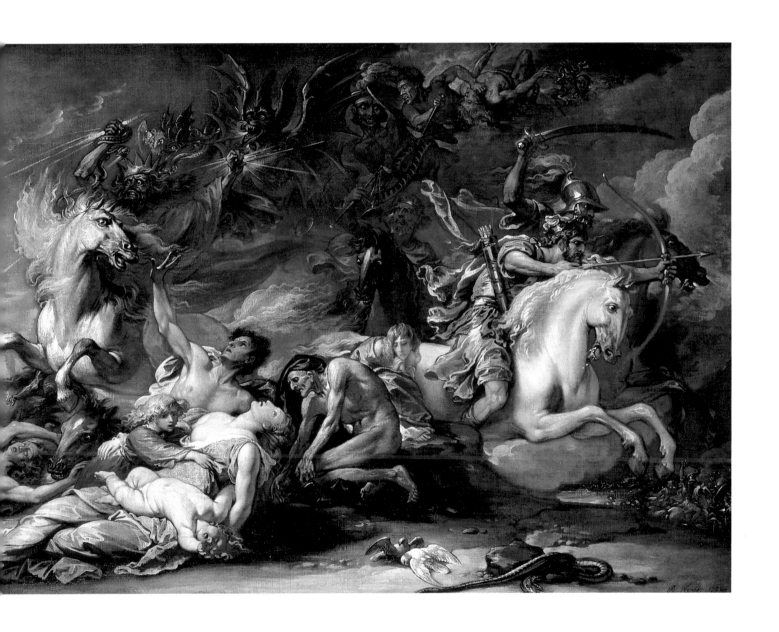

5 BENJAMIN WEST (SPRINGFIELD, PA, 1738-LONDON, 1820)

THE DEATH OF HYACINTH, 1771
Oil on canvas
90 1/2 x 75 in. (230 x 190.5 cm)
Swarthmore College, Philadelphia, on loan to the Philadelphia Museum of Art
In the collections of the Musée du Louvre from 1794 to 1801

6 JEAN BROC (MONTIGNAC, 1771-POLAND, CA. 1850)

THE DEATH OF HYACINTH, 1801 Salon
Oil on canvas
68 7/8 x 47 1/4 in. (175 x 120 cm)
Musée des Beaux-Arts, Poitiers

FIG. 34

According to ancient Greek myth, the beautiful youth Hyacinth was the friend of Apollo, god of the sun, and of Zephyr, god of the west wind. As Hyacinth and Apollo competed in discus-throwing, the jealous Zephyr diverted the discus toward Hyacinth by blowing on it. Wounded in the head, Hyacinth died. Where his blood soaked the earth, it gave birth to the flower that bears his name. On this theme of jealousy Benjamin West created a work of unusual sensuality.

The Death of Hyacinth by Benjamin West joined the collections of the Louvre in 1793 and remained there until 1801, when it was transferred with three other paintings by West to the Parisian headquarters of the Ministry of War.[1] The other works were *Juno Receiving the Cestus from Venus* (1771, University of Virginia Art Museum, Charlottesville, Virginia), *Chryseis Returned to her Father Chryses*, and *Aeneas and Creusa* (both works, ca. 1771, The New-York Historical Society). Seized in 1794 from the Earl of Kerry, an Irishman installed in France since the early 1780s, the four paintings were returned to the Kerry family a few years after the end of the Empire. While in the French government's possession, *The Death of Hyacinth* received particular attention in the French artistic community. The results confirm the importance of West for French artists at the end of the eighteenth century.

Jean Broc's painting is the first and most famous example of the influence of West's work on French artists. Along with Jacques Louis David's former student Maurice Quay (ca. 1779-1802), Broc was a member of the "Primitifs" one of several nineteenth-century artists' groups who attempted a return to the artistic purity of the early Renaissance like the Nazarenes, a group of early nineteenth-century German artists whose goal was to revive Christian art, and the later Pre-Raphaelites, a circle of English painters, poets, and critics founded in 1848. Broc, like West, used line and color to convey the impression of the hero's ebbing strength, while investing his figures with both a frailty and a disquieting eroticism. The unreality of Broc's portrayal of the tragic friends is accentuated by dreamlike colors.

West's painting also inspired sculptors Charles Antoine Callamard (1769-1821) and François Joseph Bosio (1768-1845).

The Death of Hyacinth (1810, Musée Baron Martin at Gray) by Merry-Joseph Blondel (1781-1853; fig. 34) is another manifestation of the success of West's painting. Although it was executed in Rome in 1810, it nonetheless shows some strong similarities with West's painting. As with Broc's and Callamard's works, the subject and its treatment show a common source, a shared admiration for the great American Neoclassical painter. While such paintings as the *Death of General Wolfe* (cat. 3) and *William Penn's Treaty with the Indians* (fig. 6) influenced French art only through engraved reproductions, West's paintings that were seized from the Earl of Kerry had a direct impact on French artists.

[1] For detailed information on the painting, see Helmut von Erffa and Allen Staley, *The Paintings of Benjamin West* (New Haven: Yale University Press, 1986): no.145. New research has revealed noteworthy information on the history of the painting. West's *The Death of Hyacinth* was owned by the third Earl of Kerry, who had it in Paris at the time of the Revolution. It was confiscated in 1793 and transferred to the Muséum Central des Arts in the Louvre and later in 1802 to the Ministry of War in Paris. The painting was given back to the family of the Earl of Kerry in around 1820.

FIG. 34 MERRY-JOSEPH BLONDEL (1781-1853), **THE DEATH OF HYACINTH**, 1810, oil on canvas, 89 3/4 x 58 1/2 in. (230 x 150 cm), Musée Baron Martin, Gray

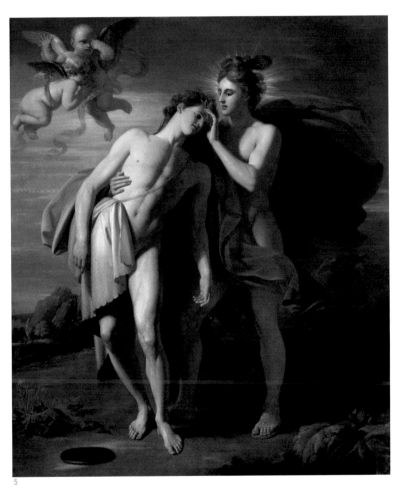

5

6

REMBRANDT PEALE (BUCKS COUNTY, PA, 1778-PHILADELPHIA, PA, 1860)

7 JACQUES LOUIS DAVID, 1810
 Oil on canvas
 28 3/4 x 23 1/4 in. (73 x 59 cm)
 Pennsylvania Academy of the Fine Arts, Philadelphia

8 JEAN-ANTOINE HOUDON, 1808
 Oil on canvas
 28 3/4 x 23 1/4 in. (73 x 59 cm)
 Pennsylvania Academy of the Fine Arts, Philadelphia

9 DOMINIQUE VIVANT DENON, 1808
 Oil on canvas
 28 3/4 x 23 1/4 in. (73 x 59 cm)
 Pennsylvania Academy of the Fine Arts, Philadelphia

This group of portraits of Frenchmen represents only three of those commissioned from Rembrandt Peale by his father, Charles Willson Peale (1741–1827).[1] Led by Charles Willson, the Peale family in the late eighteenth century authored one of the most interesting chapters in the history of museology. Contemporary with the founding in France of the Muséum Central des Arts—later the Musée du Louvre—as well as the great museums of natural history and of science, Charles Willson Peale opened a remarkable museum in Philadelphia that brought together the arts, the sciences, and history. His children bore names that paid homage to the old masters of western painting: Rembrandt (who studied with Benjamin West), Rubens, Raphael, Sophonisbe Anguissola, and Titian. Through their art and their abilities as anthropologists, naturalists, and administrators, they contributed to the creation of the first American museums, though these admittedly met with limited success.

Rembrandt Peale spent nearly a year and a half in Paris during two visits in 1808 and in 1809–10. The first was cut short by longing for his family, who accompanied him on his second, longer stay. The purpose of his visits was to paint portraits of Frenchmen celebrated in the fields of science, art, and literature for his father's museum in Philadelphia. With these commissions, Peale thus took on the challenge of working in the great tradition of the commemorative, official portrait, a genre to which his father devoted much of his artistic career with his portrayals of Revolutionary war heroes. During his second visit, Peale also devoted himself to the study of encaustic painting, the use of which had fed artistic debates for more than thirty years, and worked with John Vanderlyn, then painting his *Ariadne Asleep on the Island of Naxos* (cat. 10).

Peale painted portraits of Jacques Henri Bernardin de Saint-Pierre (1808, Corcoran Museum, Washington, D.C.), whose 1787 novel *Paul et Virginie* had earned him a high reputation in the United States, and of Abbé René Hauÿ (1808, private collection), whose work as a mineralogist fascinated the entire Peale family. He then painted the portrait of Jacques Louis David (1748–1825), the undisputed leader among French painters. He also made likenesses of Geoffroy Saint Hilaire, Georges Cuvier, Benjamin Thompson, and Count Rumford, a British-American inventor and administrator working at that time for the court of Bavaria but a resident of Paris. A specialist in thermodynamics, Rumford was famous for inventing a chimney and ovens that contributed greatly to domestic comfort thanks to their efficiency and simplicity.

Peale's portrait of Dominique Vivant Denon (1747–1825) expressed the admiration his entire family felt for the man they regarded as the creator of their era's greatest museum. For the Peales, it was obvious that Vivant Denon should be honored in their own museum. Jean-Antoine Houdon (1741–1828), the principal French sculptor of his time, also claimed a place in the series, less perhaps for his own artistic merit than for creating sculpted images of the founders of the American nation. His statue of George Washington and busts of Benjamin Franklin and Thomas Jefferson had brought him unequalled celebrity.

It was while Peale was painting David's portrait that the French artist gave him one of the most remarkable testimonies of the importance that the French accorded American artists. Although America's leading painters were largely based in England and were associated with the English school, the French were deeply aware of these artists' national identity. As he sat for Peale, David asked him, "Why is it then that all the good painters in London are American?" Peale replied: "Not all"; David then enumerated "West, Copley, Trumbull, Allston."[2]

[1] Lillian B. Miller, *In Pursuit of Fame: Rembrandt Peale, 1778-1860* (Seattle: University of Washington Press in association with the National Portrait Gallery, 1992).

[2] Rembrandt Peale, "Reminiscences," in *The Crayon* 1, no. 2 (January 10, 1855).

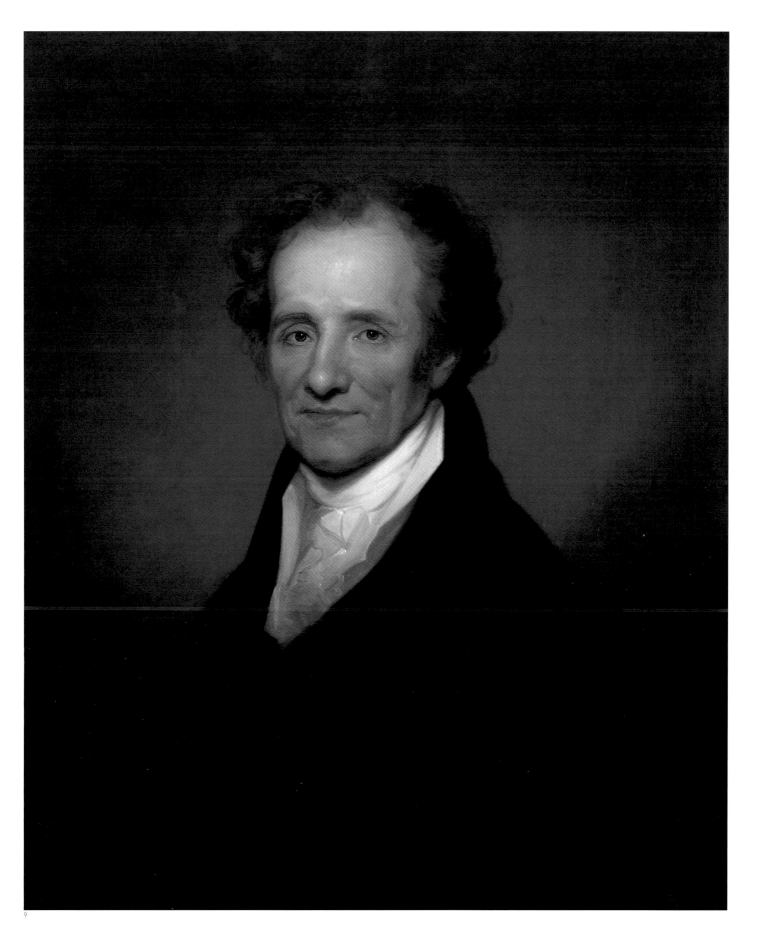

10 JOHN VANDERLYN (KINGSTON, NY, 1775–KINGSTON, NY, 1852)

ARIADNE ASLEEP ON THE ISLAND OF NAXOS, 1809–14
Oil on canvas
68 x 87 in. (175 x 221 cm)
Signed lower left: *J. Vanderlyn fect Parisiis 1814*
Pennsylvania Academy of the Fine Arts, Philadelphia

John Vanderlyn's masterpiece portrays the Greek mythological story of Ariadne, daughter of the king of Crete. Having saved the Athenian hero Theseus from the Minotaur on her native island, Ariadne fled with him to the island of Naxos. After seducing her, Theseus abandoned her while she slept, the scene shown in the painting. Theseus can be seen fleeing in the background.

During his long stays in France, from 1796 to 1801 and from 1803 to 1815, Vanderlyn was a central figure in the American community there.[1] A pupil of the painter François-André Vincent (1746–1835), in 1800 he was the first American artist to exhibit in the Salon, preceding even Benjamin West. He was also the first American artist to be awarded a gold medal, which he received in 1808 for his *Caius Marius Amidst the Ruins of Carthage* (1807, The Fine Arts Museum of San Francisco). *Ariadne Asleep* is without doubt his most important painting, and it occupied him for longer than any other. He began work on it in 1809 and continued until 1814, the year in which he signed and dated the painting. He exhibited it twice, at the Salons of 1810 and 1812. Vanderlyn took his inspiration from the Vatican's *Sleeping Ariadne*, an antique sculpture of a recumbent female with her arm thrown behind her head, then on display in the Louvre (from 1800 to 1815); he also looked to the figure of Antiope in the so-called *Pardo Venus* by Venetian Renaissance master Titian (1490–1576), also in the Louvre. Vanderlyn labored on his ambitious work in the hope that it would bring him in America the glory and fortune promised by his successes in France.

In New York, Vanderlyn exhibited *Ariadne Asleep* in the vestibule of the exhibition hall in which he displayed his panoramic views of the château and gardens of Versailles (1818–19, Metropolitan Museum of Art, New York). The reception was mixed: some viewers admired the *Sleeping Ariadne*, but the general public was shocked by her nudity. In 1835, American landscape painter and engraver Asher Brown Durand (1796–1886), who had also sojourned in Paris and is shown in Thomas Pritchard Rossiter's painting (cat. 12), made a large engraving after *Ariadne*. Since that time, its reputation has grown to such an extent that it is now regarded as a monument of American Neoclassical.

[1] For Vanderlyn's remarkable history as the first American artist to study and exhibit in Paris see Lois Marie Fink, *American Art at the Nineteenth-Century Paris Salons* (Cambridge: Cambridge University Press in association with the National Museum of American Art, 1990).

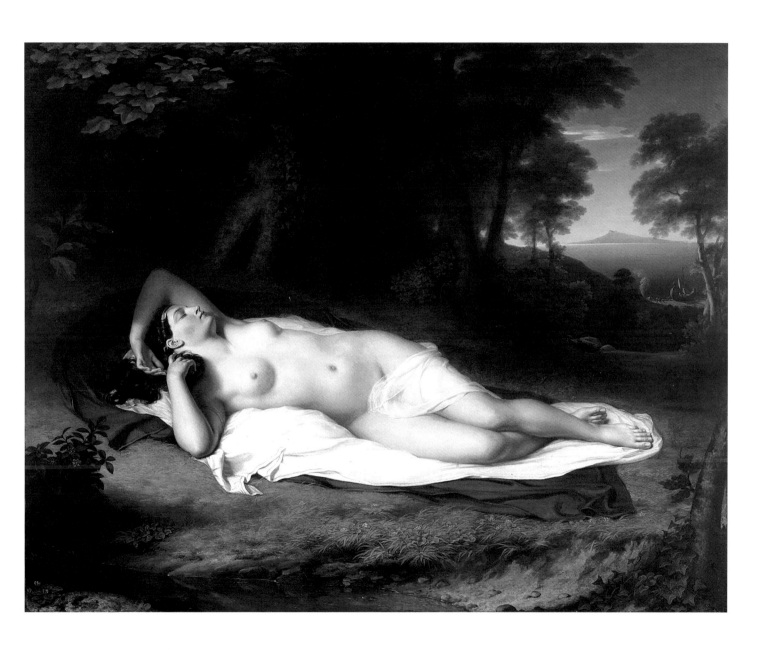

11 JOHN VANDERLYN [KINGSTON, NY, 1775–KINGSTON, NY, 1852]

THE DEATH OF JANE MCCREA, 1804
Oil on canvas
33 x 26 in. (84 x 66 cm)
Wadsworth Atheneum Museum of Art, Hartford

While John Vanderlyn's painting *The Death of Jane McCrea* was one of the most startling works ever shown in the Paris Salon, its subject was not unknown to the French public. By 1784, when Michel d'Auberteuil published a short story entitled *Miss McCrea, roman historique*, the murder of Jane McCrea was one of the best-known episodes of the American War of Independence. In 1777, English general Thomas Burgoyne and his Indian mercenaries were marching from Canada toward New York. A young woman, Jane McCrea, was on her way to rejoin her fiancé when she was captured by Indian troops advancing as reconnaissance scouts for the British. Two Indians disputed the honor of bringing her back to the English lines, and the young woman was finally killed and then scalped. The story of this particularly odious murder, whose veracity has often been questioned, long symbolized the atrocities committed against the American rebels by Indians under the direction of English commanders.

Vanderlyn's painting originated as an illustration for a poem by Joel Barlow, American ambassador to France under the presidency of Thomas Jefferson. Barlow's *Columbiade*, published in 1807, was an attempt to trace the history of the New World in verse.[1] Barlow commissioned aspiring young artist Robert Fulton (1765–1815), later famous as the inventor of the steamboat, to illustrate the murder; the resulting drawing is now lost. Disappointed by Fulton's illustration, Barlow also disdained Vanderlyn's version and turned finally to English painter and illustrator Robert Smirke (1752–1845). It was the latter's composition, more banal than Vanderlyn's, that became the model for the countless illustrations that appeared throughout the nineteenth century.

Shortly after the exhibition of his painting in the Salon of 1804, Vanderlyn sent it to the United States. It was displayed at the American Academy of Fine Arts in New York until 1842, and a few years later it became the property of the Wadsworth Atheneum in Hartford, Connecticut. Vanderlyn's composition was less popularly successful than Smirke's. For Americans, its Neoclassical marked by French example seemed inappropriate for a subject so specifically American. Nevertheless, it remains today one of the most powerful works of American painting of the first half of the nineteenth century.

[1] For an in-depth review of Barlow's epic poem see Samuel Y. Edgerton, Jr., "The Murder of Jane McCrea: The Tragedy of an American *Tableau D'Histoire*," *Art Bulletin* 47 (December 1965): 481–92.

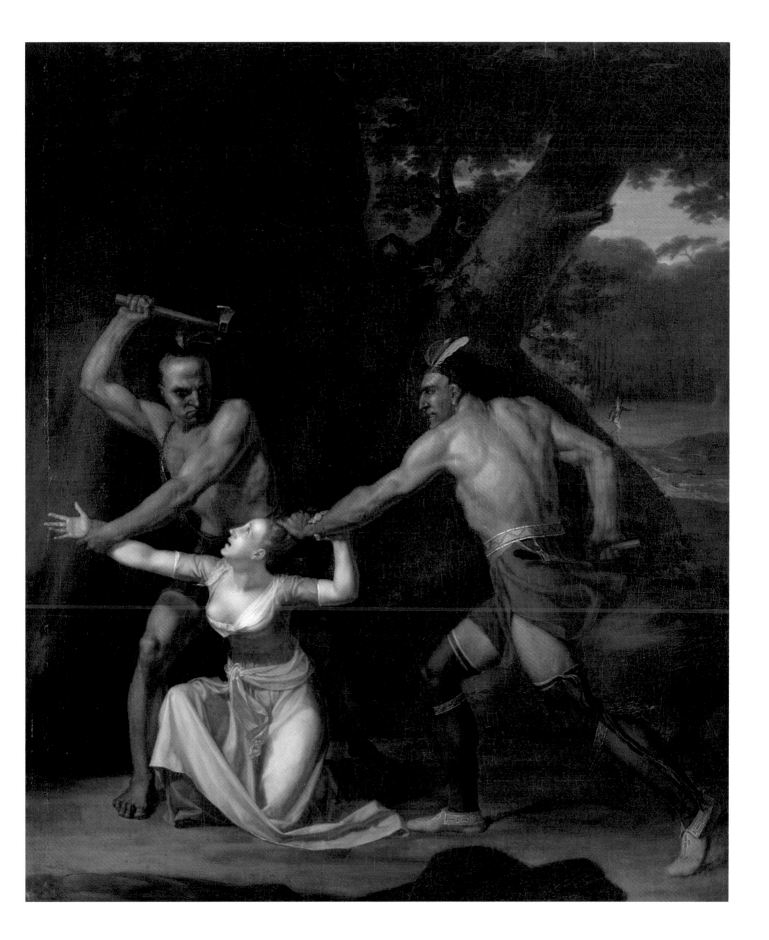

12 THOMAS PRITCHARD [OR PRICHARD] ROSSITER [NEW HAVEN, CONN, 1818-COLD SPRING, NY, 1871]

A Studio Reception, 1841
Oil on canvas
32 x 39 5/8 in. (81.3 x 102.6 cm)
Albany Institute of History and Art, New York

Thomas Pritchard Rossiter's group portrait, a fictional record of a convivial gathering, treats the theme of the artistic process. Originally exhibited in New York in October 1841, as *The Artists' Conversazione, Containing Portraits of all the American Artists at Paris, in March 1841*, the work portrays artists who had visited his studio at various times between January and June of that year.[1] Assembled before a large painting, they offer Rossiter, the standing figure on the far right, their critical comments—a reference to the "sacred conversation" of saints in Renaissance art. A painted copy of Titian's (ca. 1485–1576) celebrated *Entombment* (ca. 1520) and a miniature cast of Jean-Antoine Houdon's (1741–1828) *L'Écorché* (ca. 1767) on the clock, doubled though its reflection in the mirror, evoke the Louvre as the unofficial academy for visiting American artists.

John Frederick Kensett (1816–1881), Rossiter's studio partner, identified many of the artists in the painting in his journal entry of March 27, 1841: "Among the number who have a place therein are Messrs. Durand, Casilear, Edmonds, Freeman, Healy, and Schoff, with himself and your humble servant—a good array of talent." Comparison with photographic and painted portraits confirms the figures' identities.[2] Moving clockwise from Asher B. Durand (1796–1886) in the yellow vest, we see Francis William Edmonds (1806–1863), gesturing toward the canvas; Stephen Alonzo Schoff (1818–1904) behind him; James Freeman (1808–1884), holding the palette; Benjamin Champney (1817–1907), leaning on Durand's chair; George Peter Alexander Healy (1831–1894), who gazes at his kneeling wife, Louisa; the seated Kensett in an orange vest; Rossiter, gazing toward the viewer; and a seated Robert Cooke (unknown). The blond artist with the guitar is probably John Vanderlyn, and the partially visible portrait sketch may be of John Casilear (1811–1893). The unidentified female, meanwhile, serves both as Rossiter's model and as artistic muse for the assembled artists.

[1] For a fuller explanation of the painting see Tammis K. Groft and Mary Alice Mackay, eds., *Albany Institute of History and Art: 200 Years of Collecting* (New York: Hudson Hills, 1998): 96–97.

[2] I am particularity grateful to John Fuller McGuigan Jr. for generously sharing his meticulous research that specifically identified the artists. His investigation eliminates previously suggested artists—Thomas Cole, Daniel Huntington, and James DeVeaux—who were not in Paris during the first six months of 1841.

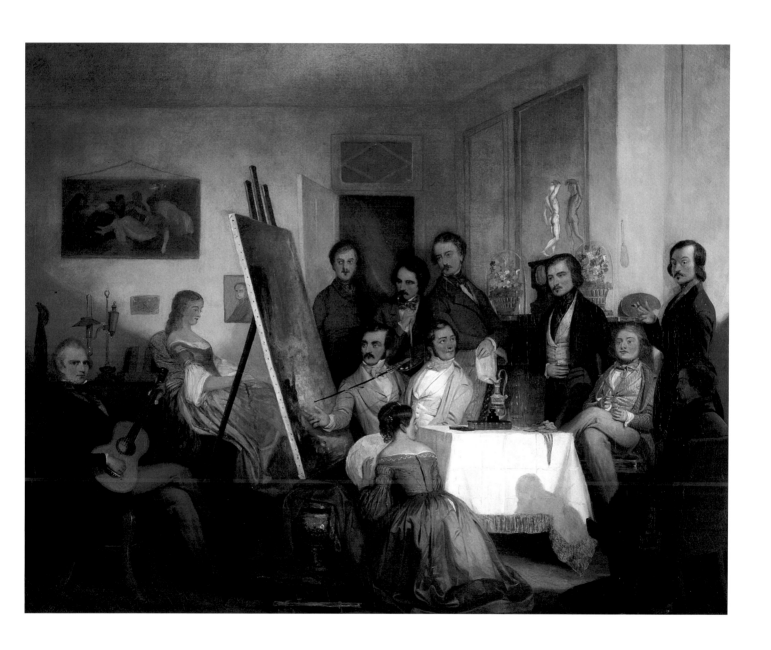

13 GEORGE CATLIN (WILKES-BARRE, PA, 1796–JERSEY CITY, 1872)

INDIAN BALL GAME, 1846
Oil on canvas
25 1/2 x 31 7/8 in. (65 x 81 cm)
Musée National de la Coopération Franco-Américaine, Blérancourt

In April 1845, George Catlin arrived in Paris from London accompanied by twelve Iowa and Ojibwa Indians, including the chief White Cloud and a young warrior, Little Wolf. His baggage consisted of no less than ten tons of material: tents, Native American objects, and five hundred and forty paintings, for the most part executed between 1832 and 1840 during a long stay in unsettled lands west of the Missouri River.

Catlin was to remain in Paris nearly three years. His Indian Gallery was accommodated in a room in the Rue Saint-Honoré, the Salle Valentino. Soon after their arrival on April 21, 1845, Catlin and his entourage were received by King Louis-Philippe in the Tuileries Palace. The invitation was repeated several times, at the Tuileries and at the Saint-Cloud Palace. Lastly, as a mark of the monarch's particular interest in the American artist, Catlin was allowed to present his exhibition in the Louvre itself, in the Salle des Séances. The visitors included such luminaries as Romantic painter Eugène Delacroix and novelist George Sand.

Louis-Philippe's interest in the United States and particularly in the Indian nations went back to his stay in America from 1796 to 1800, when, as the Duc d'Orléans, future king of France, he undertook adventurous journeys on the Ohio and Mississippi Rivers. He met Cherokee, Chickasaw, and Choctaw Indians, and was introduced to lacrosse, a Native American ball game in which team players use a woven basket on the head of a stick to catch, carry, and pass a ball. Nostalgia for his youthful travels on the American frontier induced Louis-Philippe to commission fifteen paintings from Catlin, including this one, which shows him, somewhat anachronistically, attired in a black suit and top hat to watch a lacrosse game. With some variations, notably the presence of Louis-Philippe, this painting is based on another Catlin image of lacrosse-playing, in the Smithsonian American Art Museum.

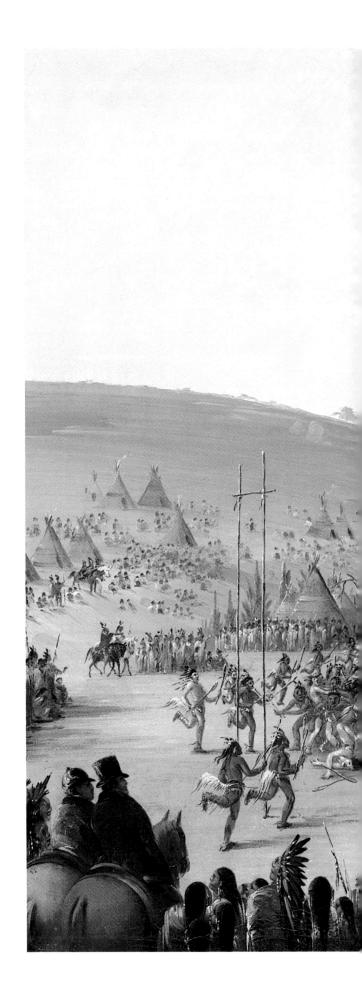

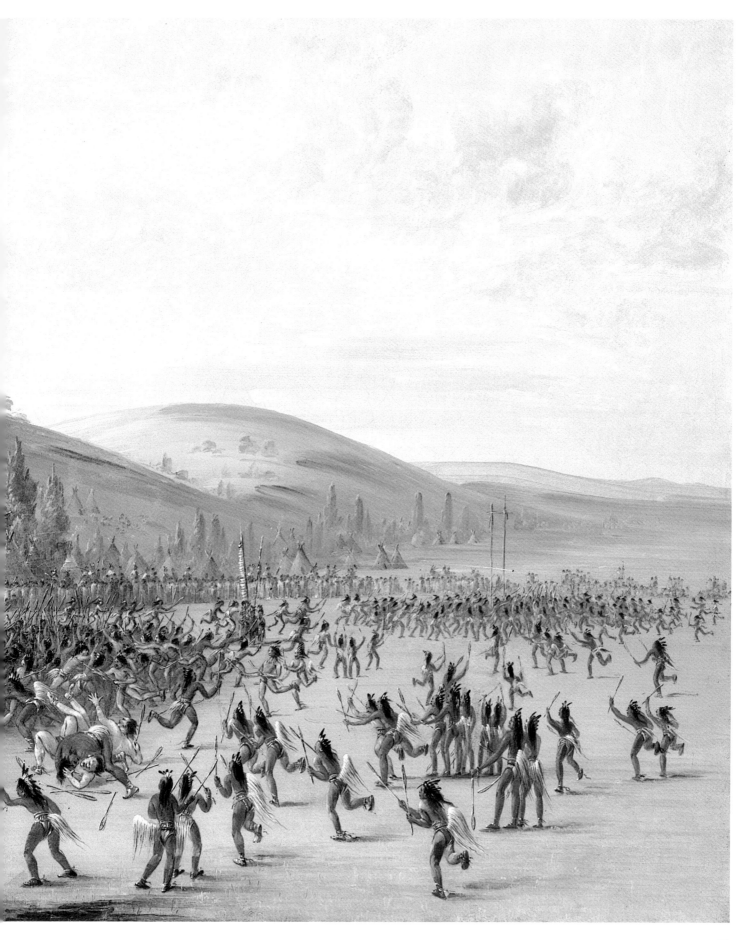

14 JAMES MCNEILL WHISTLER (LOWELL, MASS., 1834–LONDON, 1903)

AT THE PIANO, 1858–59
Oil on canvas
26 3/8 x 36 1/8 in. (67 x 90.7 cm)
Taft Museum of Art, Cincinnati, Ohio, bequest of Mrs. Louise Taft Semple

In a characteristically imperious pronouncement, American expatriate artist James Abbott McNeill Whistler repeatedly avowed, "What is not worthy of the Louvre is not art." One of the nineteenth century's most innovative, influential, and controversial artists, Whistler laid the foundations for modernism in his iconoclastic art and writings. His blatant ambition to see his art hanging in the Louvre reflected a virtually universal artistic aspiration. When the notorious modern master's portrait of his mother, *Arrangement in Gray and Black no 1: Portrait of the Painter's Mother* (fig. 28), was acquired for the Musée du Luxembourg in 1891, the American art world buzzed with appreciation and envy. Whistler spent his bohemian student days in the Louvre copying an eclectic array of paintings by old and modern masters. Their works nourished his imaginative powers, while his friendship formed in the museum with the young French student Henri Fantin-Latour (1836–1904) introduced him to modern French art and theory. Whistler's experience of the Louvre as an artistic fountainhead was invaluable.[1]

With *At the Piano*, Whistler introduced himself as an original presence in the art worlds of Paris and London. Carefully planned for its formal qualities, this composition nevertheless offers a personal narrative: it presents the artist's half-sister, Deborah Haden, playing the Whistler family piano, with her daughter Annie, in the tasteful interior of their London home. Modern in its dramatic cropping, contrasts of black and white, bold application of paint, and clever intimation of a stereoscopic view with the two points of interest, this intimate domestic scene owes much to Whistler's assimilation of seventeenth-century Dutch and eighteenth-century French interpretations of bourgeois familial harmony.

[1] For a discussion of some of Whistler's sources, see David Park Curry, *James McNeill Whistler: Uneasy Pieces* (New York: Virginia Museum of Fine Arts in association with Quantuck Lane Press, 2004). On the response to the acquisition of Whistler's *Arrangement in Gray and Black no 1: Portrait of the Painter's Mother*, see Richard Dorment and Margaret F. MacDonald, *James McNeill Whistler* (London: Tate Gallery Publications, 1994): 71–73.

15 HENRY MOSLER [NEW YORK, NY, 1841–NEW YORK, NY, 1920]

THE RETURN OF THE PRODIGAL SON (LE RETOUR), 1879
Oil on canvas
47 1/4 x 39 3/4 in. (120 x 101 cm)
Musée Départemental Breton, Quimper

Awarded a medal in the 1879 Paris Salon, Henry Mosler's *Return of the Prodigal Son* was the first painting by an American artist to be acquired by the French government. The work's supposed ethnographic accuracy was key to the state's purchase of this scene of modern Breton life. Mosler, a German-Jewish immigrant artist from Cincinnati, Ohio, transformed the Old Testament parable into a sentimental vignette of peasant life. With scrupulous care he depicted Breton costumes and accessories, in particular the handsome, ceiling-high, ancestral oak bedstead with its carved panels. A cosmopolitan artist who studied in Düsseldorf, New York, Munich, and Paris, Mosler joined an international coterie of late nineteenth-century painters who glorified vanishing rural life.[1]

Mosler may have been predisposed to such a depiction of poverty and generational discord through his friendships with other artists sympathetic to the grueling lives of the rural poor, and by his own experiences as an immigrant and expatriate. The more likely motivation for this sophisticated artist's rendering of French peasants, however, was the demand among American and European collectors for depictions of rural life as a comforting antidote to urbanization and industrialization. In selecting the biblical theme of the prodigal son, Mosler was surely aware of the famous painting in the Louvre collection, *The Punishment of Filial Ingratitude* (1778), by Jean-Baptiste Greuze (1725–1805). In contrast to the melodrama of the French master's narrative image, Mosler's interpretive strategy relied on authentic visual detail to validate his woeful scene.

[1] Barbara C. Gilbert, *Henry Mosler Rediscovered: A Nineteenth-Century American-Jewish Artist* (Los Angeles: Skirball Museum, 1995).

SWIMMING, 1885
Oil on canvas
27 5/16 x 36 5/16 in. (69.4 x 92.2 cm)
Amon Carter Museum, Fort Worth, Texas

With the end of the Civil War, Thomas Eakins, along with Mary Cassatt and other students from the Pennsylvania Academy of the Fine Arts, sought academic training in Paris. Writing home, the naive youth recorded his reaction to the masterpieces in the Louvre: "First, I went to see the statues. They are made of real marble and . . . how much better they are than the miserable plaster imitations at Philadelphia . . . There must have been half a mile of them [paintings], and I walked all the way from one end to the other, and I never in my life saw such nice funny old pictures."[1]

Studying in the studio of Jean-Léon Gérôme (1824–1904) at the École des Beaux-Arts between 1866 and 1869, Eakins devoted himself to mastering the human figure. When he returned to Philadelphia, he began an ambitious painting career in which he created some of the most iconic works of American art while promoting the French academic method of drawing and painting from the nude model. Lauded by critics near the end of his career as a leader in American realism, Eakins remained committed to truthful representation.

Swimming is an apparently photographically realistic portrayal of Eakins (in the lower right corner) and a group of nude youths enjoying a summer afternoon.[2] Unusual in American art for its depiction of male nudity, the controversial painting shocked Eakins's patron. Yet it belongs within a long tradition of representing bathers as an exercise in portraying the nude. In the position of the reclining man, Eakins paid homage to antique sculpture by quoting the pose of the *Dying Gladiator* (Capitoline Museum, Rome), a famous statue he encountered as a cast at the Pennsylvania Academy. However, it was the coloristic magnificence of the nude male portrayed in hundreds of paintings in the Louvre that challenged Eakins to excel.

[1] Eakins to Francis (Fanny) Eakins, October 30, 1866, quoted in Lloyd Goodrich, *Thomas Eakins* (Cambridge: Harvard University Press, 1982): 27–28.

[2] Doreen Bolger and Sarah Cash, eds., *Thomas Eakins and the Swimming Picture* (Fort Worth, Texas: Amon Carter Museum, 1996) provides an in-depth analysis of the painting.

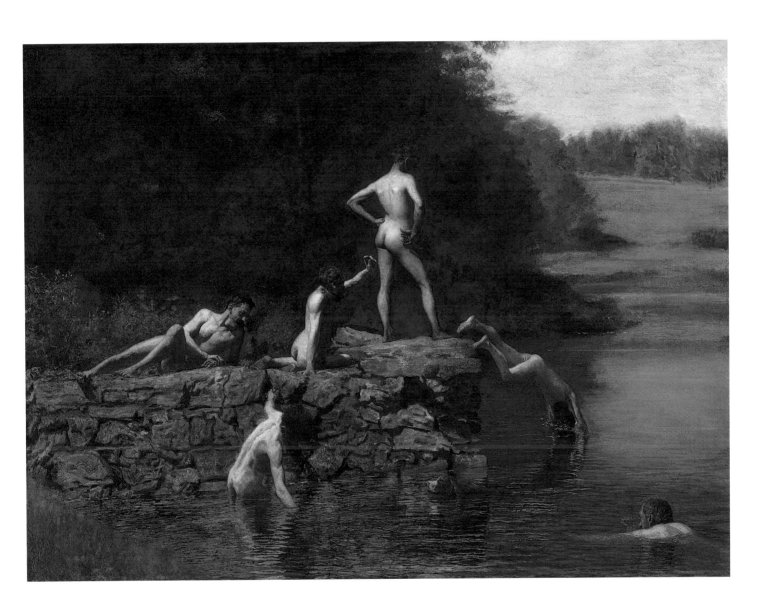

17 CHILDE HASSAM (DORCHESTER, MASS, 1859–EAST HAMPTON, NY, 1935)

UNE AVERSE—RUE BONAPARTE, 1887
Oil on canvas
40 3/8 x 77 7/16 in. (102.6 x 196.7 cm)
Terra Foundation for American Art, Daniel J. Terra Collection, Chicago

One of his generation's most consistently successful artists, Childe Hassam forged a genteel, visually sensuous, and distinctly American interpretation of Impressionism. Hassam was a leader in the New York art world. He helped found the New York Water Color Club in 1890, and in 1897 he spearheaded the formation of Ten American Painters, an organization of Impressionist artists that broke away from the more conventional Society of American Artists.

With his Boston cityscapes of the 1880s, Hassam pioneered the artistic portrayal of the modern American city. Painted in Paris early in his formative three-year stay from 1886 to 1889, *Une Averse–Rue Bonaparte* marks an important advance in the artist's urban imagery as he came under the influence of modern French art.[1] The scene is set in a fashionable neighborhood of Paris, on the left bank by Place Saint-Sulpice with the Luxembourg Gardens barely glimpsed in the far distance. Ignoring picturesque sites, the work lies somewhere between a critique of the complex realties of city life and a presentation of an urban utopia in which different social classes harmoniously share the same public spaces. Perhaps the Louvre's modern old masters also sparked the American painter's imagination, as the striking connections between *The Arrival of a Coach* of 1803 by Louis Léopold Boilly (1761–1845) and *Une Averse–Rue Bonaparte* suggest. Hassam's ambitious Parisian street scene scored a coup for the artist when it was included in the prestigious annual exhibition at the Paris Salon of 1887 and met with high praise from both French and American reviewers.

[1] H. Barbara Weinberg, *Childe Hassam: American Impressionist* (New Haven: Yale University Press, 2004): 60.

18 WILLIAM JAMES WHITTEMORE [NEW YORK, NY, 1860-NEW YORK, NY, 1955]

CHARLES C. CURRAN, 1888–89
Oil on canvas
17 x 21 in. (43.2 x 53.3 cm)
National Academy Museum and School of Fine Arts, New York

In an acknowledgment of the importance of the Louvre as the unofficial "American academy," William James Whittemore's portrait of Charles C. Curran copying in the Louvre was chosen to grace the cover of the National Academy of Design's 2004 comprehensive collection catalogue.[1] Curran and Whittemore arrived in Paris in 1888 ready to advance their artistic studies begun in New York, and they left a few years later with their experiences and memories of the Louvre recorded in this portrait. Painted in the museum, it was removed with difficulty when a guard insisted on strictly interpreting a rule prohibiting the painting of portraits in the museum. Ironically, when Curran later submitted the work as the portrait required to fulfill a condition of associate membership in the National Academy, it was rejected on the grounds of being more a work of genre than a likeness of an individual.

The image clearly depicts the traditional student practice of copying from antique sculpture. Whittemore juxtaposes Curran's profile, sharply delineated by the dark bowler hat, beard, and jacket, with the voluptuous curves of the white marble statue, humorously placed knee to nose with the modern painter. French scholarship has identified the locale shown as the Louvre's gallery of Psyché (the room adjacent to that housing the *Venus de Milo* in 1890), the sculpture as the *Crouching Venus of Tyr*, a Greek Classical period fragment, and the sarcophagus in the background as a Roman work decorated with a frieze depicting the story of Selene and Endymion.[2] Whittemore's witty tribute to his fellow student is a portrait that embodies the Louvre's effect on American artists.

[1] David Dearinger, ed., *Painting and Sculpture in the Collection of the National Academy of Design*, vol. 1, 1826–1925 (New York: Hudson Hills Press, 2004): 581.
[2] *Copier créer: de Turner à Picasso: 300 œuvres inspirées par les maîtres du Louvre* (Paris: Réunion des Musées Nationaux, 1993): 64.

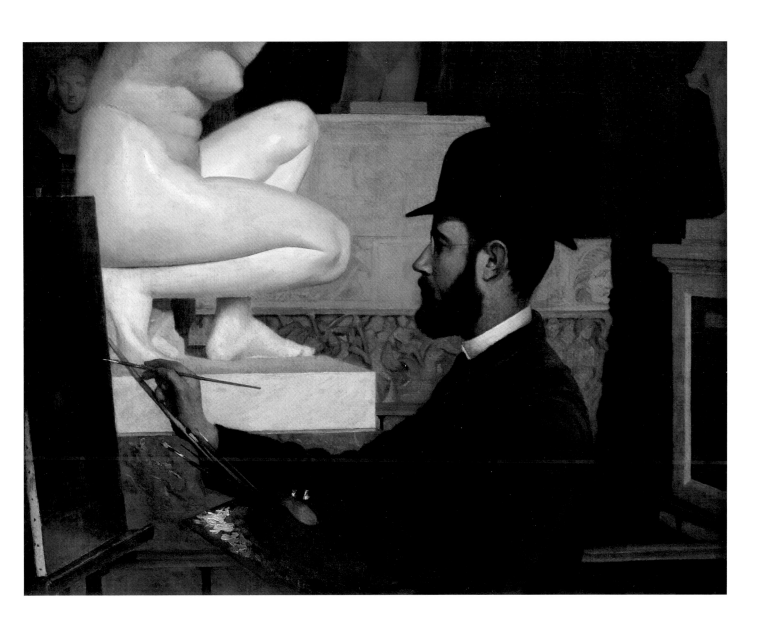

THE FAMILY, 1893
Oil on canvas
32 x 26 in. (81.2 x 66 cm)
Chrysler Museum, Norfolk, Virginia

Mary Stevenson Cassatt, one of the few American artists who achieved recognition on both sides of the Atlantic during her lifetime, was the only American invited to show with the independent French artists who came to be known as the Impressionists. The expatriate artist is recognized not only for her distinctive art, dominated by images of women and children in interiors, but also for encouraging American collectors to purchase Impressionist works as well as old master paintings. "To make a great collection it is necessary to have a modern note in it," Cassatt observed, "and to be a great painter, you must be classic as well as modern."[1] As a student, Cassatt was typical of the young artists shown in Winslow Homer's 1866 etching avidly copying masterworks in the Louvre (fig. 30). The continuing importance of the museum to Cassatt is captured by Edgar Degas in a 1880 pastel, which depicts the mature artist as she contemplates the Louvre's familiar paintings (fig. 32).

Cassatt melded the authority of religious iconography with the naturalism of contemporary subjects in her sensitive renderings of modern women with children, which are invariably characterized as modern Madonnas.[2] The Family, for example, echoes the theme of the sacred conversation seen in such works as Sandro Botticelli's (1445–1510) Virgin and Child with Young Saint John the Baptist (Madonna of the Rose Garden) of about 1468, a painting Cassatt admired in the Louvre.[3] For the poses of the red-haired young girl seen in profile and the naked baby, Cassatt also borrowed from her own masterwork, the commissioned mural she painted for the Woman's Building at the 1893 World's Columbian Exposition in Chicago. Drawing on such sources, the artist portrays the intimacy of modern family life as she evokes a classic iconographic type.

[1] Louisine W. Havemeyer, Sixteen to Sixty: Memoirs of a Collector (1961; repr., New York: Ursus Press, 1993): 278.

[2] Nancy Mowll Mathews, Mary Cassatt: A Life (New Haven: Yale University Press, 1994): 187

[3] Judith A. Barter suggests this connection in Mary Cassatt: Modern Woman (Chicago: Art Institute of Chicago in association with Harry N. Abrams, 1998): 80.

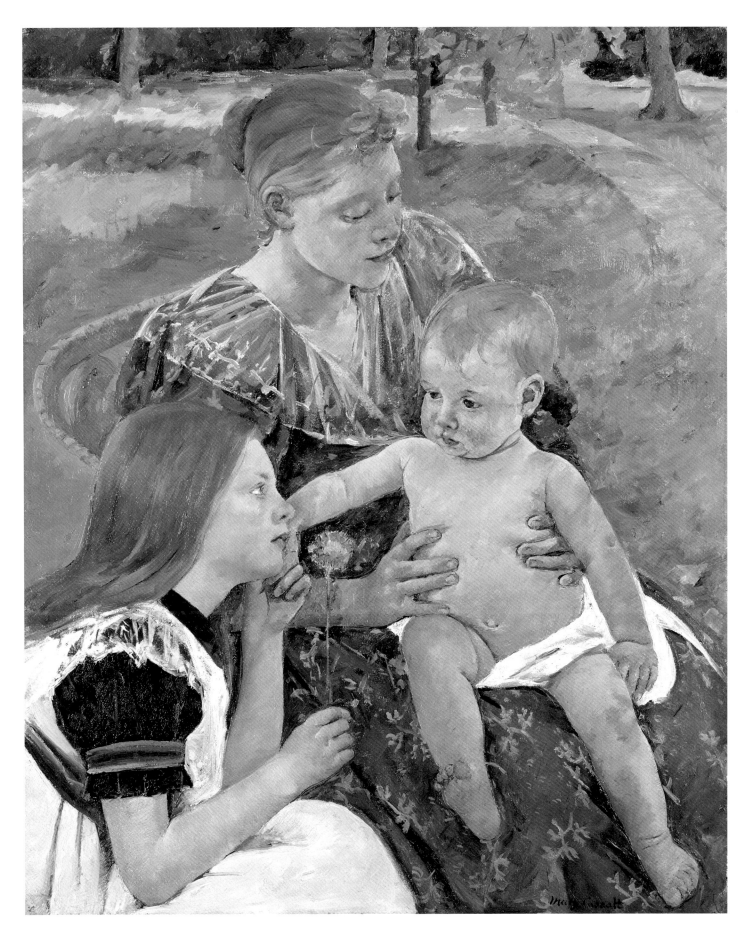

20 WINSLOW HOMER (BOSTON, MASS, 1836-PROUT'S NECK, ME, 1910)

THE GALE, 1883-93
Oil on canvas
30 1/4 x 48 3/8 in. (76.8 x 122.9 cm)
Worcester Art Museum, Worcester, Massachusetts

Perhaps the single most admired American artist of the nineteenth century, Winslow Homer used his art to document contemporary American life and to explore humankind's spiritual as well as physical relationship with nature. He launched his career as an illustrator in 1857, moving to New York City two years later. There, he attended drawing classes at the prestigious National Academy of Design and briefly studied painting privately. In 1867, Homer attended the Exposition Universelle in Paris where his paintings were on display. He spent the following year observing the masterpieces (and their copyists) in the Louvre, documented in his amusing etching (fig. 30), and absorbing the influence of progressive French landscape painters. Years later, in 1881, Homer crossed the Atlantic again to spend twenty months in the remote English North Sea fishing village of Cullercoats. His work matured toward a new monumentality as he focused on the heroic women of the village and on the perilous work of the fishermen at sea. Following his return to the United States, Homer built a studio on the Maine coast at Prout's Neck, where he spent the remainder of his career.

The Gale is one of a series of ambitious pictures on which Homer began working after he returned from England in 1883. He reworked the canvas extensively in the early 1890s. Scholars have noted the resemblance of the figure with the wind-blown cloak to the Louvre's famous *Winged Victory of Samothrace*, an antique sculpture discovered in 1863 and installed in the Louvre in 1867, while Homer was in Paris.[1] The antique sculpture lingered in Homer's memory to influence his interpretation of modern life.

[1] Alexandra R. Murphy, "Winslow Homer, American Among the Masters," *Winslow Homer in the Clark Collection* (Williamstown, Massachusetts: Sterling and Francine Clark Art Institute, 1986), and Nicolai Cikovsky, Jr., "Winslow Homer's Unfinished Business," *American Art Around 1900: Lectures in Memory of Daniel Fraad*, Studies In the History of Art 37 (Washington, D.C.: National Gallery of Art, 1990): 93–118.

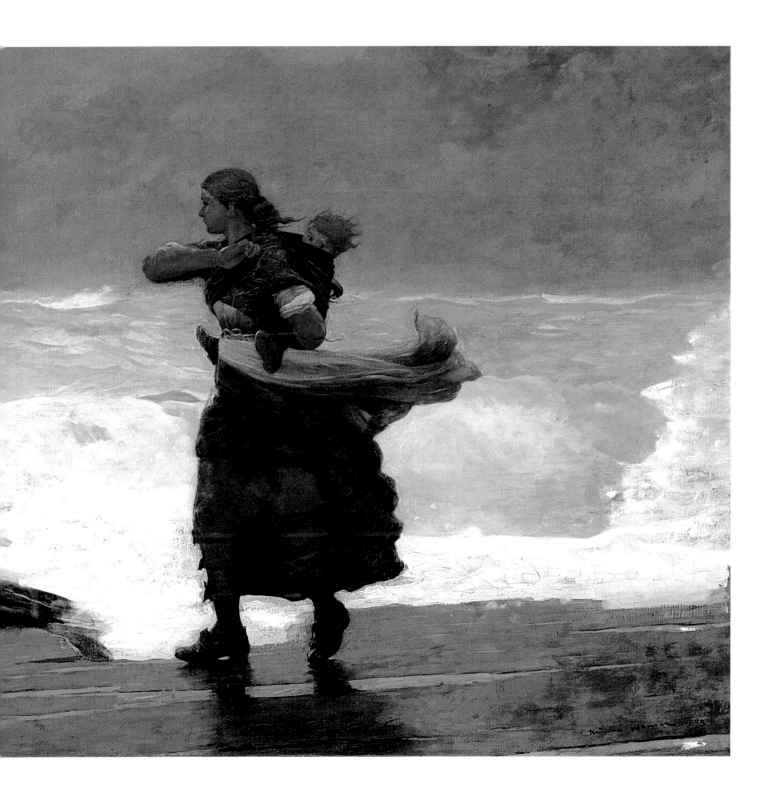

21 HENRY OSSAWA TANNER (PITTSBURG, PA, 1859–PARIS, 1937)

CHRIST AND HIS DISCIPLES ON THE BETHANY ROAD, ca. 1902–03
Oil on canvas
37 3/8 x 47 13/16 in. (66 x 93 cm)
Musée d'Orsay, Paris

Henry Ossawa Tanner's international reputation secured his place as the foremost African American artist at the beginning of the twentieth century. The eldest son of a militant African Methodist Episcopal bishop in Philadelphia, Tanner studied sporadically at the Pennsylvania Academy of the Fine Arts and experimented with various professional ventures before journeying to Paris. At the Louvre, the aspiring artist was somewhat intimidated by the masterworks he saw, writing home: "... upstairs the paintings ... [were] much more to my taste than were the old masters in the Louvre—not that they were really as fine, but they were more within my range."[1]

Tanner's art progressed from ennobling genre scenes of African Americans to more universal biblical themes. Following his return to Paris in 1894, he began interpreting rather than literally illustrating New Testament subjects in a manner that suggests cross-cultural associations, such as orientalism. Tanner's critical success was confirmed by the French state's purchase in 1897 of his painting *The Raising of Lazarus*, which joined James McNeill Whistler's *Arrangement in Grey and Black no 1: Portrait of the Painter's Mother* (fig. 28) in the room devoted to foreign painting at the Musée du Luxembourg.

After 1900, Tanner painted well-received moonlit landscapes in which he combined religious symbolism with luminous effects achieved by unusual color harmonies, such as his signature blues laid over greens. *Christ and His Disciples on the Bethany Road* exemplifies Tanner's modern color sensibility and preference for the unpretentious expression of revelatory spiritual experience. Without a doubt, the Louvre's exemplary collection of religious paintings was a continual inspiration for Tanner.

[1] Marcia M. Mathews, *Henry Ossawa Tanner: American Artist* (Chicago: University of Chicago Press, 1969): 68.

132

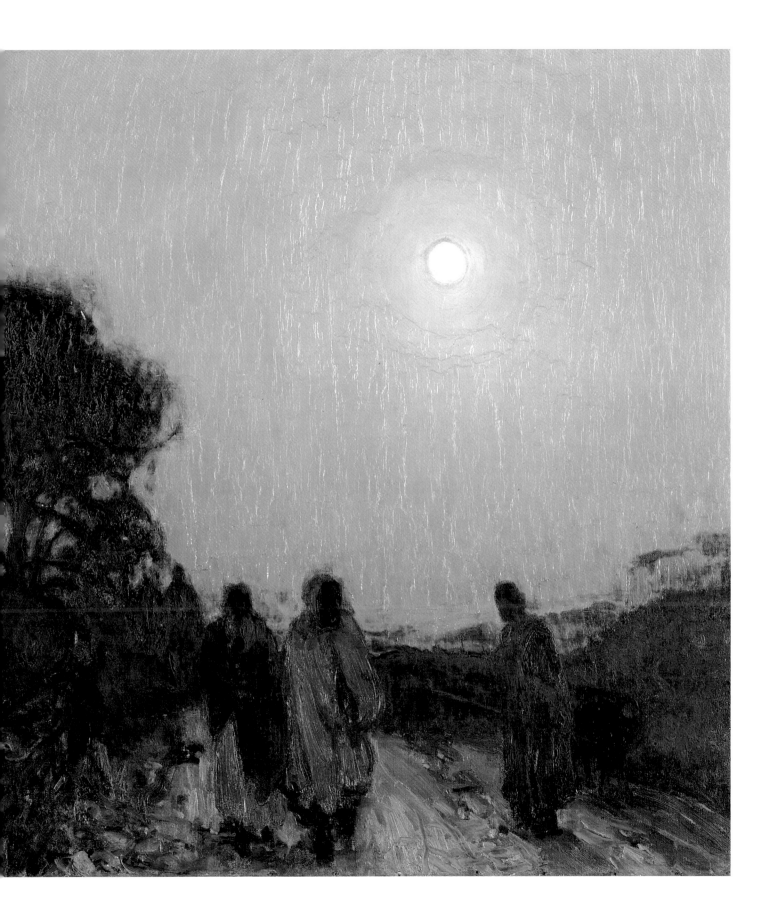

22 MAURICE PRENDERGAST [ST. JOHN'S, NEWFOUNDLAND, 1858–NEW YORK, NY, 1924]

SALEM WILLOWS, 1904
Oil on canvas
26 x 34 in. (66 x 86.4 cm)
Terra Foundation for American Art, Daniel J. Terra Collection, Chicago

Maurice Brazil Prendergast was a member of The Eight, the group of dissident artists, led by Robert Henri, whose notorious 1908 exhibition advanced early American modernism. After working as a commercial artist in Boston for many years, Prendergast radically changed his professional goals after a three-year stay in Paris, from 1891 to 1894. Returning to Paris thirteen years later, the innovative colorist was attracted to the radical color theory of the Post-Impressionists. Prendergast's first Parisian interlude inspired the major theme in his art—fashionably dressed women in park settings—and initiated aspects of his signature style—high-keyed color, flatness, and decorative compositional patterning.

In *Salem Willows*, Prendergast transformed a popular suburban Boston amusement park into a modern version of the *fête galante*, the imagery of aristocratic courtship in Arcadian settings popularized in the paintings of French Rococo artist Antoine Watteau (1684–1721). Prendergast sketched such a work in the Louvre, Watteau's *Gathering in a Park* (ca. 1717).[1] In *Salem Willows* he emulated the French artist's vision of a sensually colored pastoral idyll in which elaborately costumed ladies romp with attentive gentlemen by a romantically shimmering sea. The burgeoning modernist artist responded to Watteau's sparkling surfaces, reinterpreting them for his distinctive symbolist aesthetic.

[1] My thanks to Nancy Mathews for guiding me to Prendergast's sketch of the Watteau painting. Carol Clark, Nancy Mowll Mathews, and Gwendolyn Owens, *Maurice Brazil Prendergast, Charles Prendergast: A Catalogue Raisonné* (Munich: Prestel in association with Williams College Museum of Art, 1990): 563.

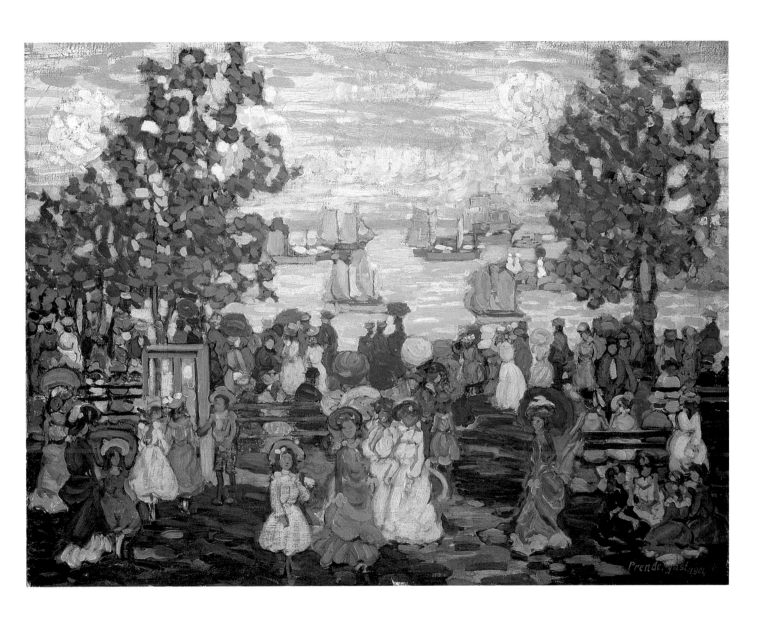

23 ROBERT HENRI [CINCINNATI, OH, 1865–NEW YORK, NY, 1929]

SALOME, 1909
Oil on canvas
77 x 37 in. (196.9 x 94 cm)
The John and Mable Ringling Museum of Art, Sarasota, Florida

Robert Henri, who succeeded William Merritt Chase as New York's most charismatic teacher of painting, was a pivotal figure in American art. His philosophy of artistic individuality became a fundamental assumption in American art in the first half of the twentieth century. Although trained at prestigious art schools—the Pennsylvania Academy of the Fine Arts and the École des Beaux-Arts—the rebellious Henri defied their conservative exhibition policies. His unorthodox ideals shaped his choice of subjects and the style of his paintings, particularly the city images, rendered in dark tones and painterly brushwork that defined the movement later given the name the "Ashcan school."

Notwithstanding his commitment to an art of modernity, Henri acknowledged the influence of the Louvre on his own artistic develop-ment. Writing from Paris in 1898, he noted, "This is one of my greatest advantages in Paris, to go to the Louvre—see what is really good and great. It is my way of study and there is nothing better or more stimu-lating than my visits there." A year later, Henri's *La Neige* (1899) was acquired by the French state for the Musée du Luxembourg, and it pleased the artist to think that his work would share the gallery with Whistler's portrait of his mother.[1]

Henri was a cognoscenti of modern music, dance, and theater. When New York audiences were scandalized by Richard Strauss's 1907 opera *Salome*, based on Oscar Wilde's play of the same name, the opera inspired the intrepid artist to invite Mademoiselle Voclexca to perform the notorious "Dance of the Seven Veils" in his studio. In the painter's interpretation, the lithesome biblical temptress strikes an animated pose that reveals her legs though her transparent costume. There is no direct correspondence between Henri's provocative dancer and the boisterous nudes depicted in the Louvre's *Marie de' Medici* cycle (1621–25) by Peter Paul Rubens (1577–1640). The American artist, nevertheless, captured the Flemish master's flair for portraying the sensuous power of women.

[1] William Innes Homer, *Robert Henri and His Circle* (Ithaca: Cornell University Press, 1969): 94.

STILL LIFE, FISH, 1912
Oil on canvas
32 1/18 x 39 9/16 in. (81 x 100.2 cm)
Brooklyn Museum, J. B. Woodward Memorial Fund, New York

Both as an artist and as America's most influential teacher of painting in the late nineteenth and early twentieth centuries, William Merritt Chase was instrumental in introducing his compatriots to progressive approaches to art-making. A student in New York City before studying at the Royal Academy in Munich, Germany, between 1872 and 1878, Chase subsequently settled in New York and exhibited with success at the traditional National Academy of Design and at its rival, the progressive Society of American Artists. The dapper Chase was an eclectic artist who assimilated many of the influences shaping contemporary art, from Japanese prints to the work of the old masters. As a teacher, Chase stressed technique over subject matter and tolerated individual and experimental approaches. He regularly conducted tours abroad so that his students could study works in European museums.

As still-life painting enjoyed a revival at the turn of the twentieth century, Chase came under the influence of French eighteenth-century master Jean-Baptiste Siméon Chardin (1699–1799), whose famous paintings of fish were on view at the Louvre. Preferring a loaded brush and swirling strokes to the French artist's smooth surfaces, Chase earned the praise of critic and collector Duncan Phillip as "unequalled by any other painter in the representation of the shiny, slippery fishness of fish."[1] Chase painted *Still Life, Fish* as a demonstration for his students during a trip to Bruges, Belgium. It bears out his prediction that "I will be remembered as a painter of fish . . . and I enjoin my pupils to paint still life as one of the best exercises in form and color."[2]

[1] Duncan Phillips, "William Merritt Chase," *The American Magazine of Art 8* (December 1916): 49.

[2] William Henry Fox, "Chase on Still Life," *Brooklyn Museum Quarterly* 1 (January 1915): 196–200.

Sᴌᴀᴠᴇs, 1924–27
Oil on canvas
66 7/16 x 72 3/8 in. (168.8 x 183.8 cm)
Terra Foundation for American Art, Daniel J. Terra Acquisition
Endowment Fund, Chicago, T. H. Benton and R. P. Benton
Testamentary Trusts/UMB Bank Trustee/Licensed by VAGA, New York

America's foremost muralist and its most popular artist in the 1930s, Thomas Hart Benton acknowledged his debt to paintings he examined in the Louvre as a student between 1908 and 1911: "I remember the *Salle Carree* [sic], the great Rubens room, *The Apotheosis of Catherine de Medici*. I'm sure I wanted right away to paint a great big wall like that."[1] Benton regarded the process of drawing after masterpieces as a means of understanding the "abstract principles . . . in those Renaissance masters I loved so much."[2] In the late 1920s, he published a theory of compositional organization deeply informed by such study. A prolific artist, entertaining writer, and stimulating teacher, Benton had a national impact. Jackson Pollock (1912-1956), his most famous student, adopted Benton's all-over method of composition and visual rhythm in his famous drip paintings.

After serving in World War I, Benton conceived the "American Historical Epic" series, a mural-like project that would represent American history based on the common man's experience by exploring themes of racial conflict and economic exploitation. Laced with contemporary racial references, *Slaves* is the Missouri artist's indictment of the historical abuse of Africans as agricultural laborers. Benton juxtaposes a black man in the pose of a martyred saint, drawn from Counter-Reformation imagery, with a contemporary silent-film character, the evil, bullwhip-cracking Simon Legree, based on the slave owner in the novel *Uncle Tom's Cabin* (1852). Benton's pictorial strategy recalls that of earlier American artists, such as Mary Cassatt and Thomas Eakins, who combined a contemporary idiom and the potent imagery of the old masters.

[1] Thomas Hart Benton, *An Artist in America* (Columbia: University of Missouri Press, 1983): 33–42.

[2] Paul Cummings, Interview with Thomas Hart Benton, Martha's Vineyard, Mass., July 23, 1973 (transcript, Archives of American Art, Smithsonian Institution, Washington, D.C.): 73.

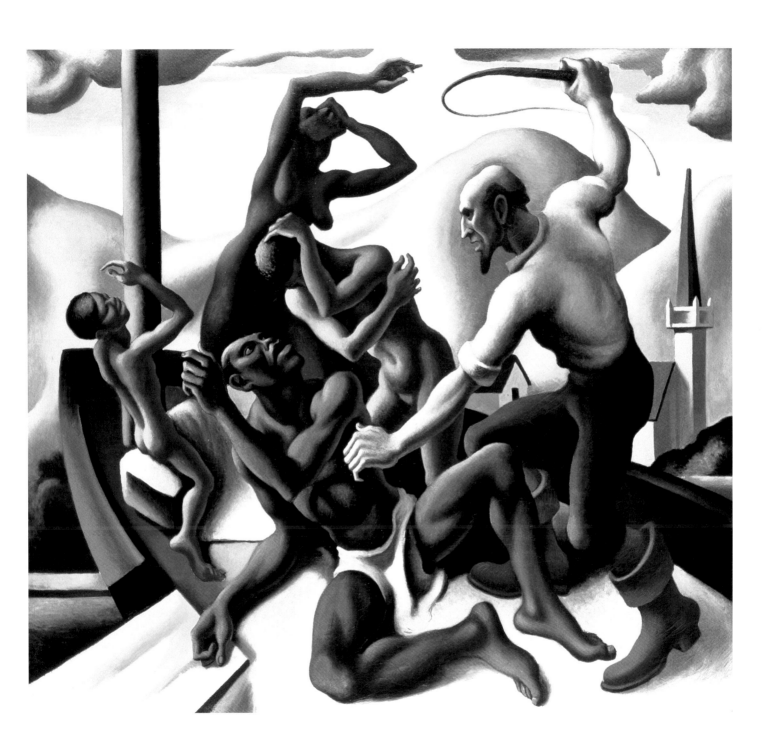

26 EDWARD HOPPER [NYACK, NY, 1882–NEW YORK, NY, 1967]

DAWN IN PENNSYLVANIA, 1942
Oil on canvas
24 3/8 x 44 1/2 in. [61.9 x 112.4 cm]
Terra Foundation for American Art, Daniel J. Terra Collection, Chicago

Edward Hopper arrived in Paris in 1907 predisposed by the teachings of Robert Henri to admire the French masters of an earlier time. Scholars have identified his three years in Paris, during which he observed the art scene and roamed the museums rather than studying at academies, as critical to the formation of his artistic identity as an observant outsider.[1] In Paris, Hopper painted thirty-one canvases. Most portray street scenes: vignettes of architectural monuments, such as the long river facade of the Louvre, infused with light and the disquieting stillness that would characterize his later paintings. A few years later, in New York, Hopper drew on memories of the paintings of Antoine Watteau (1684–1721) he had seen in the Louvre. The eighteenth-century master's *commedia dell'arte* types, for example, reappear in his *Soir Bleu* (1914, Whitney Museum of American Art), his depiction of a French café scene. In 1935 Hopper acknowledged the continuity of his artistic themes: "In every artist's development the germ of the later work is always found in the earlier."[2]

Just as he had used the ordinary and unique aspects of barges, roads, bridges, and stairways in his Parisian paintings to evoke psychological tension, Hopper imbued the commonplace with a sense of alienation in his renowned later works. *Dawn in Pennsylvania* is one of many images in which the artist used the railroad to signal the rootlessness and anonymity of modern life. Yet the work's formal qualities, such as the elongated horizontal format and carefully framed void at its center, echo the stage-like settings characteristic of Watteau's well-known *fête galante* paintings. The precise architectural settings and weather conditions of Hopper's earliest paintings were indeed the "germ" of the specificity of setting and time in such later works as this depiction of a Pennsylvania railway station, an image that bears out his critical reputation as a distinctly American artist.

[1] Gail Levin, "Edward Hopper, Francophile," *Arts Magazine* 53:10 (June 1979): 114–21, and Richard R. Brettell, "Comment Edward Hopper devint en France un peintre américain," *Edward Hopper: Les années parisiennes 1906–1910* (Giverny, France: Musée d'Art Américain, 2004): 24–87.
[2] Robert Hobbs, *Edward Hopper* (New York: Abrams, 1987): 23.

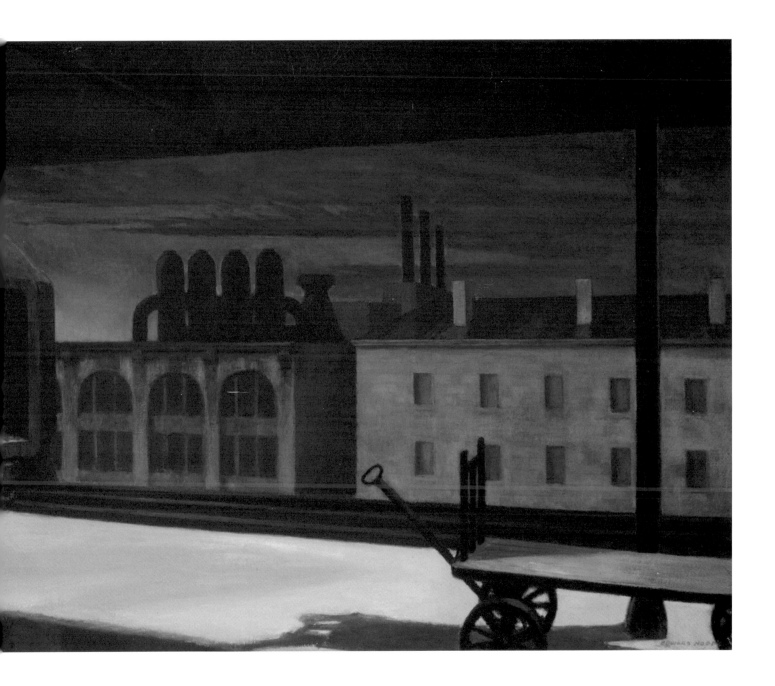

27 WALT KUHN [NEW YORK, NY, 1877–WHITE PLAINS, NY, 1949]

CLOWN WITH DRUM, 1942
Oil on canvas, 60 7/8 x 41 3/8 in. (154.6 x 105.1 cm)
Terra Foundation for American Art, Daniel J. Terra Collection, Chicago

Antoine Watteau's haunting portrayal of the self-aware actor, *Pierrot* (previously known as *Gilles*), of around 1718–19, entered the Louvre's collection in 1869, becoming the iconic portrayal of the poignant and solemn clown. In 1901, during his student days in Paris, Walt Kuhn came to know this unforgettable image of a stock character from the Italian theater's *commedia dell'arte*, which would resonate decades later in his portrayals of vaudeville actors and circus performers. American artists' interpretations of circus culture carried a European pedigree, from Jacques Callot (1592–1635) to Watteau (1684–1721) to Pablo Picasso (1881–1973). By the 1930s, vaudeville and the circus had been eclipsed by movies and other newer forms of entertainment, but the sheer number of American circus paintings produced in the 1930s and 1940s suggests a nostalgic interest in such familiar diversions amid the privations of the Great Depression and World War II.

Actively involved in writing, directing, and designing stage productions in the 1920s, Kuhn also painted individuals in the circus world. His model for *Clown with Drum* was not a clown, however, but a local boxer named Joe Pascucciello.[1] Rather than Pierrot's traditional garb of a loose white tunic with balloon sleeves and white pantaloons, he wears a tight-fitting shirt that emphasizes his muscular physique and minimizes the comic association of clowns. His expressionless white face, reminiscent of the popular nineteenth-century French *pantomime blanche*, underscores the static solemnity of his pose; his attribute, the bass drum, is similarly silenced. Embodying contrasting notions of performance and isolation, Kuhn's melancholy clown is a metaphor for the predicament of the modern artist.

[1] Philip Rhys Adams, *Walt Kuhn, Painter: His Life and Work* (Columbus: Ohio State University Press, 1998): 200.

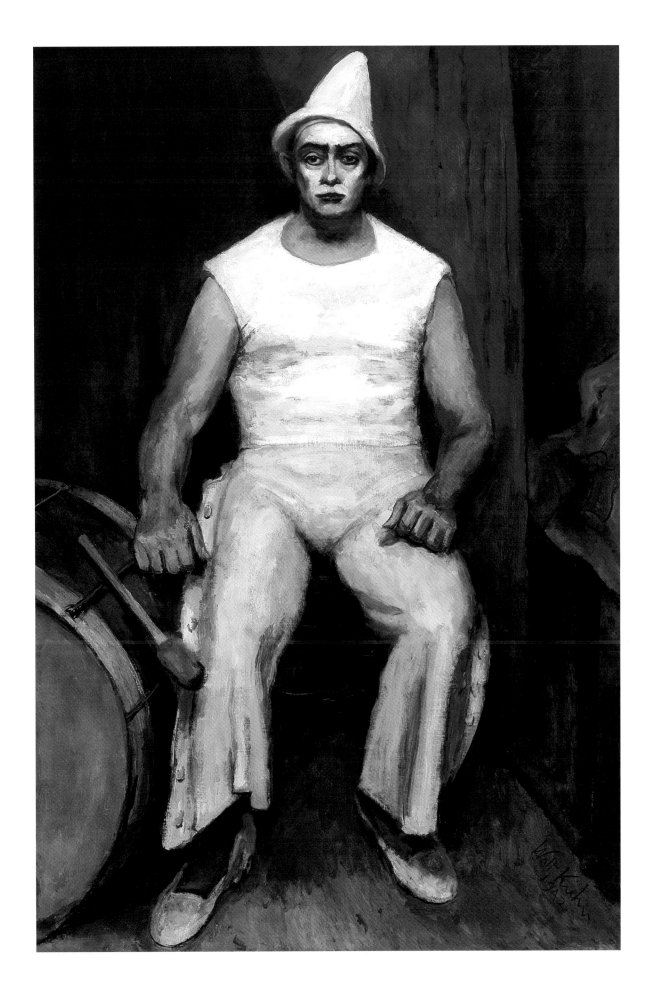

INDEX

Index of names mentioned in the text and the captions.
Page numbers in bold indicate illustrations.

BIBLIOGRAPHY

BENEDITE (Leonce). *Exposition d'artistes de l'École américaine*. Paris: Musée National du Luxembourg, 1919.

BERTIER DE SAUVIGNY (Guillaume de). *La France et les Français vus par les voyageurs américains, 1814-1848*. Paris: Flammarion, 1982.

BIZARDEL (Yvon). *American Painters in Paris*. New York: MacMillan, 1960.

BIZARDEL (Yvon). *Les Américains à Paris pendant la Révolution*. Paris: Calmann-Lévy, 1972.

BURNS [Sarah]. *Inventing the Modern Artist: Art and Culture in Gilded Age America*. New Haven and London: Yale University Press, 1996.

CLARK [Eliot]. *History of the National Academy of Design, 1825-1953*. New York: Columbia University Press, 1954.

COHN [Marjorie B.]. *Francis Calley Gray and Art Collecting for America*. Cambridge: Harvard University Press, 1986.

CORN [Wanda M.]. "Coming of Age: Historical Scholarship in American Art," *Art Bulletin*, LXX: 2, June 1899, pp. 188-207.

COWDREY [Mary Bartlett]. *American Academy of Fine Arts and American Art-Union, 1816-1852*. New York: The New-York Historical Society, 1953.

CRAVEN [Wayne]. "The Grand Manner in Early Nineteenth-Century American Painting: Borrowing from Antiquity, the Renaissance, and the Baroque," *The American Art Journal*, April 1979, pp. 5-43.

DURAND (Echeverria). *Mirage in the West: A history of the French Image of American Society to 1815*. Princeton: Princeton University Press, 1957.

DUNLAP [William]. *A History of the Rise and Progress of the Arts of Design in the United States*. 1834, New York: Dover Publications, 1969.

ERFFA [Helmut von] and STALEY (Allan). *The Paintings of Benjamin West*. New Haven: Yale University Press, 1986.

FINK (Lois Marie). "American Artists in France, 1850-1870," *American Art Journal*, 5:2, November 1973, pp. 32-49.

FINK (Lois Marie). "The Innovation of Tradition in Late Nineteenth-Century American Art," *The American Art Journal* 10:2, November 1978, pp. 63-71.

FINK (Lois Marie). *American Art at the Nineteenth-Century Paris Salon*. Washington D.C.: Smithsonian Institution, and Cambridge: Cambridge University Press, 1990.

FINK (Lois Marie) and TAYLOR (Joshua). *Academy: The Academic Tradition in American Art*. Washington D.C.: Smithsonian Press, 1975.

FOSHAY (Ella M.]. *Mr. Lumen Reed's Picture Gallery: A Pioneer Collection of American Art*. New York: Abrams, 1990.

GOODYEAR [Frank H. Jr.]. *In This Academy: The Pennsylvania Academy of the Fine Arts, 1805-1976*. Philadelphia: Pennsylvania Academy of the Fine Arts, 1976.

GOULD (Cecil). *Trophy of Conquest: The Musée Napoléon and the Creation of the Louvre*. London: Faber and Faber, 1965.

GRANT (Susan), "Whistler's Mother Was not Alone: French Government Acquisitions of American Paintings, 1871-1900," *Archives of American Art*, 32:2, 1992, pp. 2-15.

GRANT (Susan). "Paris: A Guide to Archival Sources for American Art History," *Archives of American Art*. Washington, D.C.: Smithsonian Institution, 1997.

GRIFFIN [Randall C.]. *Homer, Eakins, and Anshutz: The Search for American Identity in the Gilded Age*. University Park, Pennsylvania: Pennsylvania State University Press, 2004.

HARRIS [Neil]. *The American Artist in American Society. The Formative Years, 1790-1860*. 1966, Chicago: University of Chicago Press, 1982.

JAFFÉ [Irma B.]. *John Trumbull: Patriot-Artist of the American Revolution*. Boston: New York Graphic Society, 1975.

JONES (Russell M.]. "American Painters in Paris: The Rate of Exchange, 1825-48," *Apollo, The International Magazine of the Arts*, February 1992, pp. 73-77.

LEVENSTEIN (Harvey). *Seductive Journey: American Tourists in France from Jefferson to the Jazz Age*. Chicago: University of Chicago Press, 1998.

MARRINAN (Michael). *Painting Politics for Louis-Philippe: Art and Ideology in Orleanist France, 1830-1848*. New Haven: Yale University Press, 1988.

MCCAULEY [Elizabeth Anne]. *Industrial Madness: Commercial Photography in Paris, 1848-1871*. New Haven: Yale University, 1994.

MCCLELLAN (David Andrew). *Inventing the Louvre: Art, Politics, and the Origins of the Modern Museum in Eighteenth-Century Paris*. Berkeley: University of California Press, 1994.

MESLAY (Olivier), BARRINGER (Timothy), WALLACH (Allan), SAVINEL (Christine), COHEN-SOLAL (Annie), CHASSEY (Éric de), BUTT (Gavin), and HOORMANN (Anne). *L'Art américain: Identités d'une nation*. Paris: Musée du Louvre/ENSBA/Terra Foundation for American Art, 2005.

MILLER [Lillian B.]. "'An Influence in the Air': Italian Art and American Taste in the Mid-Nineteenth Century," in *The Italian Presence in American Art, 1760-1860*. New York: Fordham University Press, 1989, pp. 26-52.

MORSE [Edward Lind] ed. *Samuel F. B. Morse: His Letters and Journals*. Boston and New York: Houghton Mifflin Company, 1914.

STAITI (Paul). *Samuel F.B. Morse*. Cambridge and New York: Cambridge University Press, 1990.

RÉAU (Louis). *L'Art français aux États-Unis*. Paris: Henri Laurens, 1926.

ROGER (Philippe). *The American Enemy. A Story of French Anti-Americanism*, trans. Sharon Bowman. Chicago and London: University of Chicago Press, 2005.

TATHAM (David). "Samuel F.B. Morse's *Gallery of the Louvre*. The Figures in the Foreground," *American Art Journal* 13, autumn 1981, pp. 38-48.

TOMKINS [Calvin]. *Merchants and Masterpieces: The Story of the Metropolitan Museum of Art*. New York: E. P. Dutton, 1970.

TROYEN (Carol]. "Innocents Abroad. American Painters at the 1867 Exposition universelle, Paris," *The American Art Journal*, 16:4, autumn 1984, pp. 2-29.

VIATTE [Françoise]. "La chalcographie du Louvre d'hier à aujourd'hui," *Nouvelles de l'estampe* 148, October 1996, pp. 43-46.

WEINBERG (Barbara H.). *Art Thoughts: the Experiences and Observations of an American Amateur in Europe*. New York: Garland, 1976.

WEINBERG (Barbara H.). *The Lure of Paris. Nineteenth-Century American Painters and Their French Teachers*. New York: Abbeville Press, 1991.

WIESINGER (Véronique). "La Politique d'acquisition de l'État français sous la Troisième République en matière d'art étranger contemporain: l'exemple américain (1870-1940)," *Bulletin de la Société de l'Histoire de l'Art français*, 1993, pp. 263-99.

WIESINGER (Véronique) et al. *Le Voyage de Paris. Les Américains dans les écoles d'art, 1868-1918*. Paris: RMN, 1990.

WUNDER [Richard P.]. *Hiram Powers, Vermont Sculptor, 1805-1873*. Newark: University of Delaware Press, 1991.

EXHIBITION CATALOGUES

Paris 1889. American Artists at the Universal Exposition, Annette Blaugrund. New Brunswick and New Jersey: Rutgers University Press, 1999.

Paris 1900. The "American School" at the Universal Exposition, Diane P. Fischer. New Brunswick and New Jersey: Rutgers University Press, 1999.

Trois siècles d'art aux États-Unis, Musée du Jeu de Paume and MoMA. New York and Paris: RMN, 1938.

Henry Benbridge (1743-1812), American Portrait Painter, Robert G. Stewart. National Portrait Gallery. Washington D.C.: Smithsonian Institution Press, 1971.

Les Américains et la Révolution française / The Americans and the French Revolution, Véronique Wiesinger. Musée National de la Coopération Franco-Américaine, Château de Blérancourt. Paris: RMN, 1989.

Le Voyage de Paris: les Américains dans les écoles d'art, 1868-1918, Musée National de la Coopération Franco-Américaine, Château de Blérancourt. Paris: RMN, 1990.

Paris 1900: les artistes américains à l'Exposition universelle, Musée Carnavalet. Paris Musées, 2001.